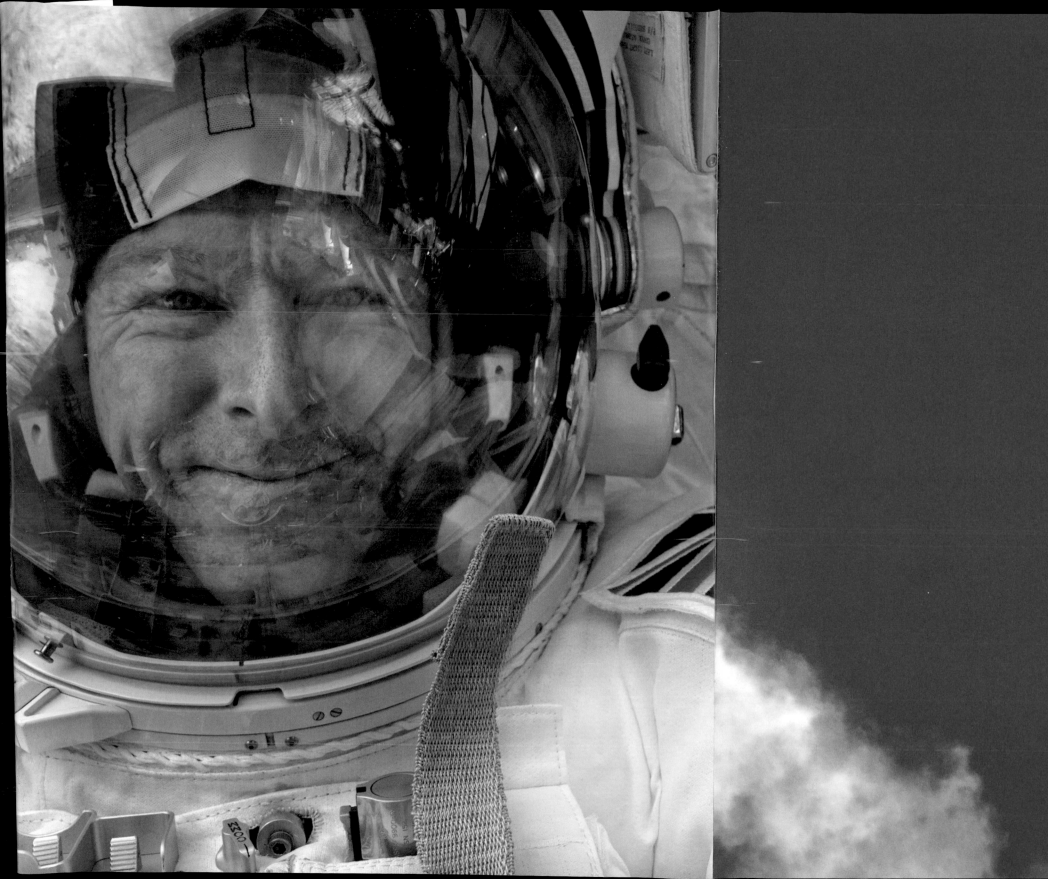

Hello, is this planet Earth?

TIM PEAKE

Hello, is this planet Earth?

My View from
the International
Space Station

CENTURY

1 3 5 7 9 10 8 6 4 2

Century
20 Vauxhall Bridge Road
London SW1V 2SA

Century is part of the Penguin Random House group of companies whose
addresses can be found at global.penguinrandomhouse.com.

Some of the images and captions included in this book were first posted by Tim Peake on his
social media accounts during his mission on board the International Space Station.

First published by Century in 2016

www.penguin.co.uk

A CIP catalogue record for this book is available from the British Library.

ISBN 9781780897158

Printed and bound in Germany by Firmengruppe APPL aprinta druck, Wemding
Colour separations by BORN
Design: Two Associates

Penguin Random House is committed to a sustainable future for our business, our readers
and our planet. This book is made from Forest Stewardship Council® certified paper.

To Thomas and Oliver, who help me to see
the world through new eyes every day.

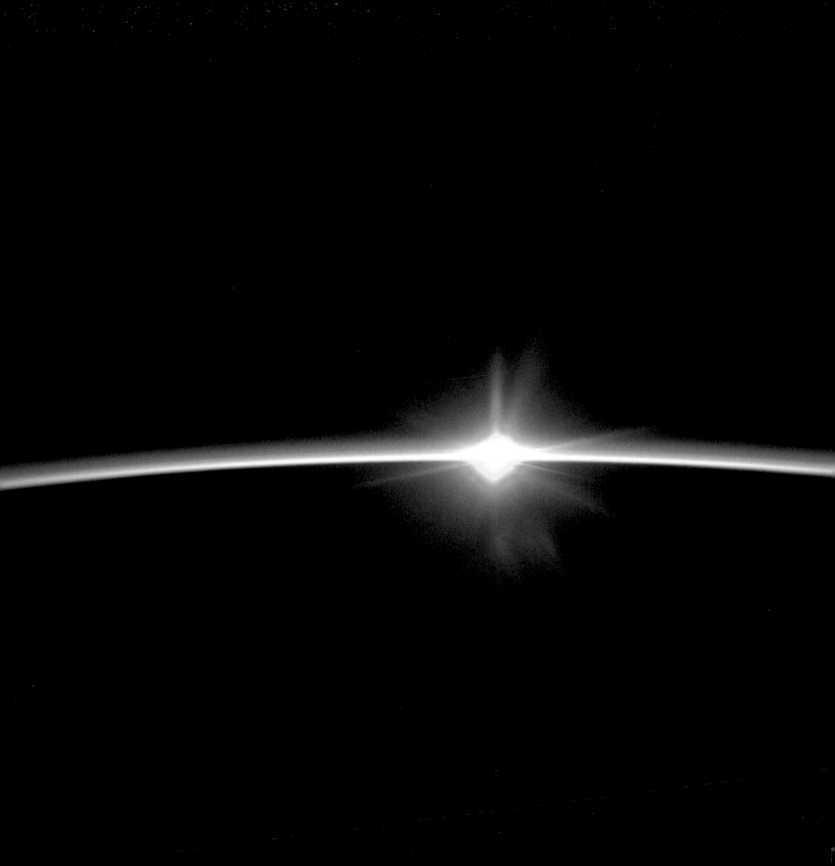

'Once you have tasted flight, you will forever walk the Earth with your eyes turned skyward, for there you have been, and there you will always long to return.'
Leonardo da Vinci

'Nature is painting for us, day after day, pictures of infinite beauty.'
John Ruskin

'Oh! I have slipped the surly bonds of Earth,
And danced the skies on laughter-silvered wings;
Sunward I've climbed, and joined the tumbling mirth
of sun-split clouds.'
John Gillespie Magee, Jr

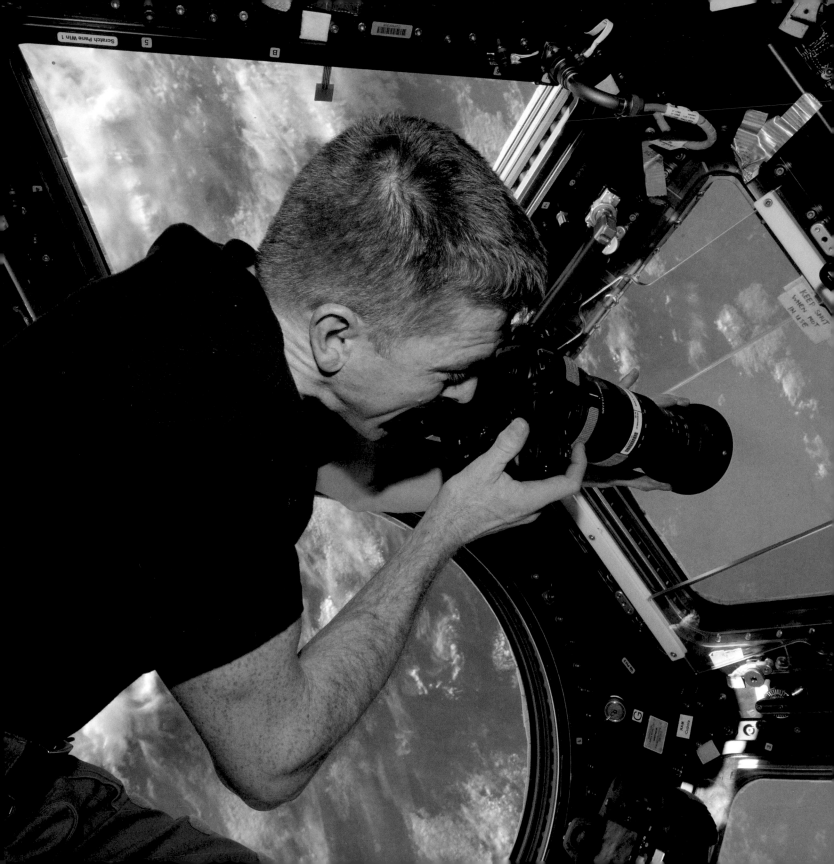

The view from the Cupola window on board the International Space Station.

NIGHT
AND DAY

Earth has so many secrets and the longer you spend in space the more time you have to uncover and appreciate them. Even every sunrise and sunset is unique and special in its own way.

'Ciao Bella!'

Sixty million people live here. The lights of Naples and Rome light up Italy's west coast.

Ionian Sea

● = Location of International Space Station when the photo was taken

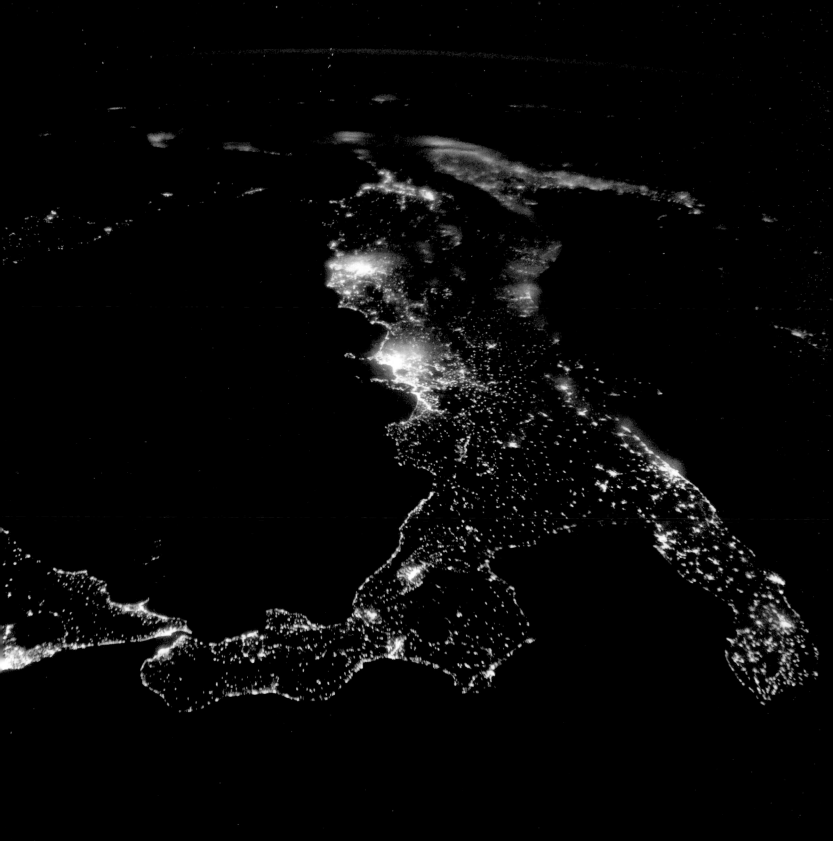

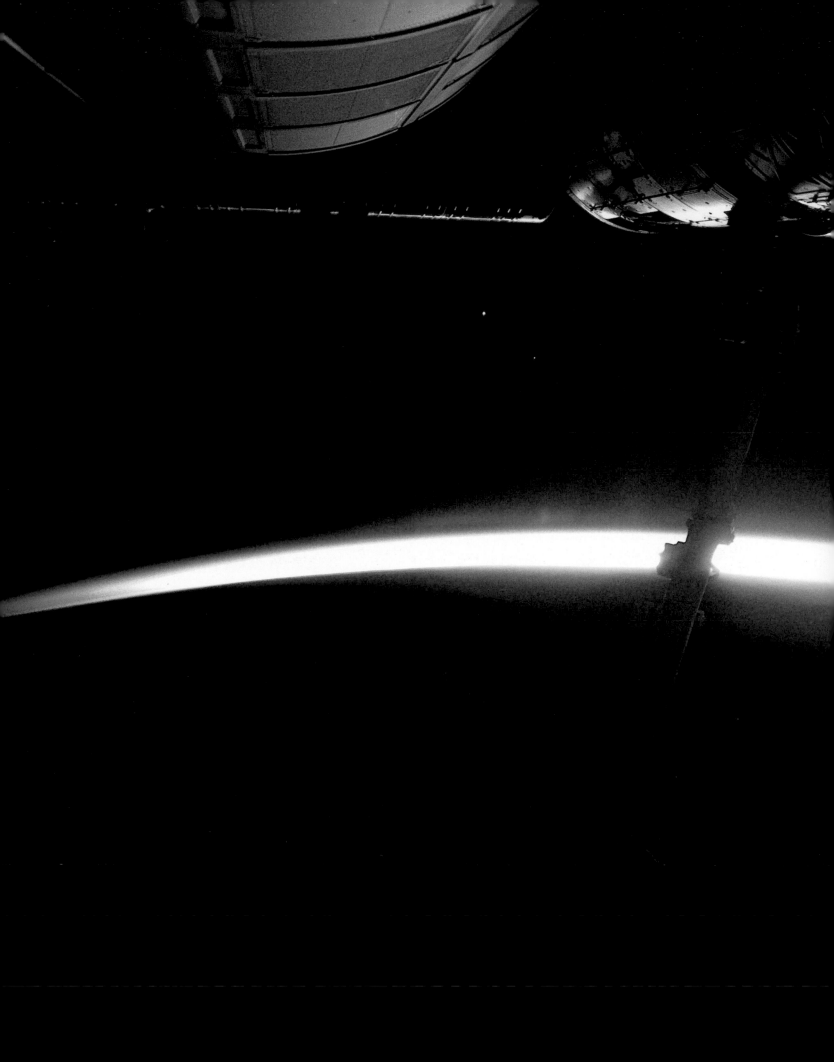

'Our space station takes on a blue glow just before dawn – cool!'

Looking forward from the Cupola window the US, Japanese and European laboratories are illuminated.

15 FEBRUARY 2016

Southern Indian Ocean

'Wake up,
it's a beautiful morning.'

**As the International Space Station
orbits Earth, we can see 16 sunrises
every 24 hours.**

24 DECEMBER 2015

Atlantic Ocean

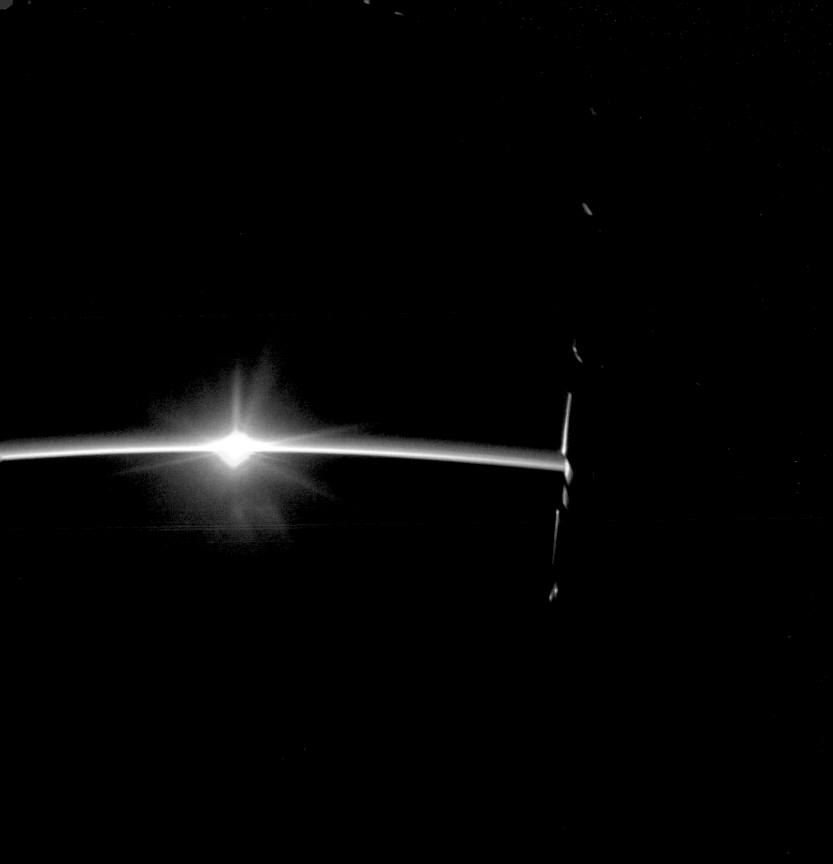

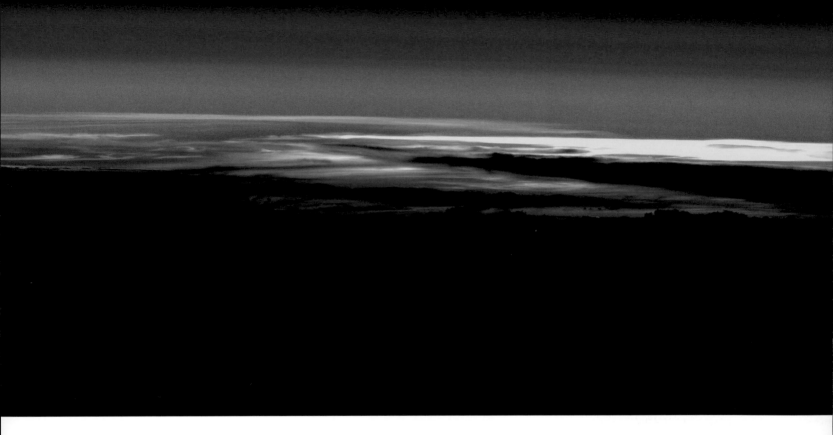

'A little motivation for a Monday morning…'

This breath-taking sunrise was taken using a Nikon D4 camera with a 400mm lens. Sometimes the sun rises so rapidly that it's hard to keep up adjusting the camera settings.

31 MAY 2016

Somewhere over Europe

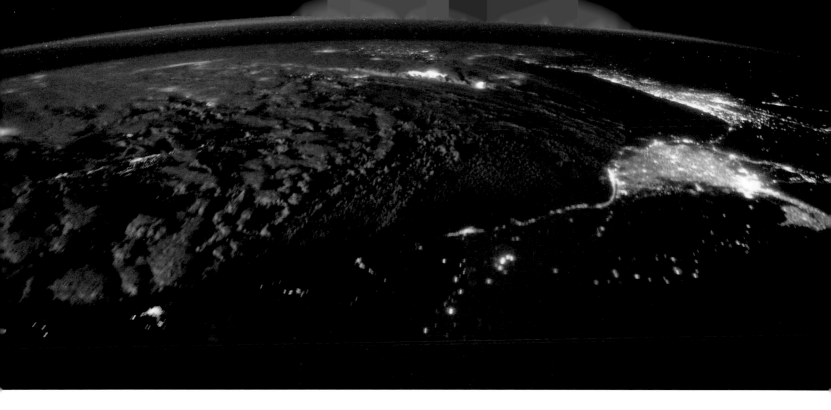

Cairo lights, a cloudy Mediterranean with lightning over Cyprus and a yellow-green atmosphere under the stars.

17 JANUARY 2016

Siwa, Egypt

'Good morning, Earth.'

It almost looks like the sun is rising from between the clouds – the fifth and most spectacular sunrise of the day.

27 MARCH 2016

Central China

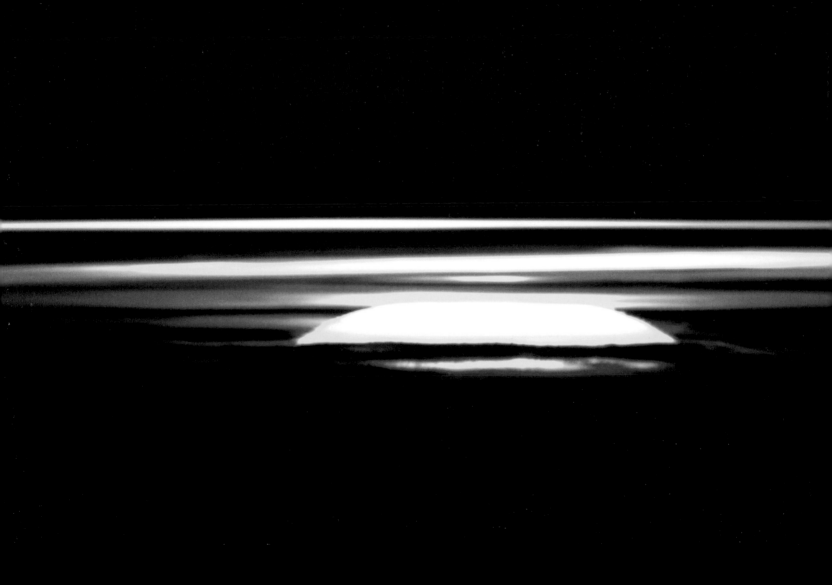

'Hey, I recognise that place!'

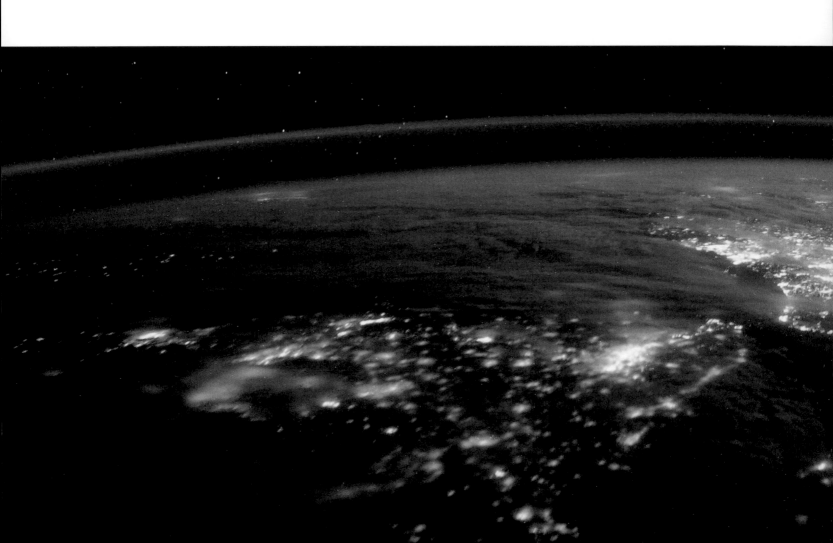

Looking to the east along the English Channel with the UK on the left and France on the right. The streetlights from the densely populated cities London, Paris, Brussels, Rotterdam and Amsterdam glow brightly in the centre of the picture.

28 JANUARY 2016

Brest, France

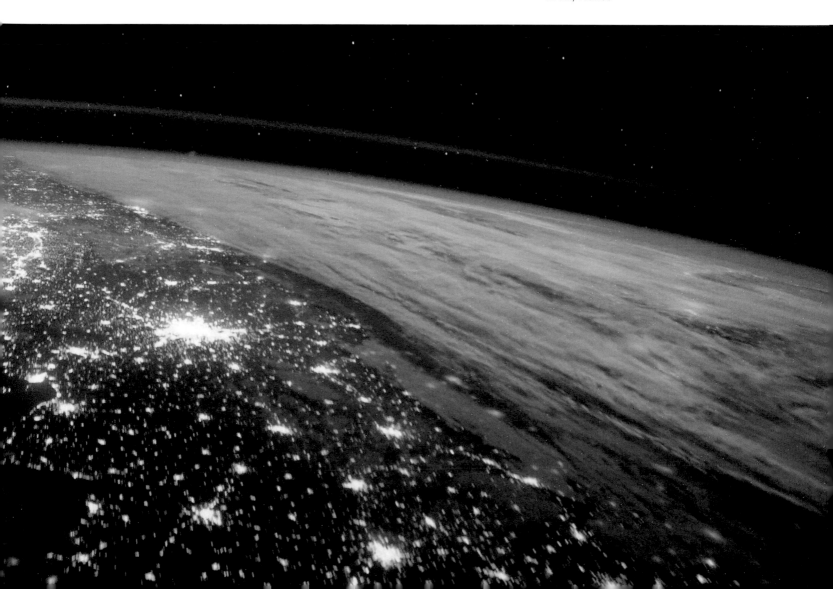

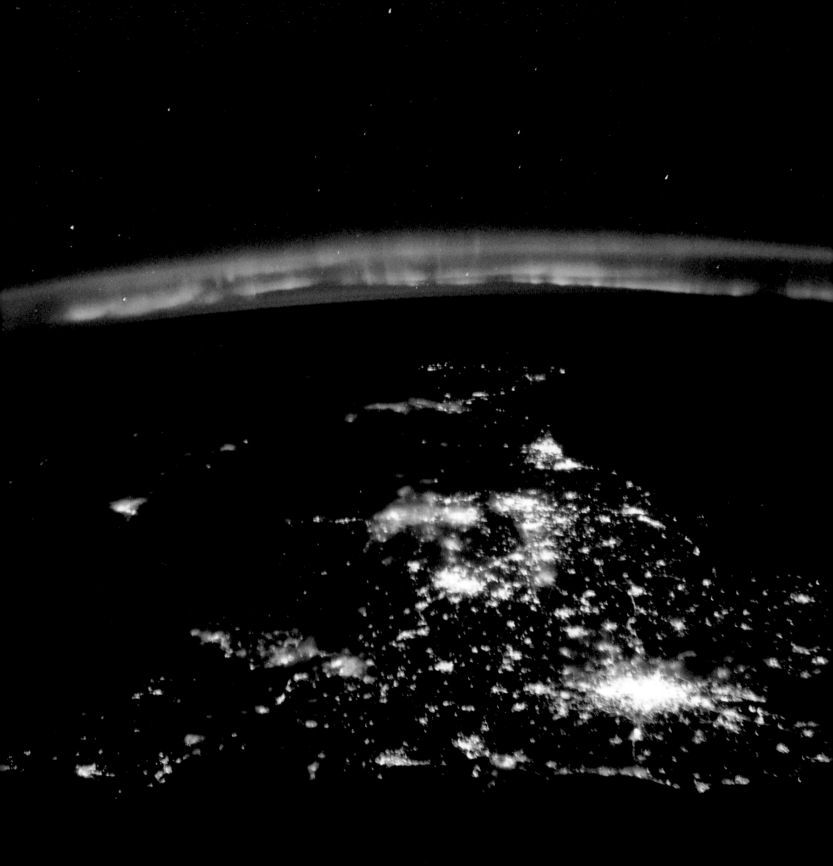

'The United Kingdom under an aurora.'

5 APRIL 2016

English Channel

Overleaf:
The River Thames flows through the centre, with many of London's famous bridges visible. The distinctive Isle of Dogs and Thames Barrier can also be seen. The central dark regions mark London's royal parks, with Richmond Park lower left.

30 JANUARY 2016

London, England

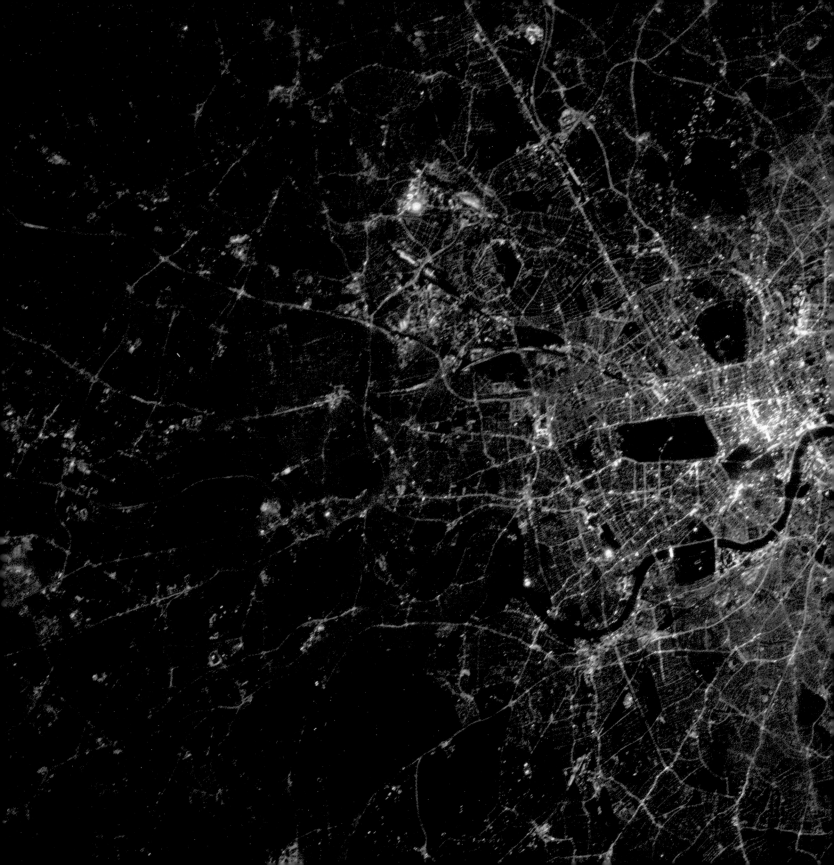

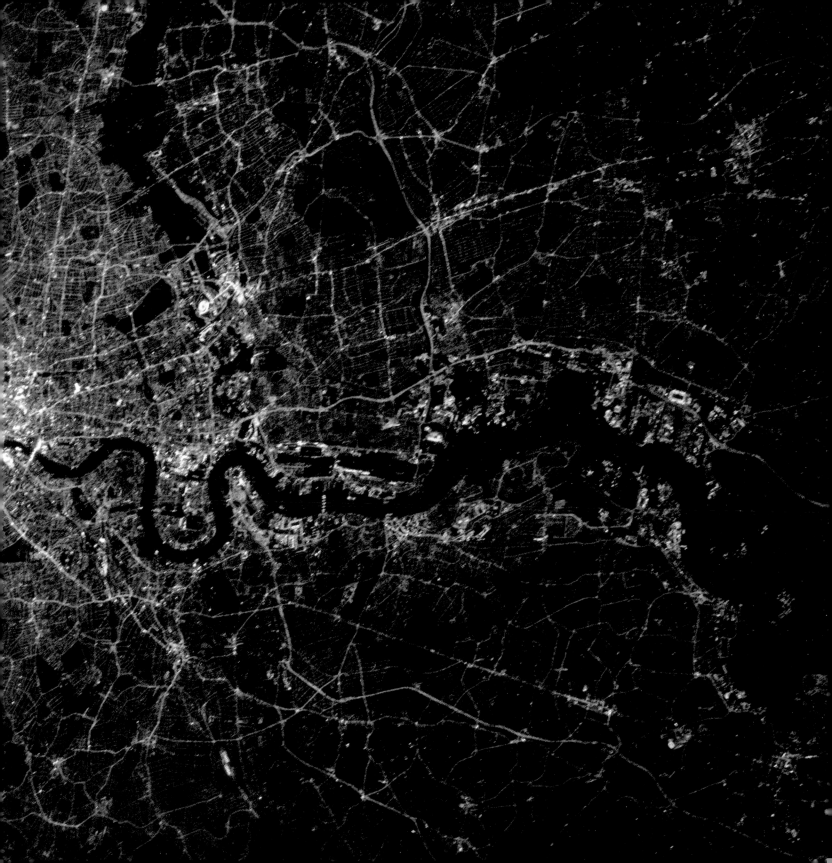

'Can we see other planets from space? Here's Venus rising just before the Sun.'

In addition to Earth, the planets of Mars, Jupiter, Saturn and Venus are clearly visible with the naked eye from the International Space Station.

28 APRIL 2016

Western Australia

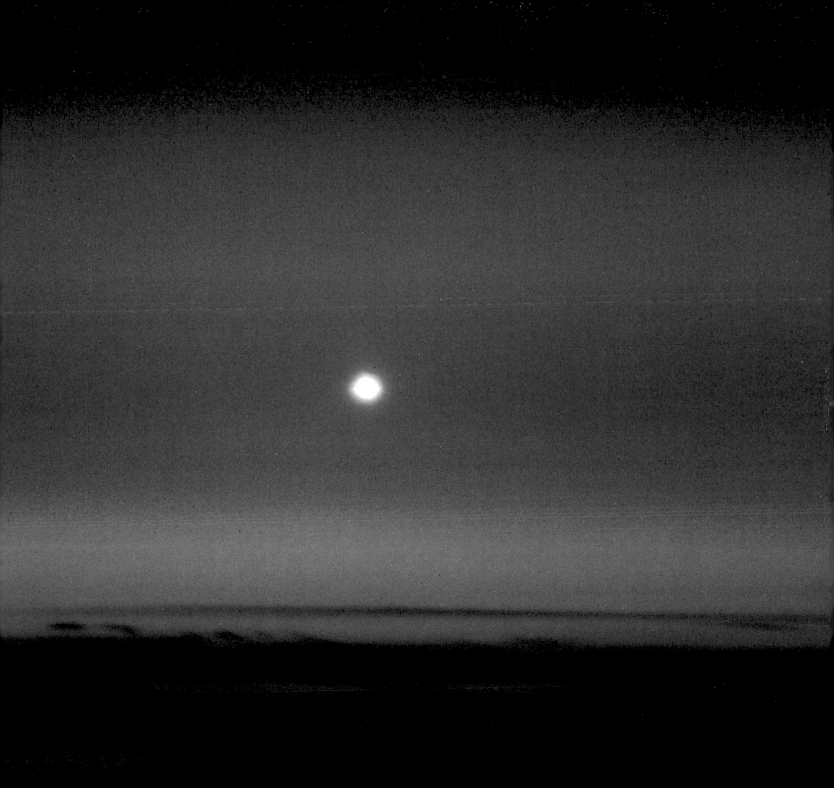

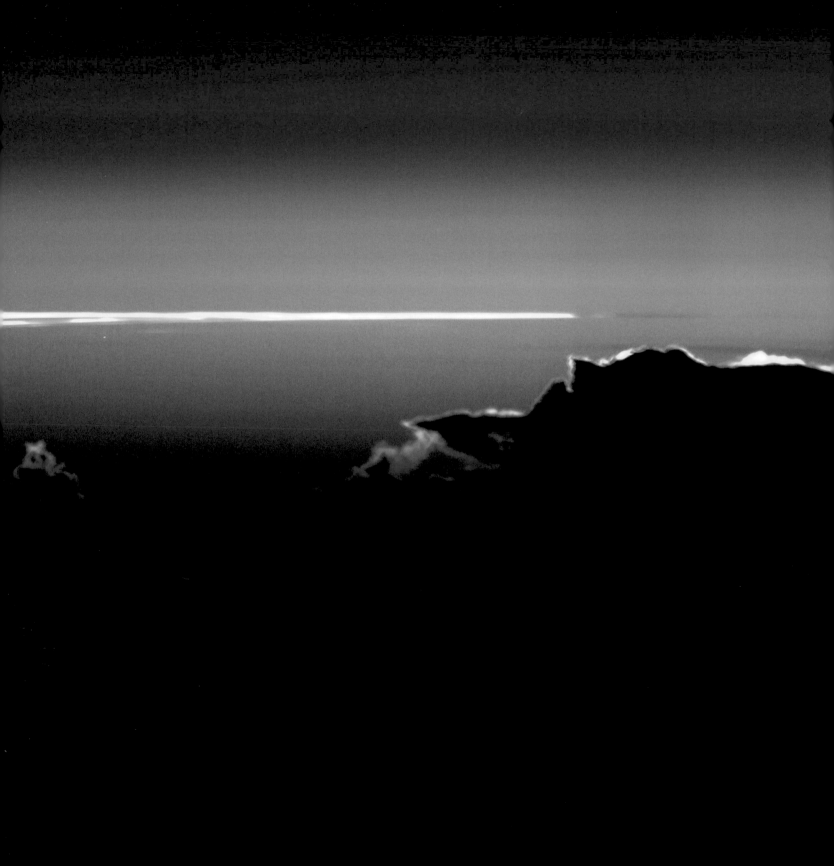

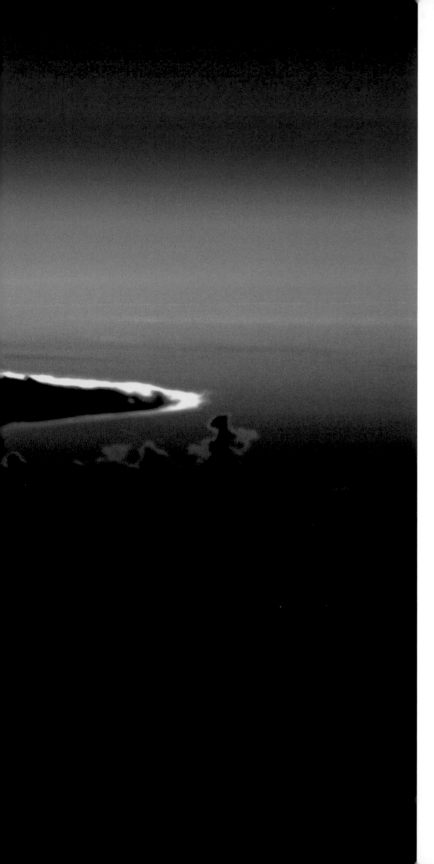

'A beautiful Pacific sunset.'

The distinctive anvil shape of a cumulonimbus cloud over the Pacific Ocean.

1 JUNE 2016

Kiribati, Pacific Ocean

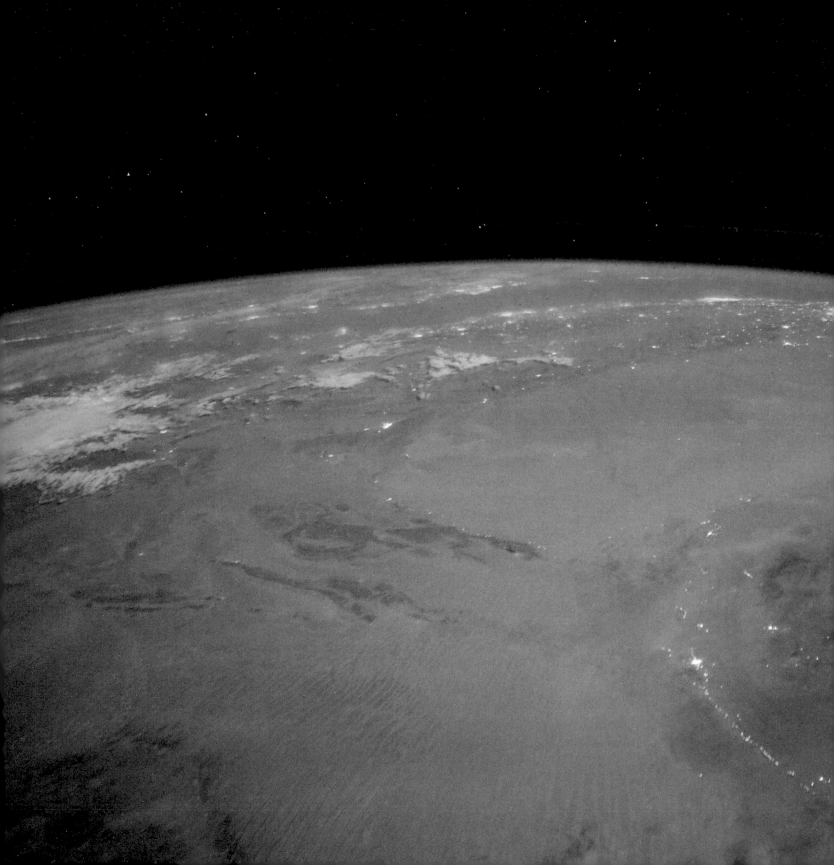

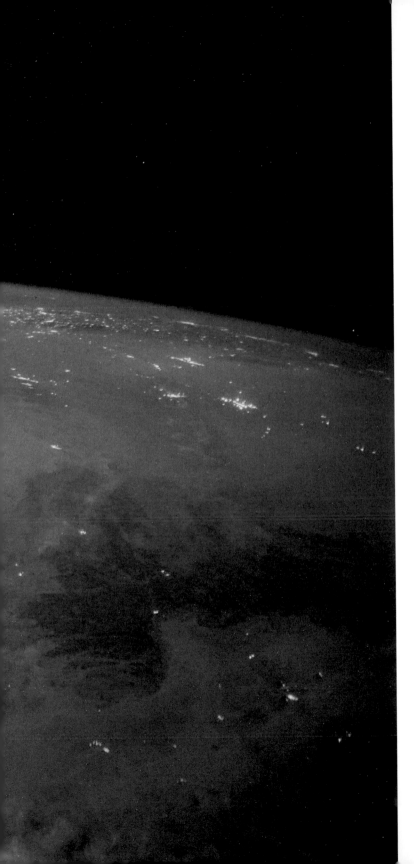

'Night-time Sahara – you can really see how thin Earth's atmosphere is in this pic.'

This is mostly just Algeria in the frame... In this pic you can see from the coast of Morocco on the left, Strait of Gibraltar and Spain top left, across to cities on the Tunisian coast on the right – a distance of around 2200 km. The line of lights in the centre are towns and villages along the N6 highway in Algeria.

21 MAY 2016

Adrar, Algeria

'We have phases of 'short nights' on the International Space Station – sunlight is nearly always visible right now.'

Taken looking northeast from over Tunisia, this pic shows Corsica and Sardinia left, the Tyrrhenian Sea, Italy and Sicily at right. Look closely and you can spot the dark mounds of Mt.Vesuvius next to Naples and Mt.Etna next to Catania, Sicily.

21 MAY 2016

Tunis, Tunisia

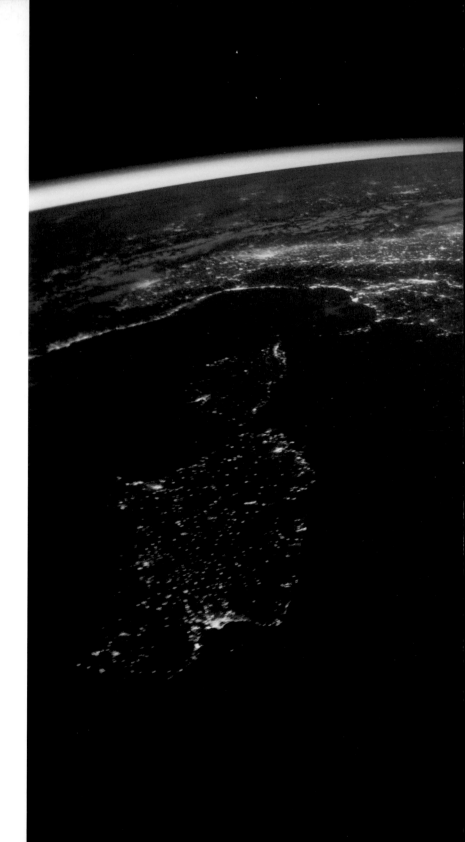

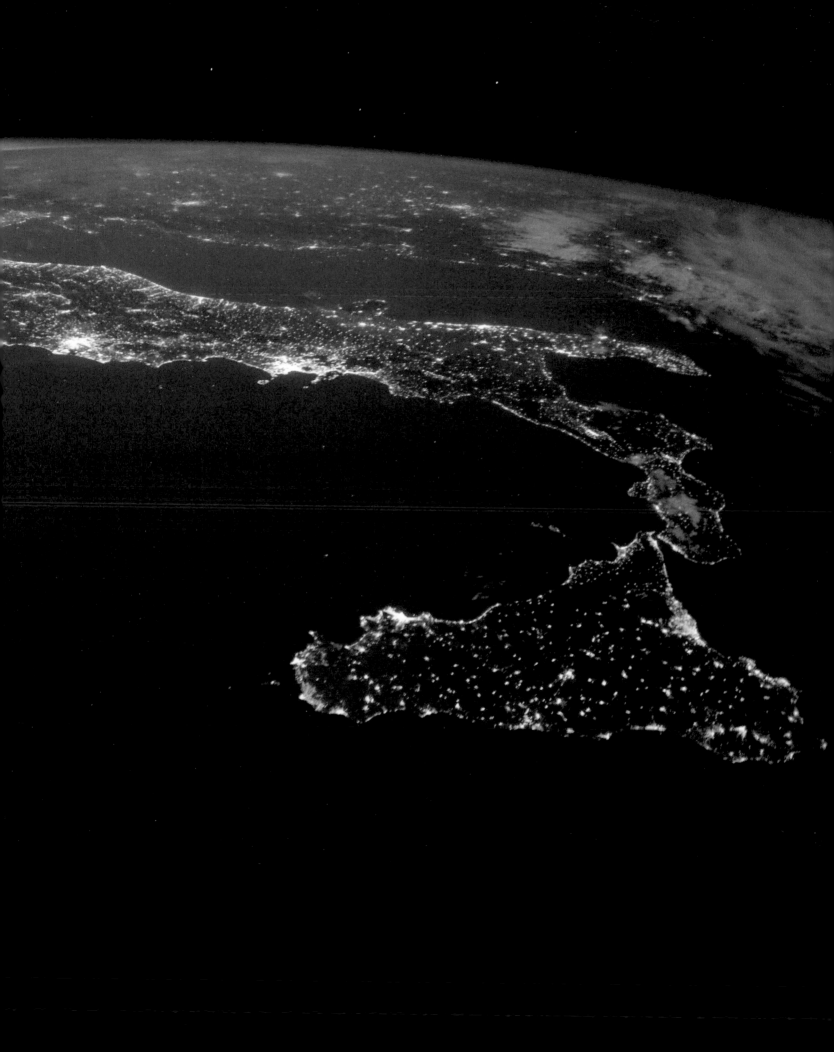

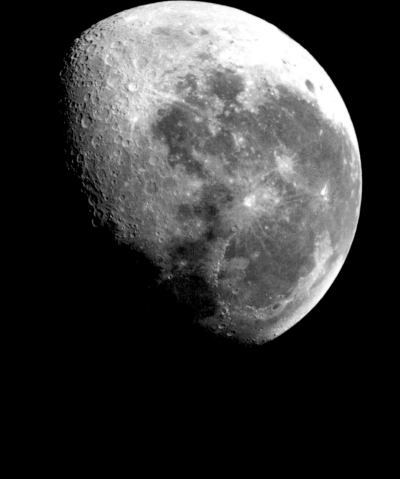

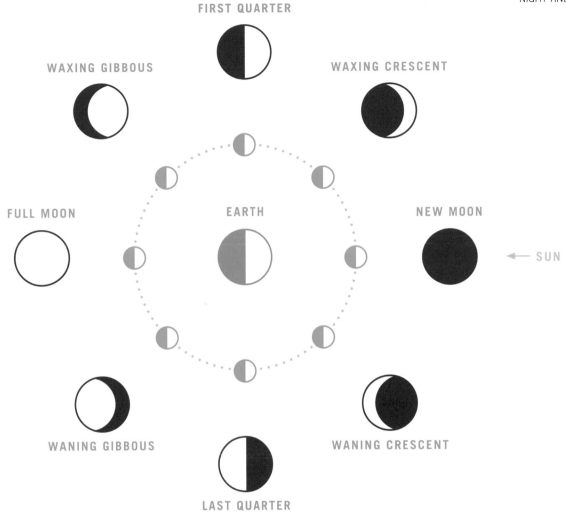

FIRST QUARTER

WAXING GIBBOUS

WAXING CRESCENT

FULL MOON

EARTH

NEW MOON

← SUN

WANING GIBBOUS

WANING CRESCENT

LAST QUARTER

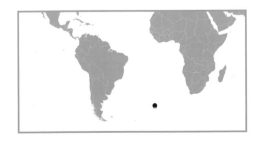

'I was looking for Antarctica —
hard to spot from our orbit.
Settled for a moonset instead.'

28 MARCH 2016

Southern Atlantic Ocean

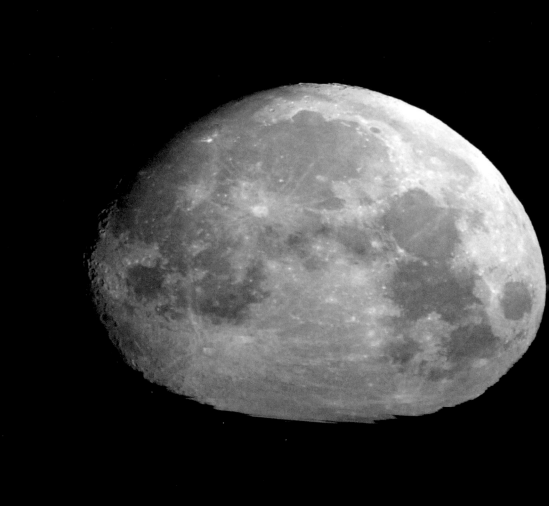

'Tonight's waxing gibbous moonset. Goodnight, Earth :)'

This is a normal phase of the Moon. 'Gibbous' means the moon is more than half illuminated. 'Waxing' means growing in illumination. Where's the rest of the Moon? Well, you're seeing the bottom half of the Moon through the top of Earth's atmosphere, which is fluid and causes this refraction effect (a bit like the heat hazes you see over roads on a hot day).

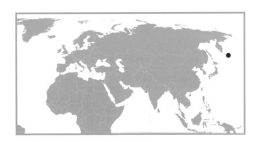

19 MAY 2016

Bering Sea

43

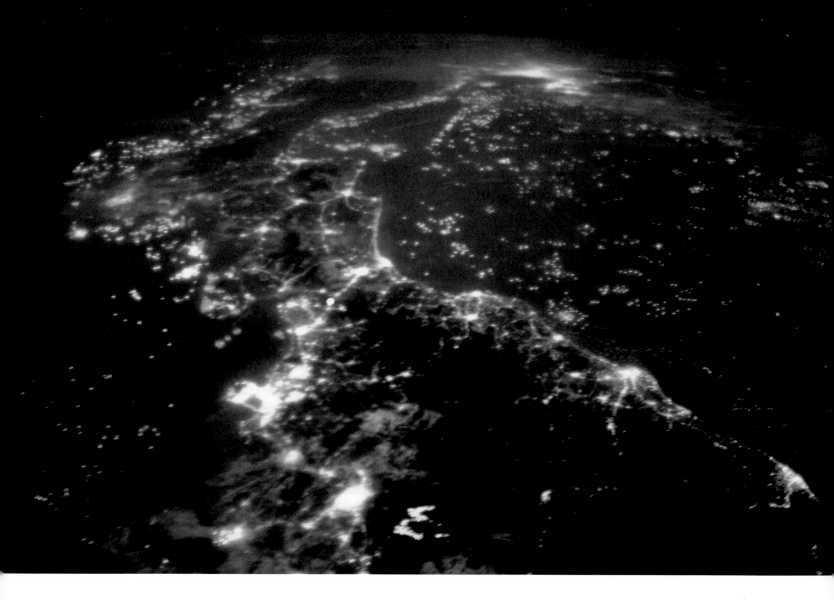

'A sea of green fishing boats light up the night.'

Looking north over Malaysia towards Bangkok at top. Left is Malaysia's capital Kuala Lumpur. All the dots of light in the sea are fishing boats, directing their spotlights into the sea to attract phytoplankton — which in turn attracts squid.

17 MARCH 2016

Gulf of Thailand

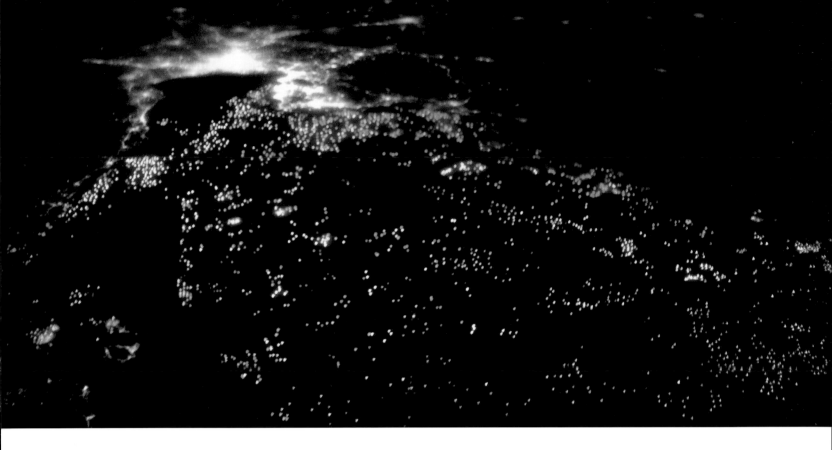

**A close-up of fishing boats
in the Gulf of Thailand,
with Bangkok at the top.**

13 MARCH 2016

Gulf of Thailand

45

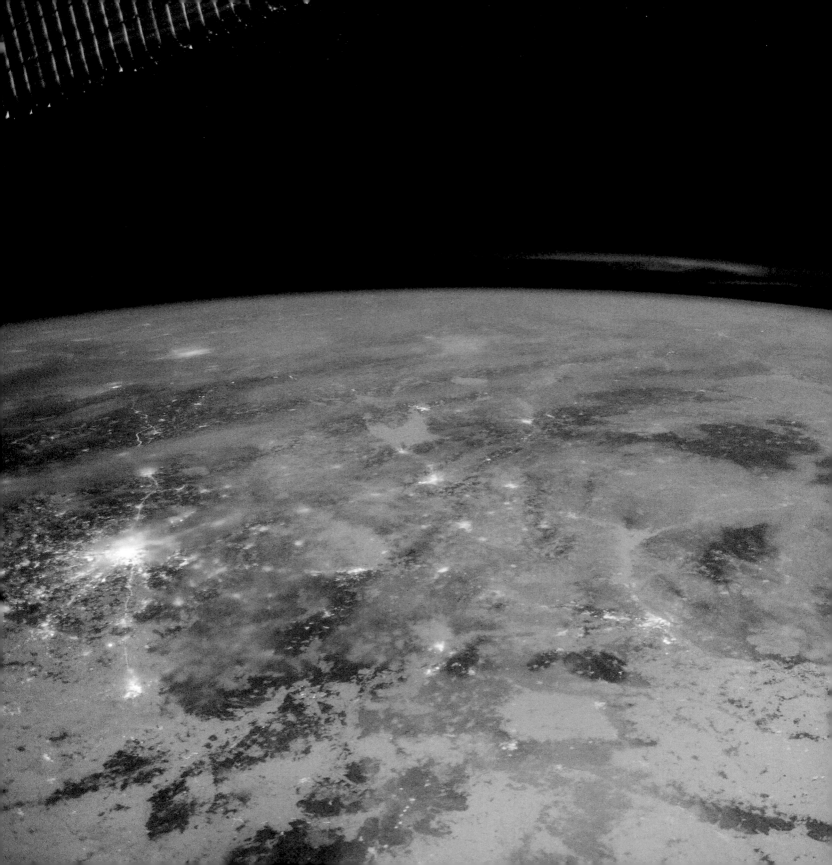

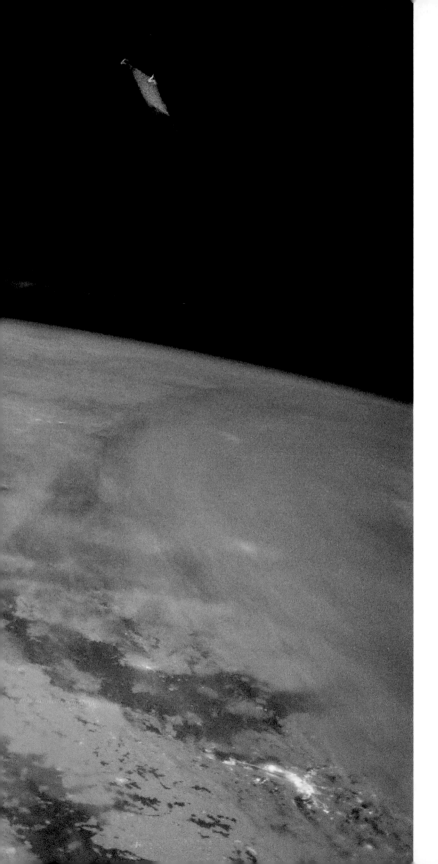

'Frozen planet.'

A wintry looking Moscow under the aurora. To the north east of the city lies the Gagarin Cosmonaut Training Centre, where all astronauts spend many months training on the Soyuz spacecraft and Russian segment of the International Space Station.

23 JANUARY 2016

Moscow, Russia

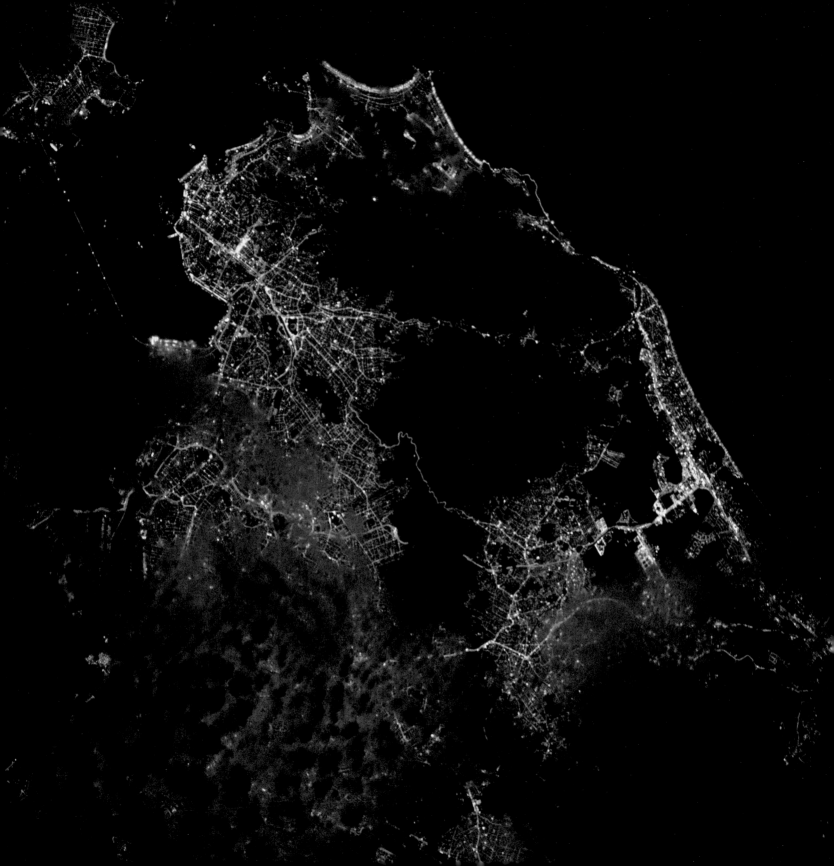

'A cloudy Rio de Janeiro —
a city I would love to visit.'

**The dark area in the centre is the
Tijuca National Park. You can see the
coastlines of Copacabana and Ipanema
at the top, and the Rio-Niterói Bridge
crossing Guanabara Bay on the left.**

19 MARCH 2016

Rio de Janeiro, Brazil

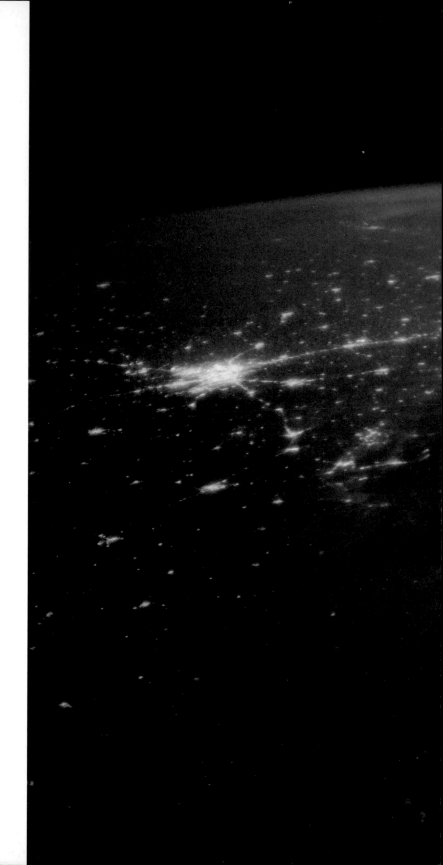

'A moonlit pass-by of New Delhi and the Himalayas.'

New Delhi on the left, with the main Asian Highway 1 (AH1) heading towards the lights of Ludhiana, Jalandhar, Amritsar and Lahore near the horizon.

22 MARCH 2016

Uttar Pradesh, India

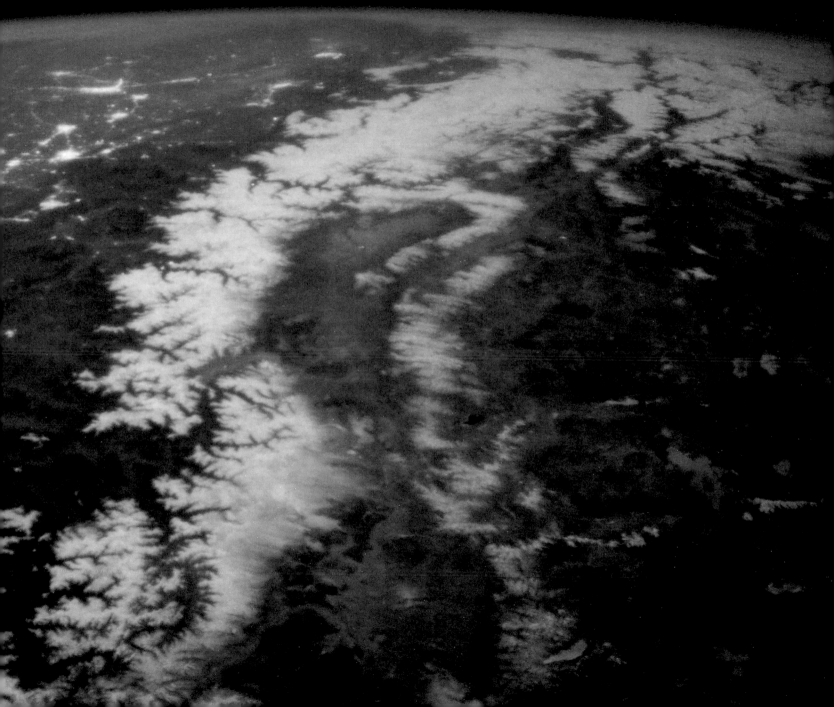

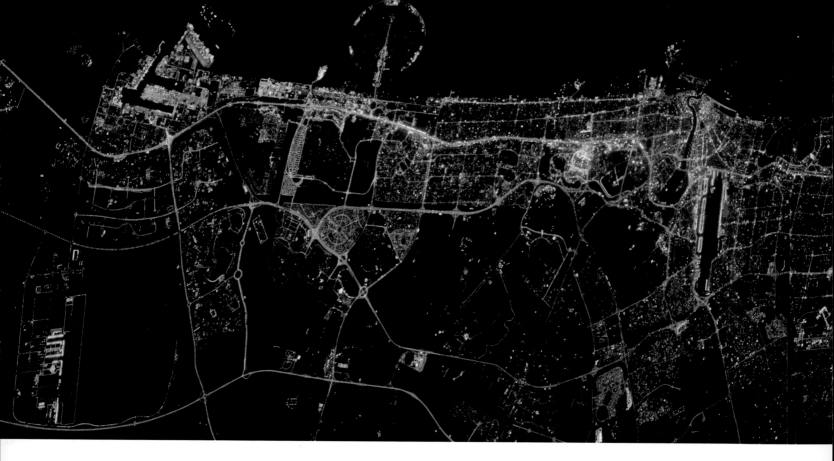

'Dubai at night – always easy to recognise!'

11 APRIL 2016

Dubai, United Arab Emirates

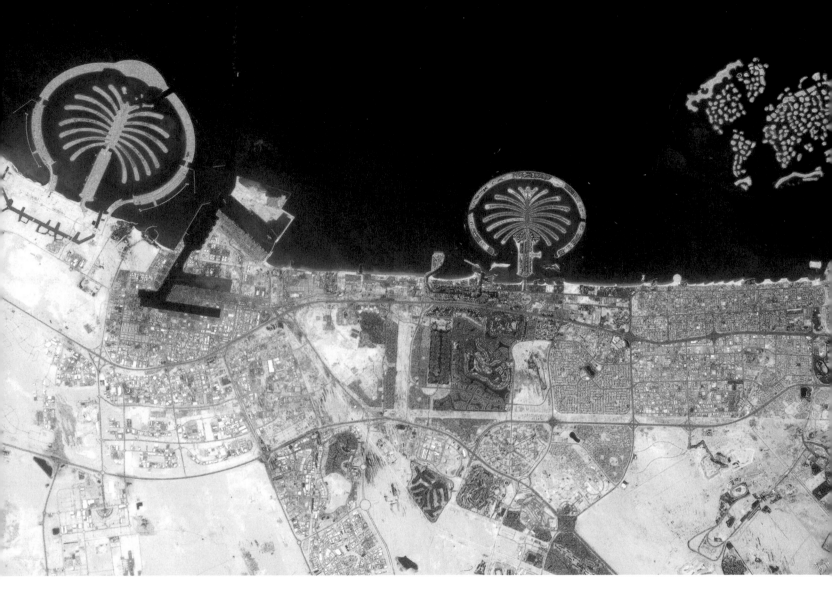

10 APRIL 2016

Dubai, United Arab Emirates

Palm Jebel Ali on the left, next to Jebel Ali deep port – the world's largest man-made harbour. Palm Jumeirah and the World Islands to the right. Palm Jebel Ali is still under construction – hence it is not illuminated in the photo of Dubai at night.

53

'Moonlit mountains over Kyrgyzstan.'

Cities of Bishek, Almaty and Urumqi lit up like beacons, looking east. Kazakhstan is on the left, the Taklamakan desert of northern China is on the right.

21 MAY 2016

Tashkent, Kyrgyzstan

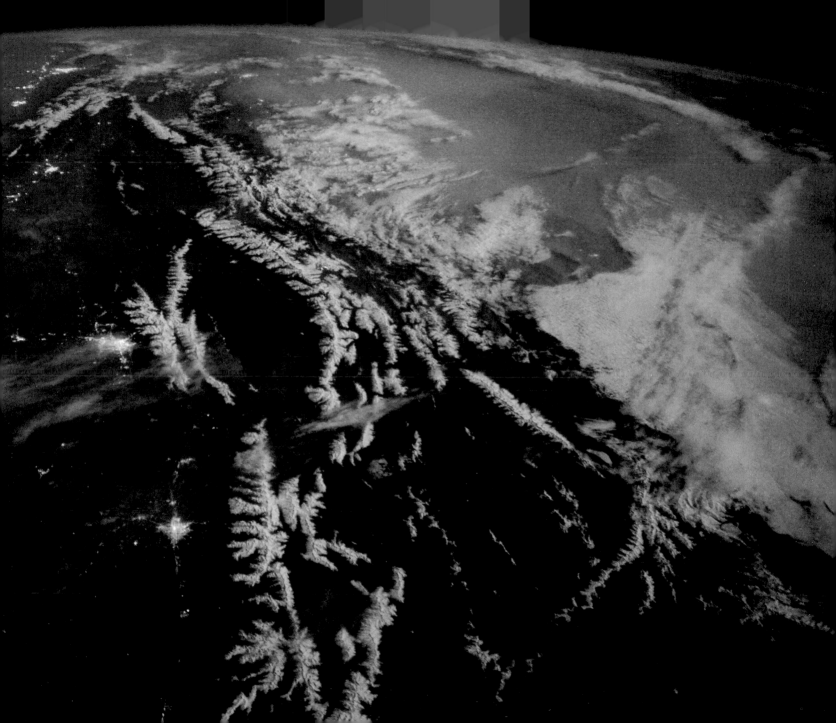

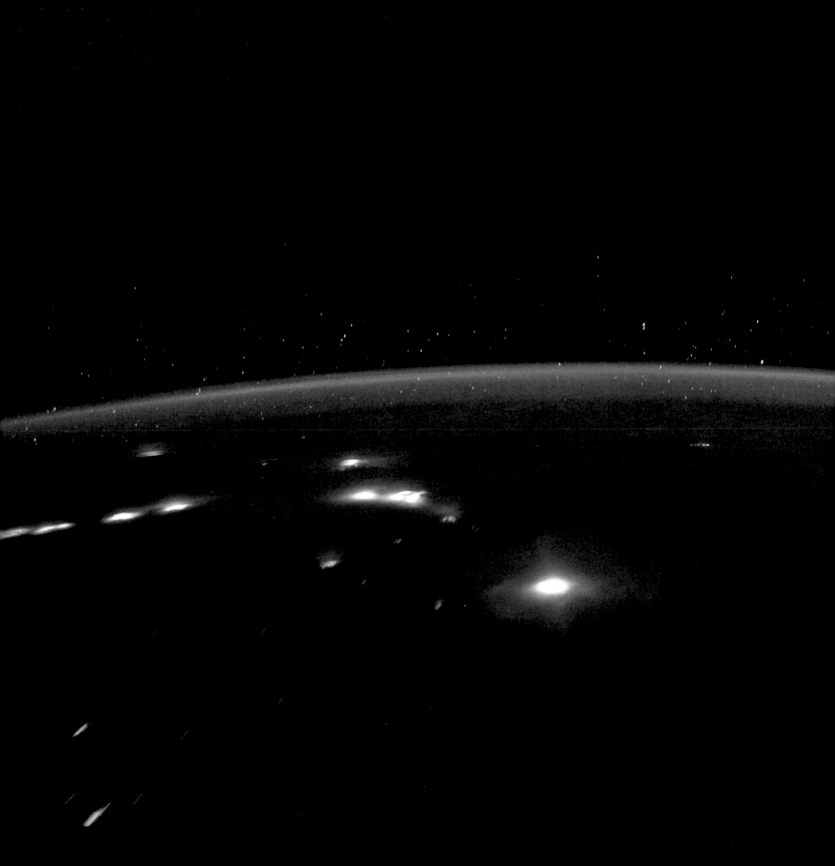

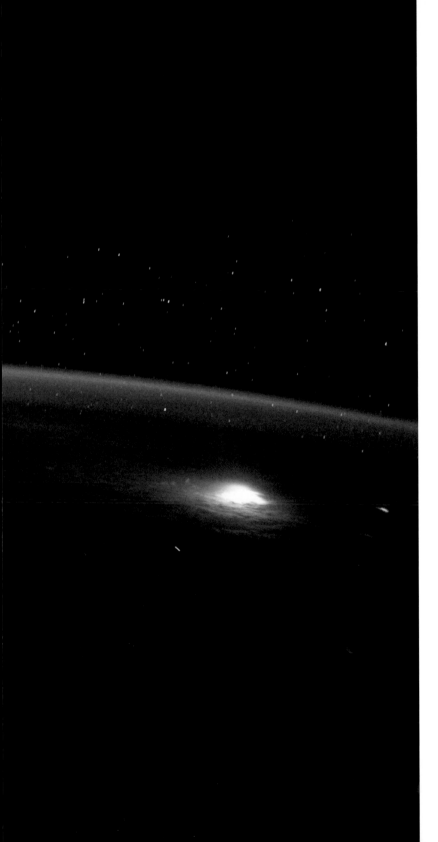

'Lightning as we
passed over South
Africa. Every day
I see new and amazing
things up here! Of
interest are the
number of lightning
storms in just a
two-second exposure.'

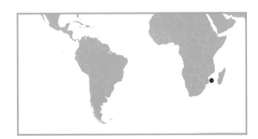

8 JANUARY 2016

Mozambique Channel

'Been some great night passes over Europe recently…'

Northern Europe, from Brittany in France at left to the Netherlands and Germany on the right. This photo was taken looking towards the UK with the aurora borealis on the horizon. Look closely and spot the constellation Pleiades (Seven Sisters) above Ireland.

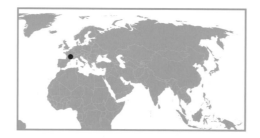

5 APRIL 2016
Dijon, France

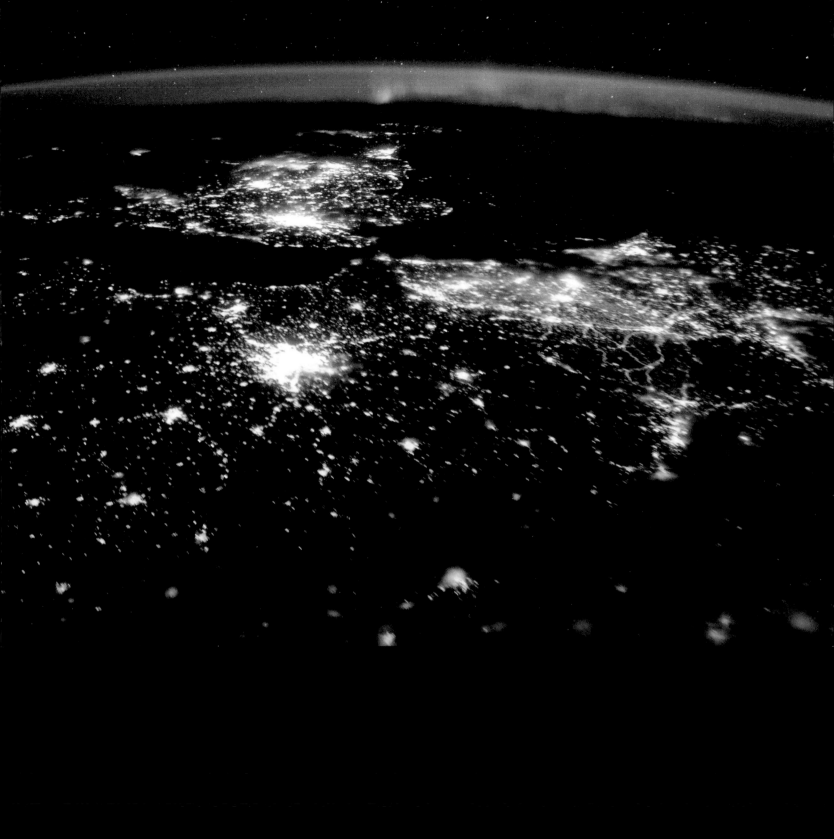

OCEANS
AND RIVERS

The science fiction writer Arthur C. Clarke once claimed that it was 'inappropriate' to call our planet 'Earth' when 'quite clearly it is Ocean.' I couldn't agree more. A day never failed to pass on board the ISS when I didn't marvel at the shimmering reflection of the Sun on a lake, the meandering path of a river or the symphony of blues singing from the ocean.

The unmistakable view of the Amazon rainforest, with the river of its namesake carving its sinuous path.

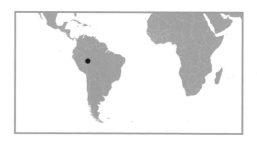

6 APRIL 2016

Brazil, South America

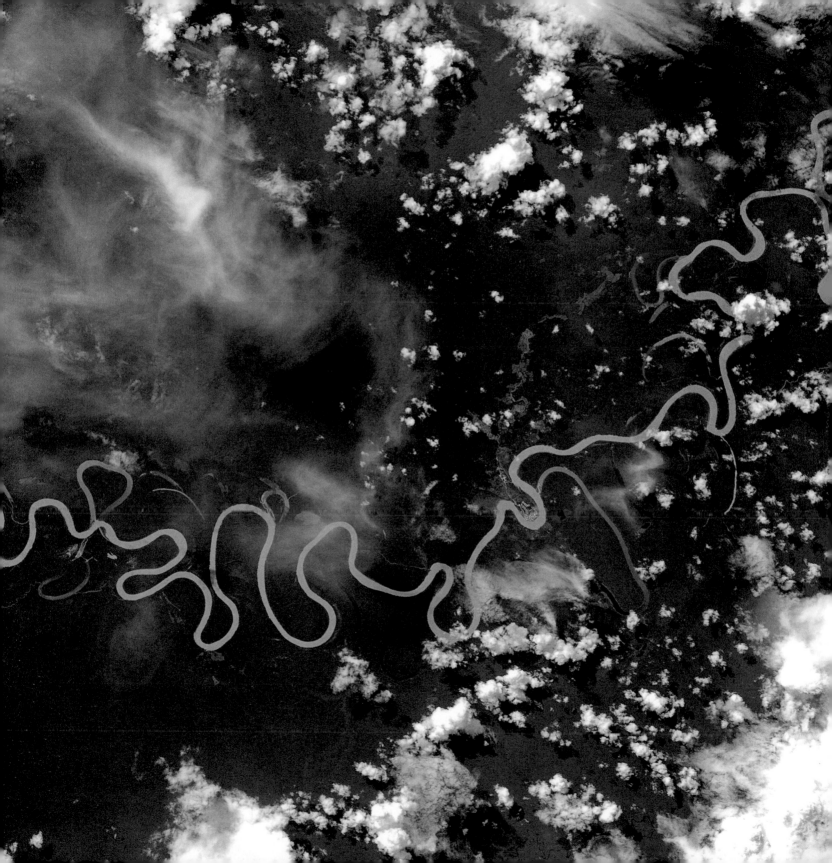

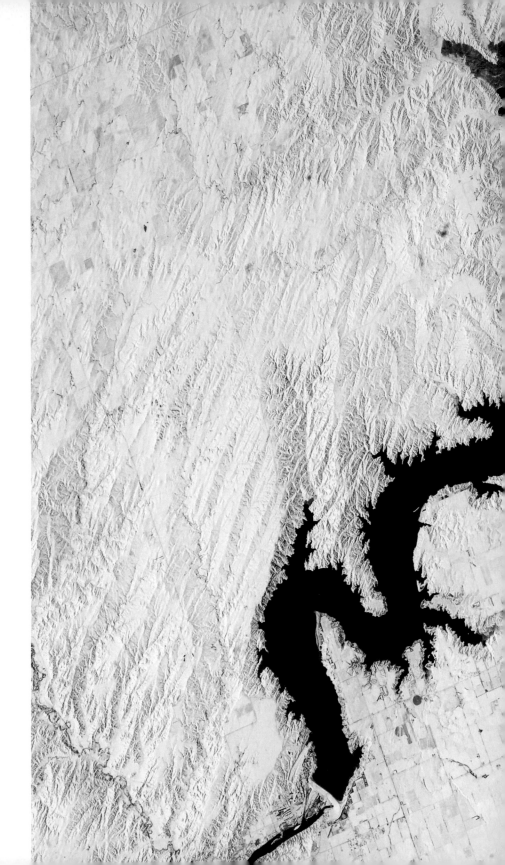

'Dragon Dam! This river looks like a serpent's tail.'

Oahe Dam (bottom left), which is located north of Pierre in South Dakota, gives this river its distinctive shape.

1 JANUARY 2016

Pierre, South Dakota, USA

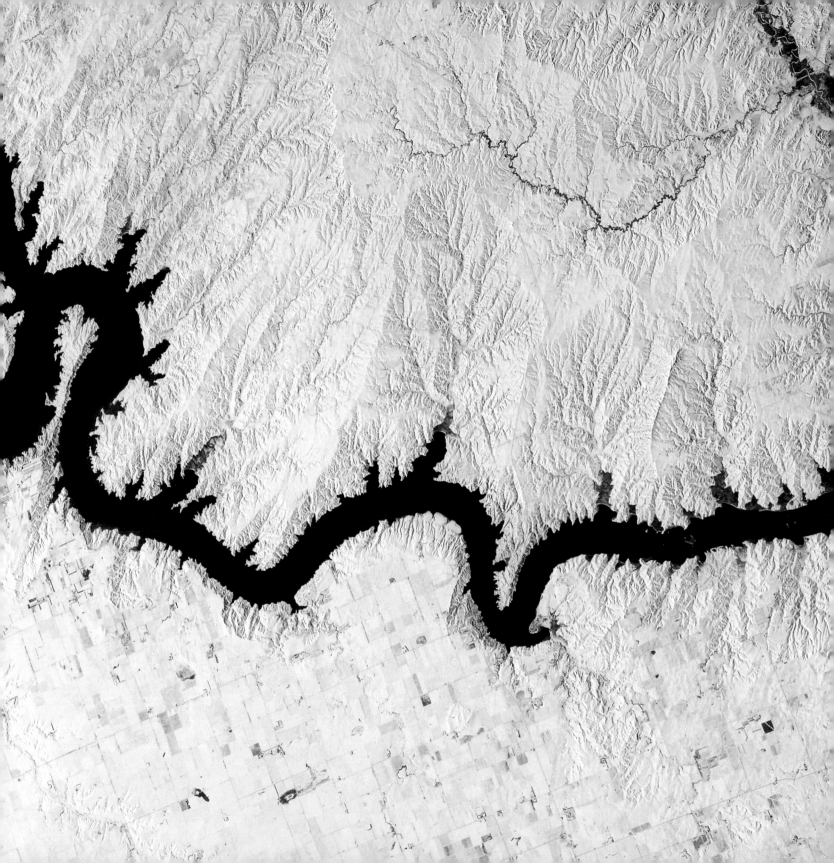

'Granted – not the most exciting pic ever but this iceberg drifting off Antarctica is about the size of London.'

The International Space Station's orbit seldom offers a clear view of Antarctica, so a picture of an iceberg taken by an astronaut in space is quite a rare occurrence. However, we tracked down the iceberg with the help of Leif Toudal from the Danish Meteorological Institute, ably assisted by Europe's Sentinel-1A radar satellite and NASA's Aqua satellite, both flying well above us in the Space Station at roughly 700 km.

Here the iceberg is seen off the coast of South Georgia and the South Sandwich Islands. Thanks to Leif and his assistants, we know that the iceberg in the picture is 'A56', reported to be around 26km by 13km, meaning it would fit inside London's Circular Road along its length with room to spare over its width. It has been estimated to be 30m high, which means it could extend 270m below the sea, considering most icebergs conceal 90% of their volume underwater.

27 MARCH 2016

South Atlantic Ocean, near South Georgia and the South Sandwich Islands

South Atlantic Ocean

'What are the odds – just passing the Cupola and spotted the same iceberg from over two months ago :)'

Carried by the Antarctic Circumpolar Current and westerly winds, A56 is drifting by about 25 km a day. Since my previous viewing, A56 had travelled to the east into the South Atlantic Ocean.

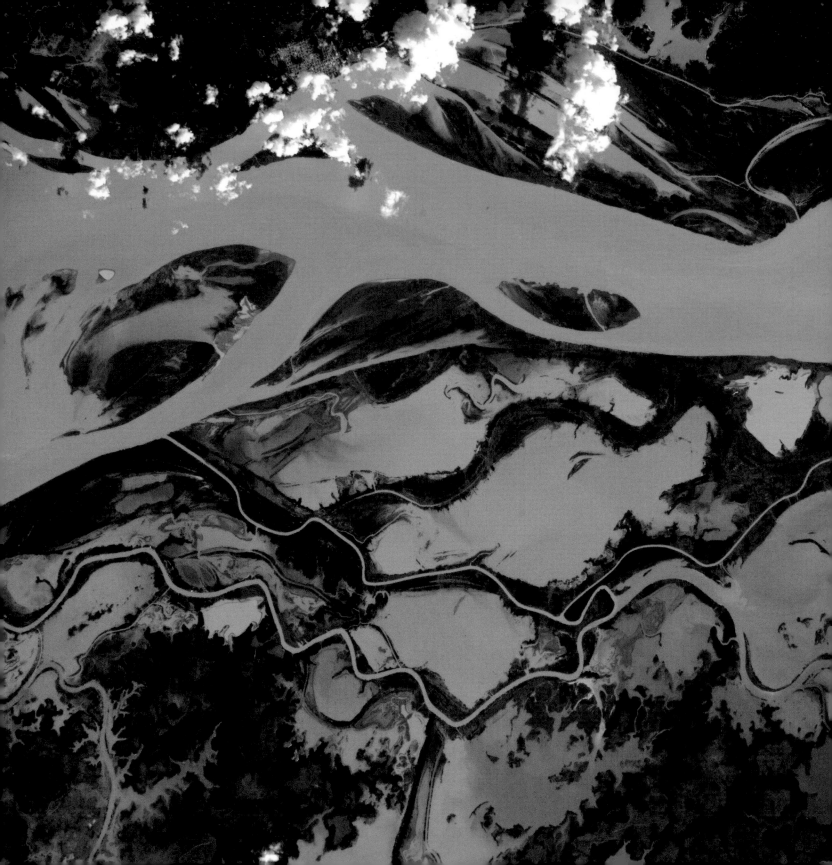

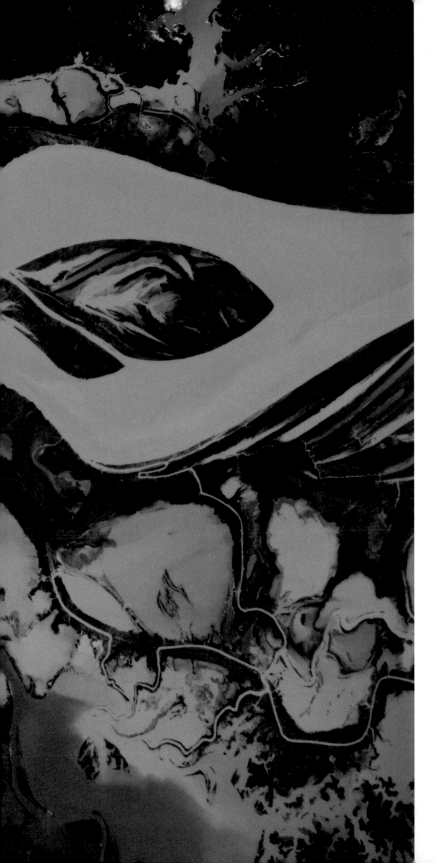

'The vast waters of the Tapajós river, Amazonia.'

The Tapajós river is approximately 1900 km long. It is estimated to be home to more than 500 fish species.

4 APRIL 2016

Brazil, South America

'Spotted a magnificent
swirling plankton
bloom off the coast
of Argentina.'

**This dance in turquoise is
caused by a massive gathering
of phytoplankton, a microscopic
plant that floats near the sunlit
surface of the ocean.**

1 APRIL 2016

Patagonia

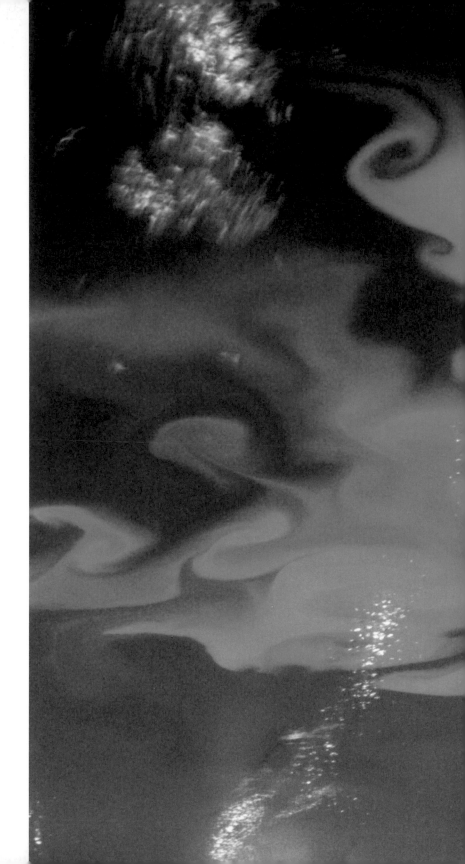

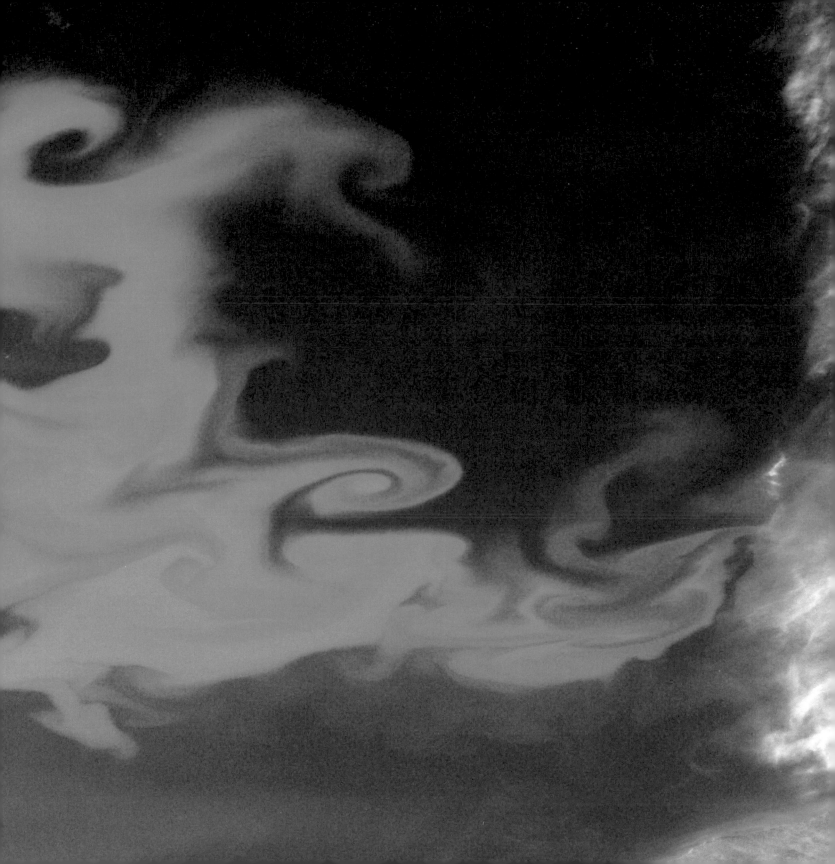

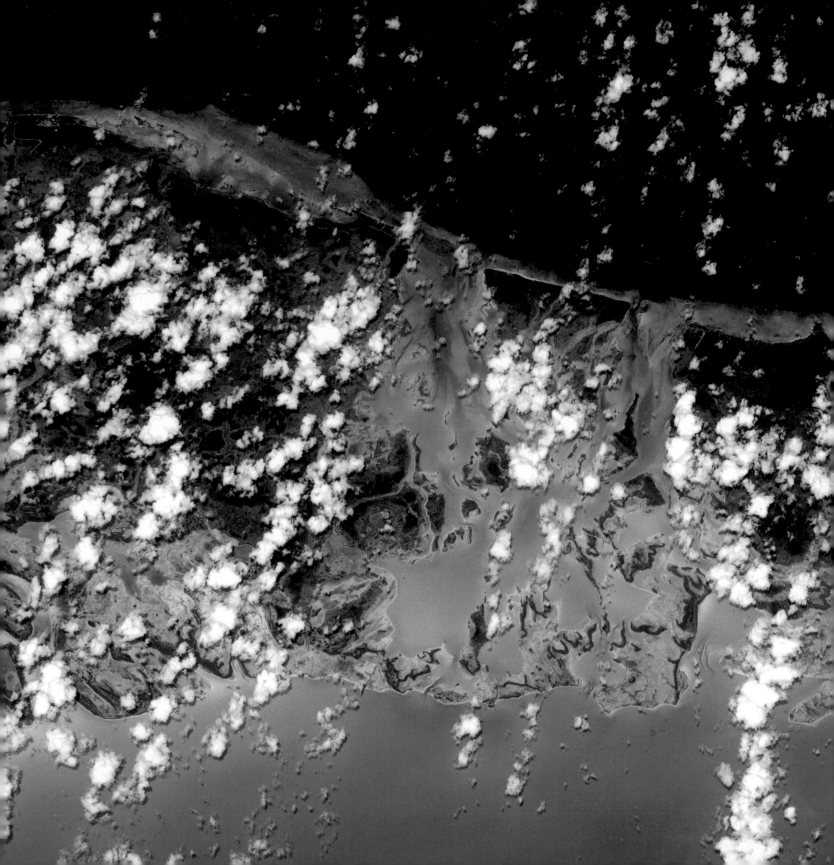

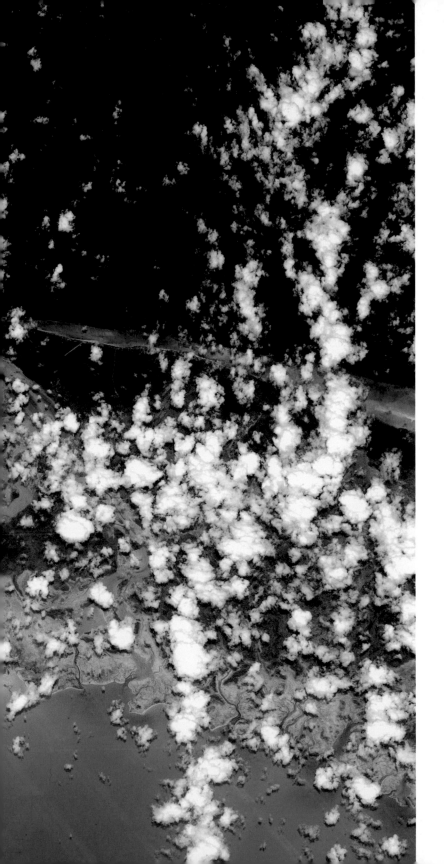

'I bet there's some good diving to be had off that drop-off.'

Diving is a favourite pastime of mine. I was fortunate enough to spend 12 days living under the ocean as part of NASA's Extreme Environment Mission Operations (NEEMO) mission in 2012, helping to develop asteroid mission scenarios.

9 APRIL 2016

Rolleville, Exuma, The Bahamas

71

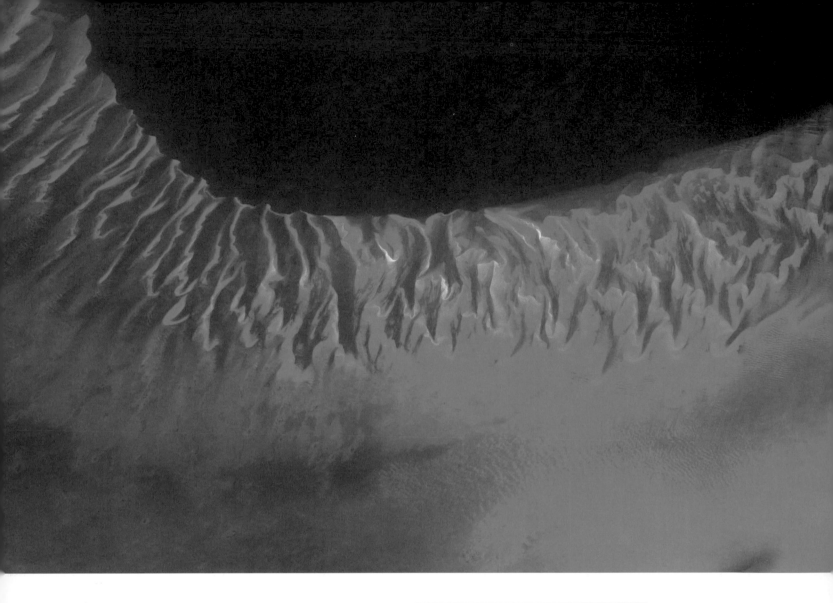

'Fifty shades of blue: the Bahamas.'

9 APRIL 2016
Rolleville, Exuma, The Bahamas

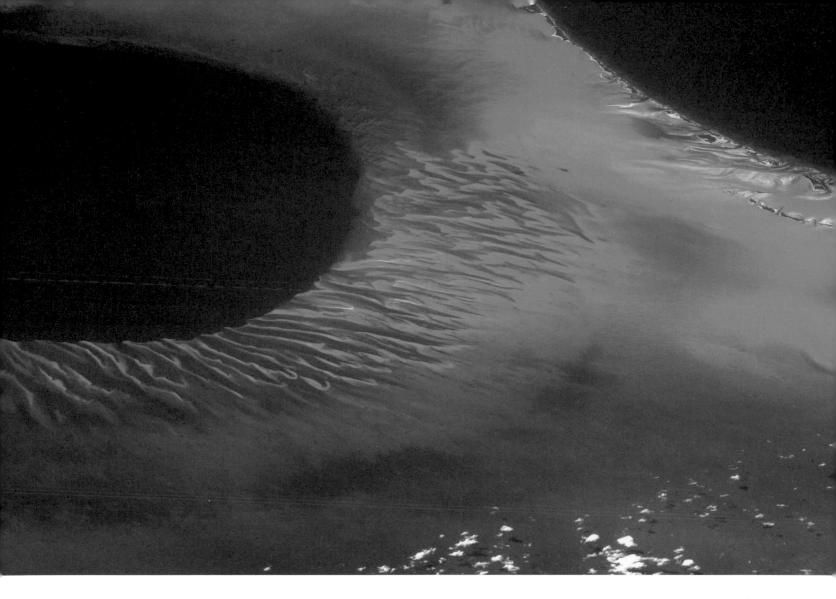

The word 'Bahamas' comes from the Spanish 'baja mar', which means low or shallow waters.

9 APRIL 2016

Rolleville, Exuma, The Bahamas

73

'The entrance to the Red Sea from the Gulf of Aden.'

The Red Sea is at the bottom of the image, with the Gulf of Aden in the distance. Yemen is on the left. The spectacular mountains of Eritrea and Ethiopia are on the right.

29 FEBRUARY 2016

Sudan, North Africa

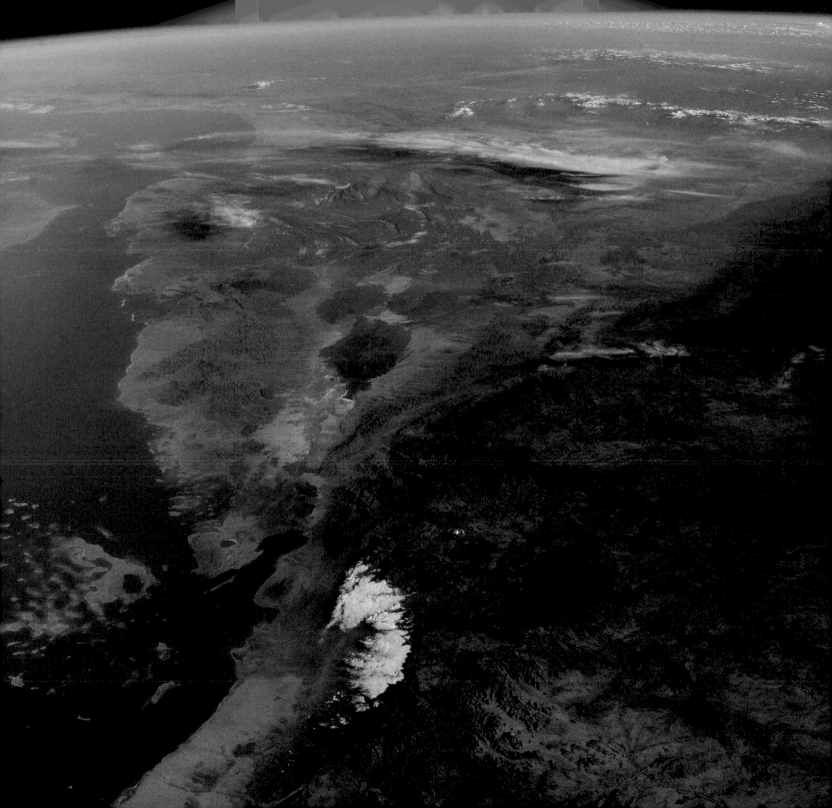

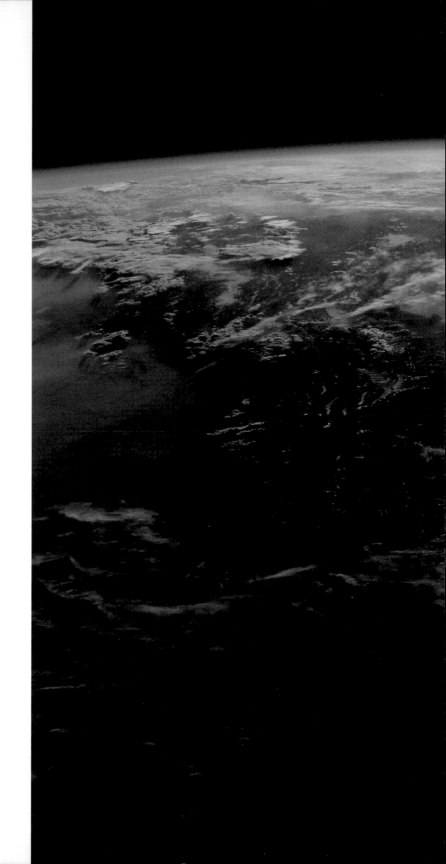

'A sliver of light, shining out from the darkness.'

Evening sun illuminates Kapchagay Reservoir and the Ile River in south-eastern Kazakhstan.

5 APRIL 2016

Central Kapchagay Reservoir, Imeni Frunze, Almaty, Kazakhstan

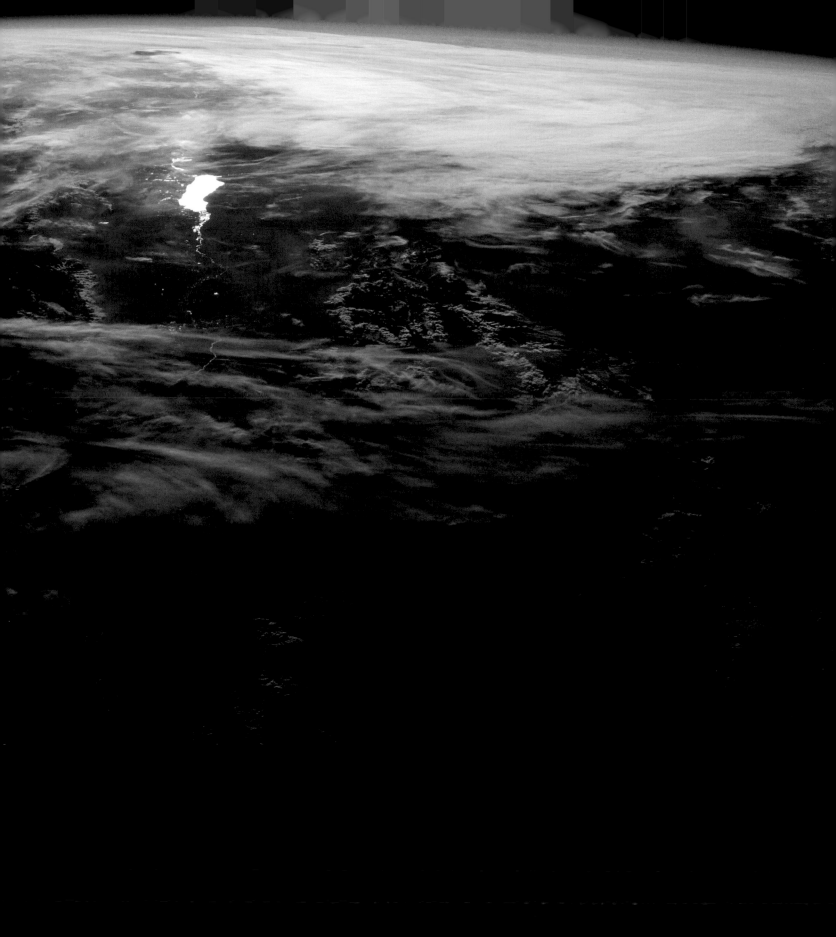

'Every day spent living in space is a great day, but today was particularly special. I got to speak with one of my inspirational heroes Professor Stephen Hawking and his amazing daughter Lucy, who developed the Principia Space Diary to engage children with STEM subjects. As well as talking about dark matter, quantum entanglement, alien life and lightbeam-powered nanocraft, we also got to see an amazing pass over the Bahamas and this – my favourite reef.'

29 APRIL 2016

Santa Cruz del Sur, Camaguey, Cuba

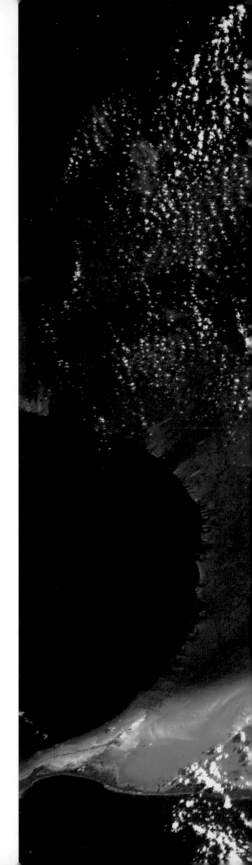

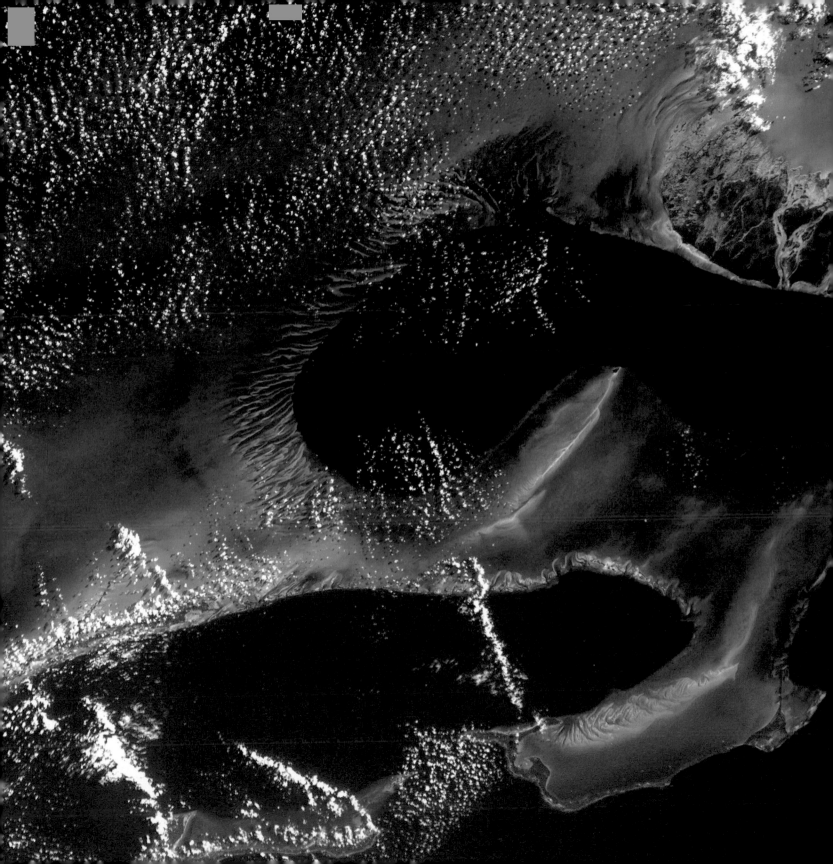

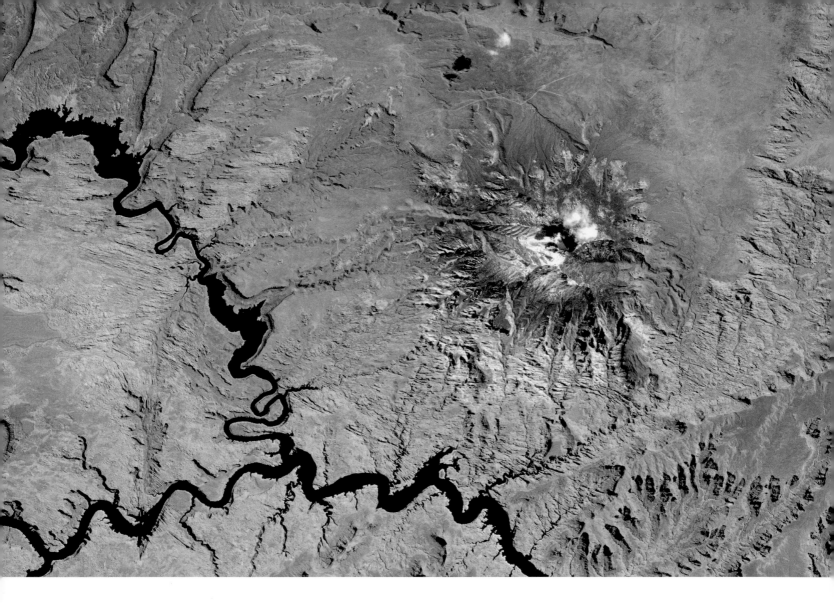

'The San Juan River
snakes around Navajo
Mountain, Utah.'

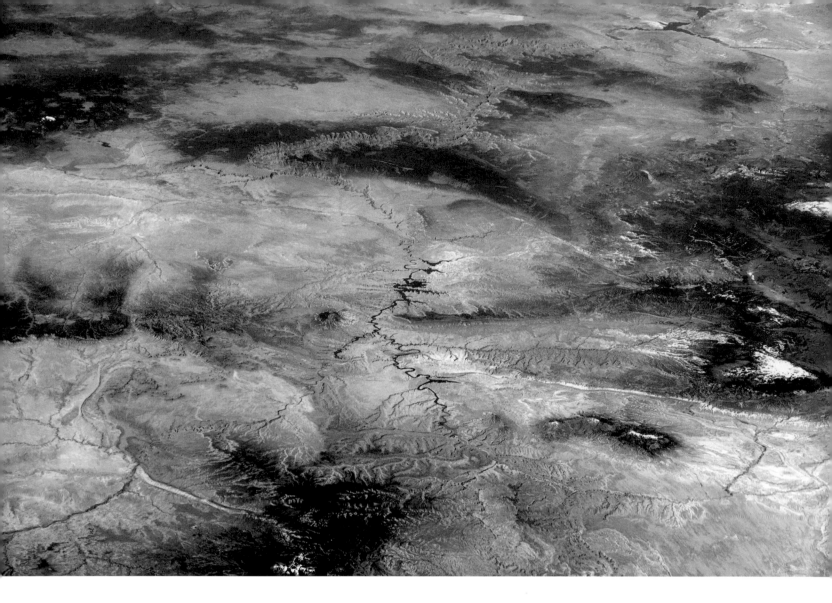

Follow the Colorado River from Lake Powell (centre) through the Grand Canyon to Lake Mead (top right).

'A lot of National Parks in this pic!'

12 MAY 2016

Grand Junction, Colorado, USA

81

'From one mighty ocean to another – ships passing through the Panama Canal.'

Nearly 15,000 ships use the Panama Canal every year, which connects the Atlantic and Pacific oceans. On average, it takes a ship eight to ten hours to pass through the canal.

9 MARCH 2016

Fuerte Davis, Colon, Panama

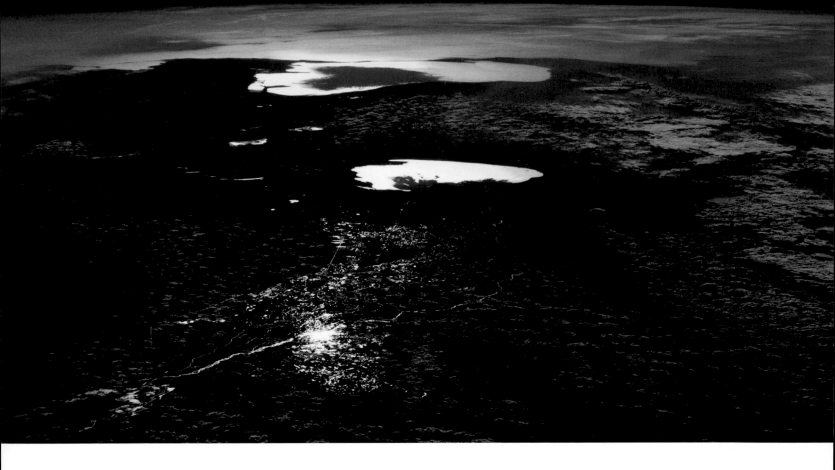

'Reflections. Today was my birthday. 44 laps around the Sun, and 1775 around Earth!'

Sunlight reflecting off Lake Sarygamysh, Turkmenistan (centre) with the Caspian Sea and Garabogazköl lagoon on the horizon.

7 APRIL 2016

Tashauz, Turkmenistan

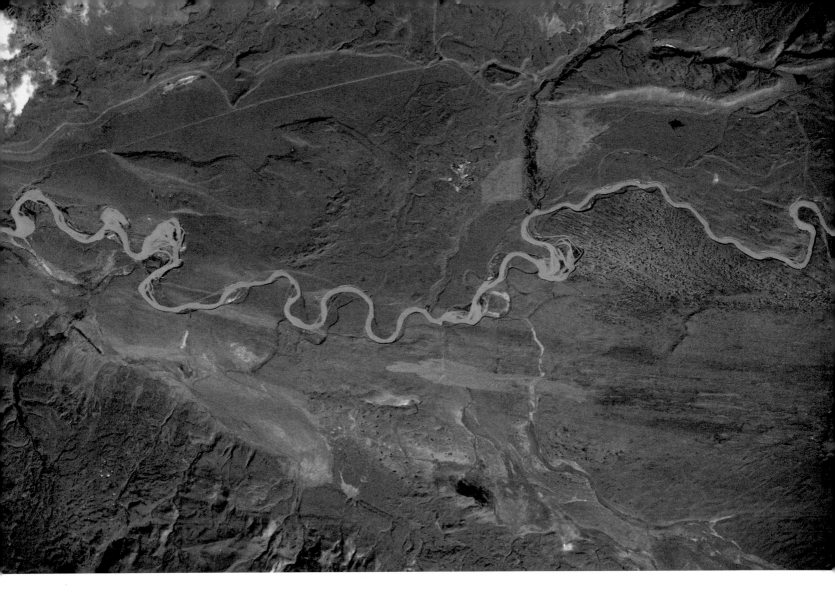

23 MARCH 2016

Rio Bote, Santa Cruz Province, Argentina

The stunning turquoise of this glacial river is incredibly distinctive from space. Flowing from the ice fields of Patagonia, it winds its way eastwards across Argentina to spill into the South Atlantic.

'Rio Santa Cruz in all its glory!'

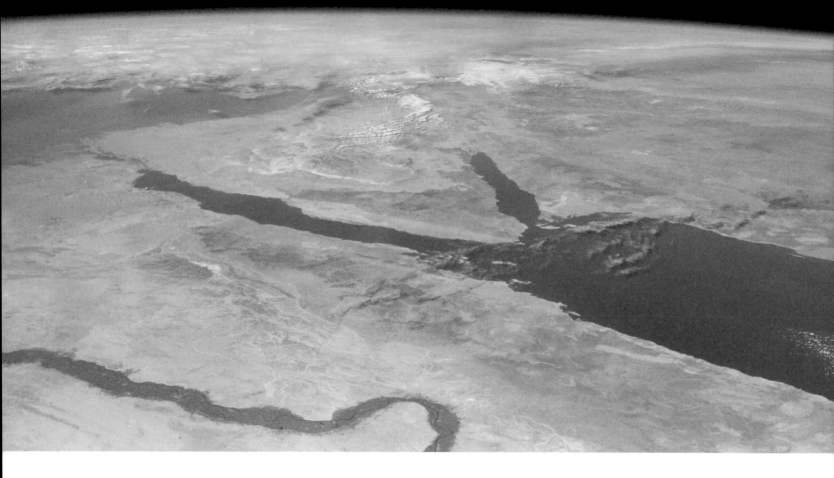

'Great view of Sinai Peninsula and River Nile. One of my favourite diving spots down there in the Red Sea!'

4 JANUARY 2016

Abu Rudeis Airport, South Sinai, Egypt

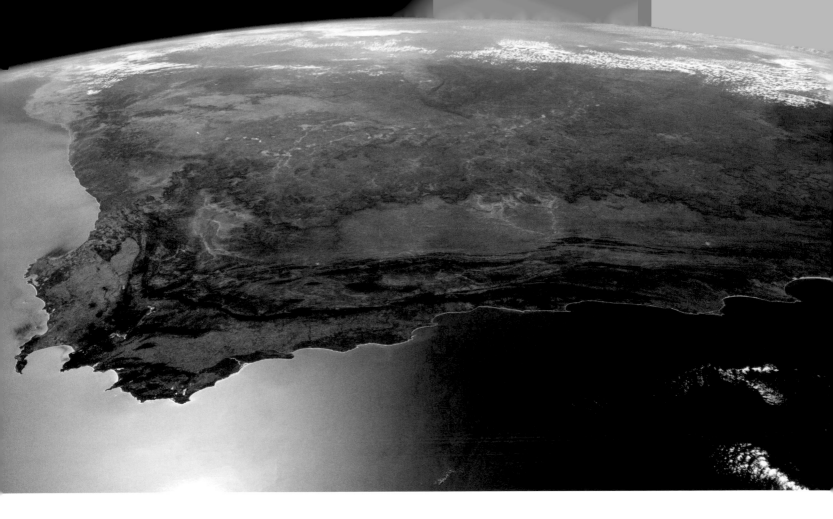

Riversdale, Western Cape, South Africa

'Lovely pass-over South Africa today. Still in awe of Eddie Izzard running 27 marathons across that stretch of land!'

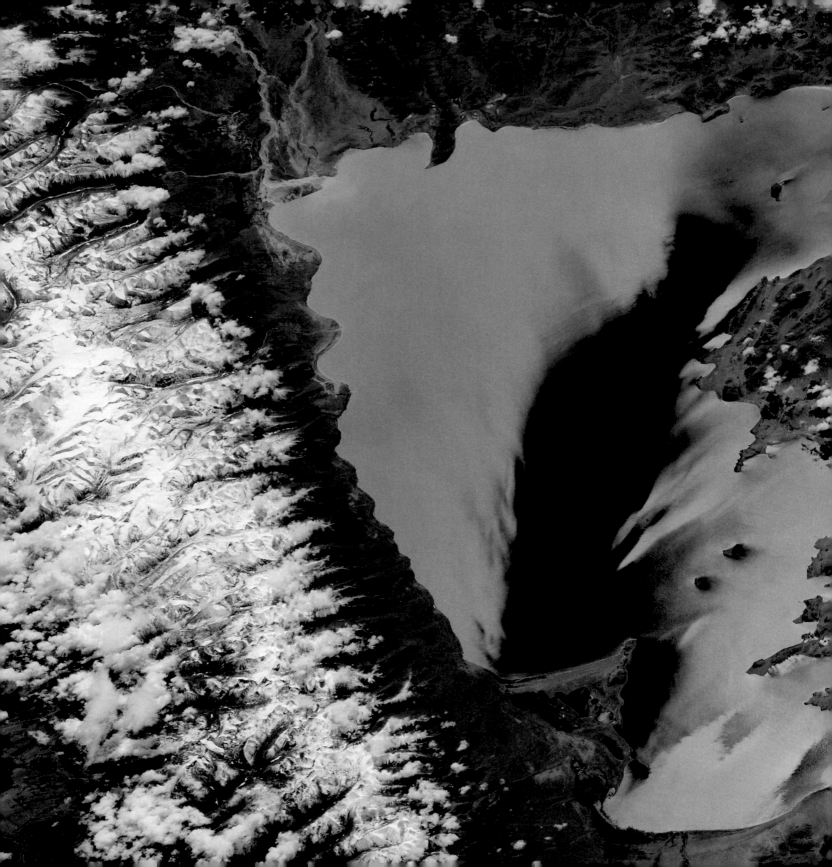

'Heavenly Lake.'

Sunlight reflects stunning colours off Nam Co lake in China. In Mongolian, the lake is known as Tenger nuur, which means 'Heavenly Lake'.

9 JUNE 2016

Damxung, Tibet, China

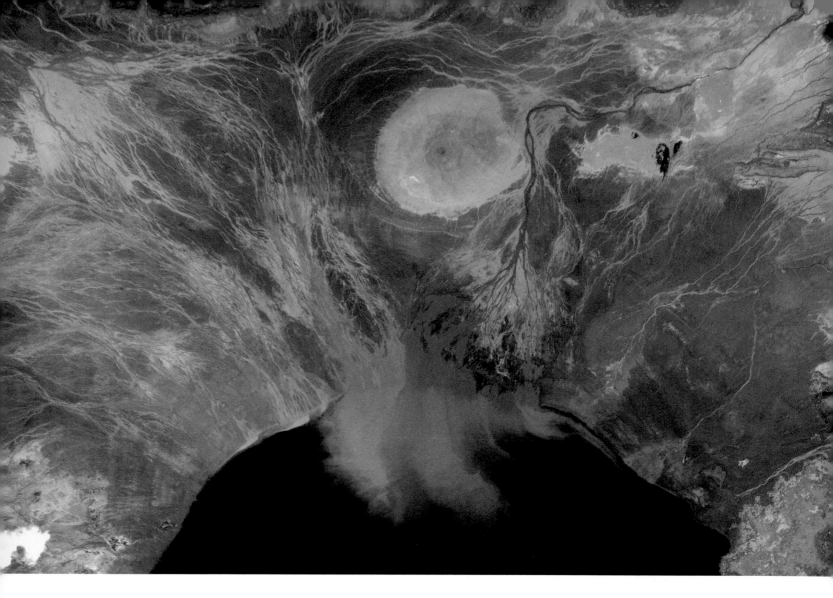

'Knotted wood and rusty water?'

Sediment from the Awash river spills into Lake Abbe, situated between Ethiopia and Djibouti.

Afar, Ethiopia

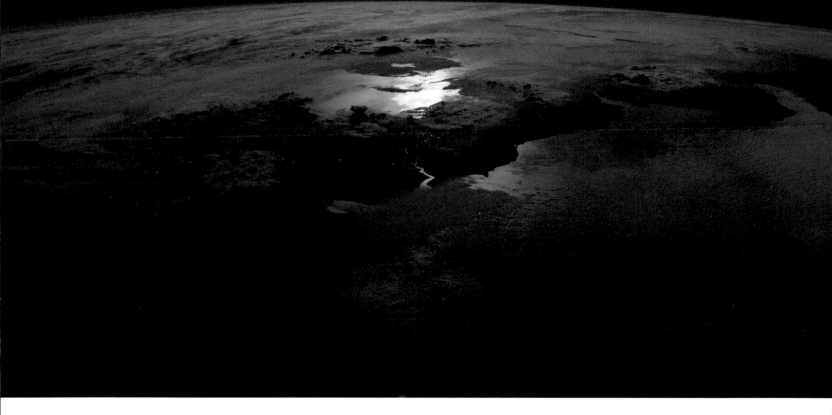

The Humber is a relatively short river, only 59 km long. It is a tidal estuary formed by the River Trent and the River Ouse.

'Summer sun setting over the UK.'

Amsterdam, Netherlands

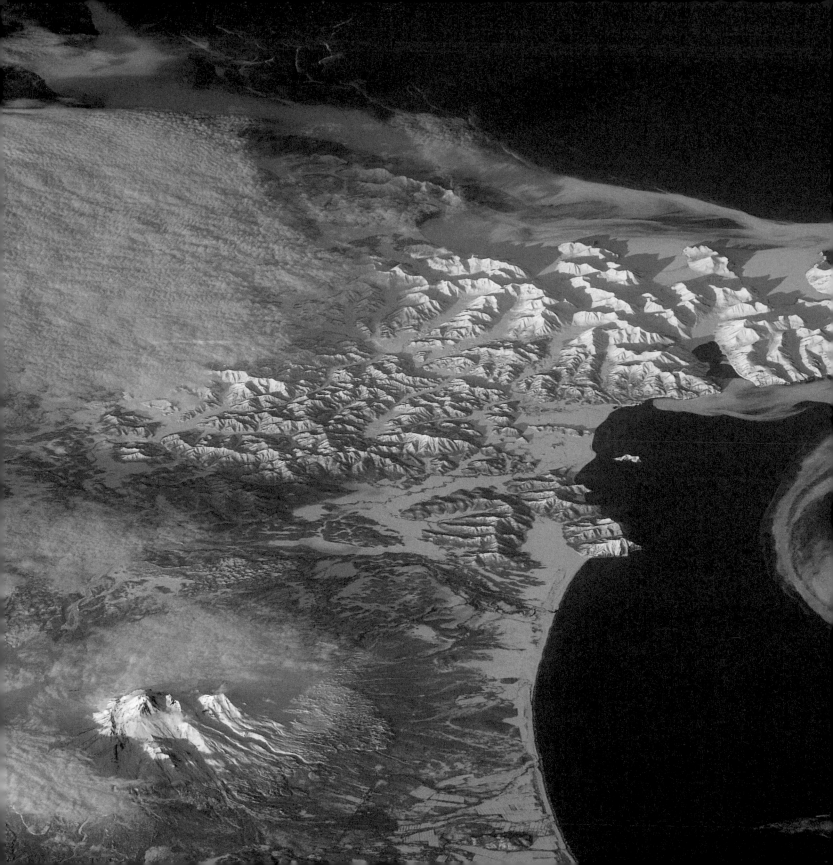

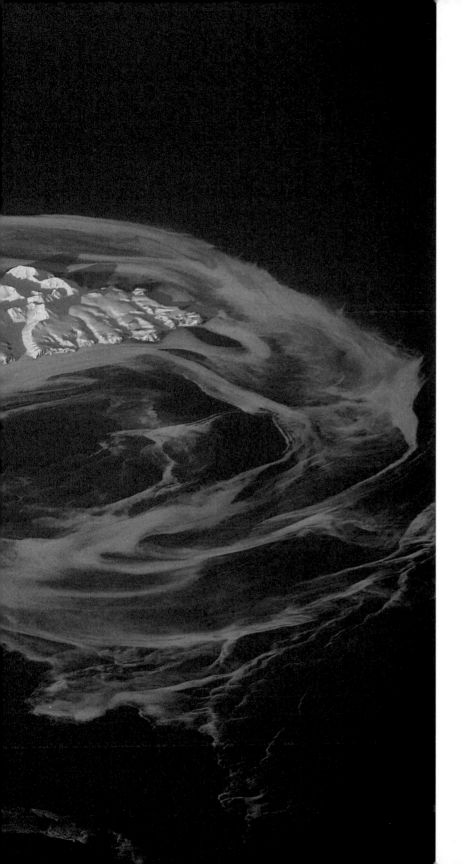

'Swirling sea ice in the evening sun.'

Last of the Bering Sea ice melting along this part of Russia's coastline.

18 APRIL 2016

Kamchatka Krai, Russia

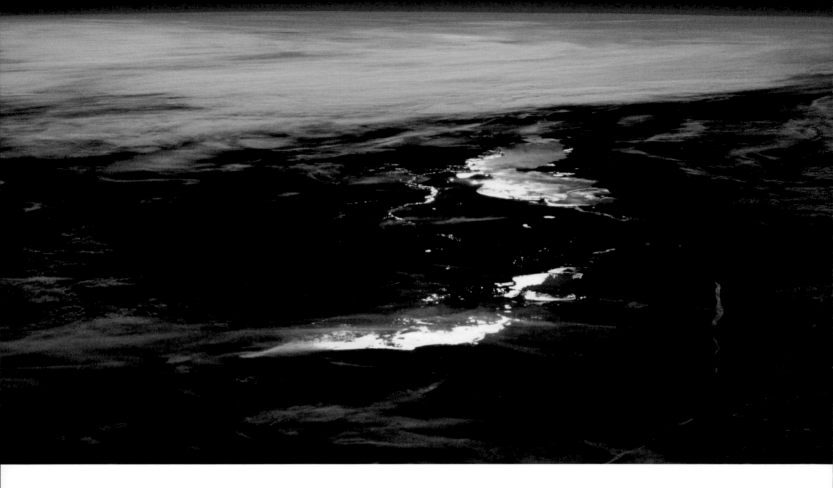

'Liquid gold.'

Lake Alakol and Lake Balkhash reflecting sunlight, in Kazakhstan.

5 APRIL 2016

Imeni Molotova, Almaty, Kazakhstan

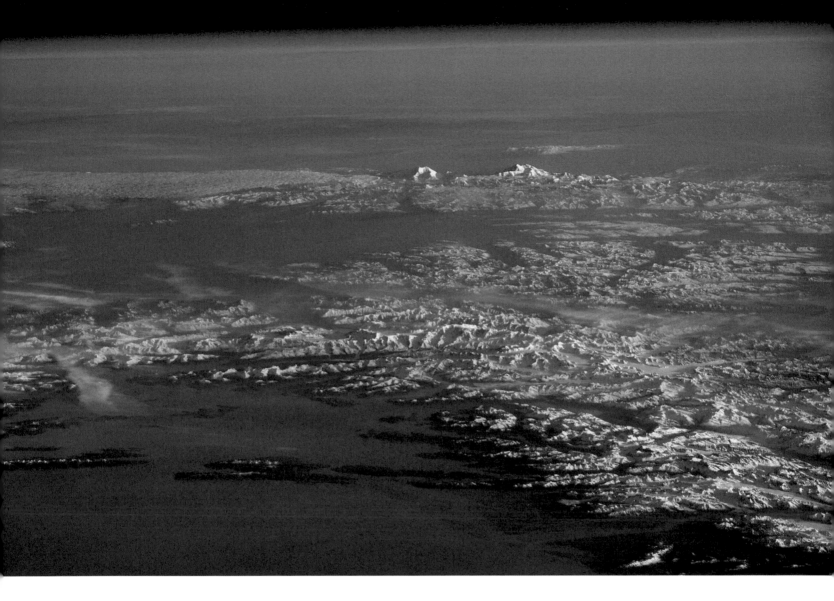

14 MAY 2016

Prince William Sound, Alaska, USA

The rugged beauty of Alaska. I fell in love with this place when I kayaked Prince William Sound (foreground) from Valdez to Whittier, aged 18. Mount Denali and Mount Foraker stand out in the centre.

'Alaska – a paddle down memory lane.'

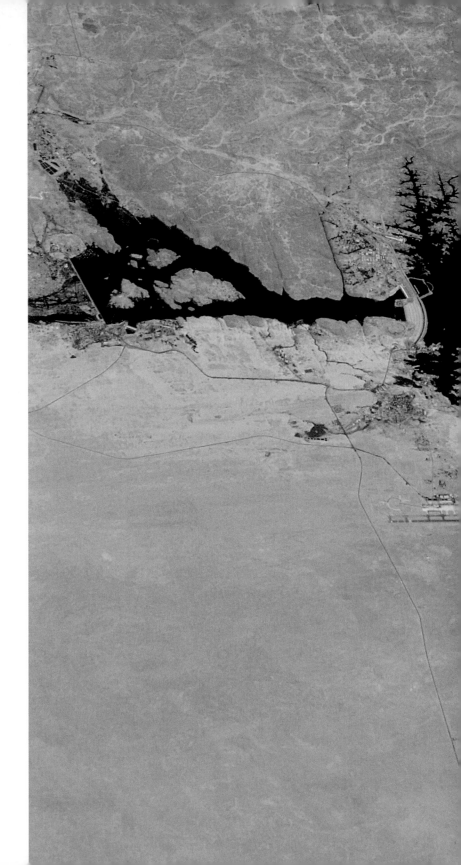

'Taking the path of least resistance.'

The Aswan High Dam on the River Nile, creating Lake Nasser. North is left in this picture.

8 MAY 2016

Ad Dakkah, Aswan, Egypt

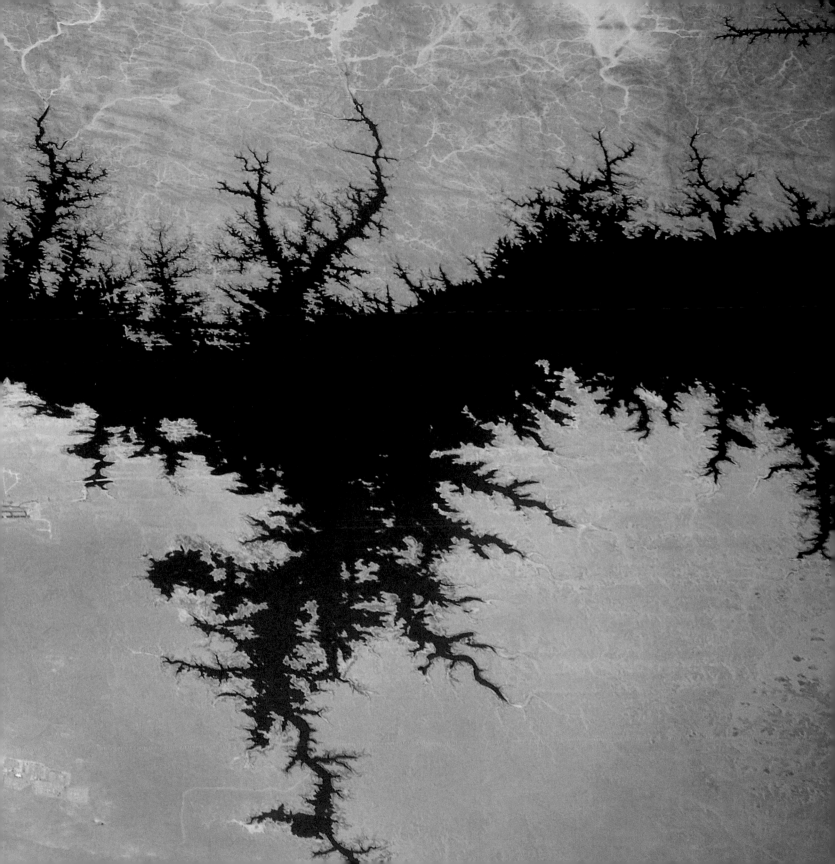

'Beautiful Bermuda!'

From above, this island in the Atlantic resembles an infinity symbol, or a shoe print.

12 FEBRUARY 2016

Bethaven, Paget, Bermuda

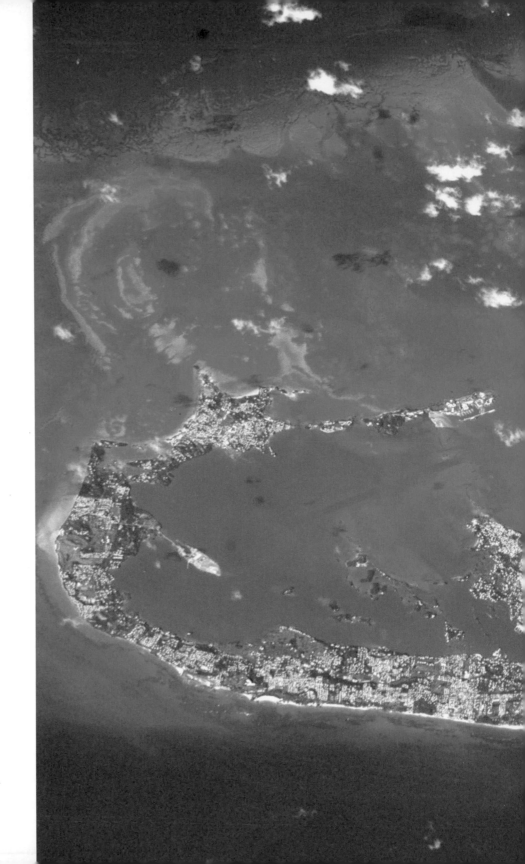

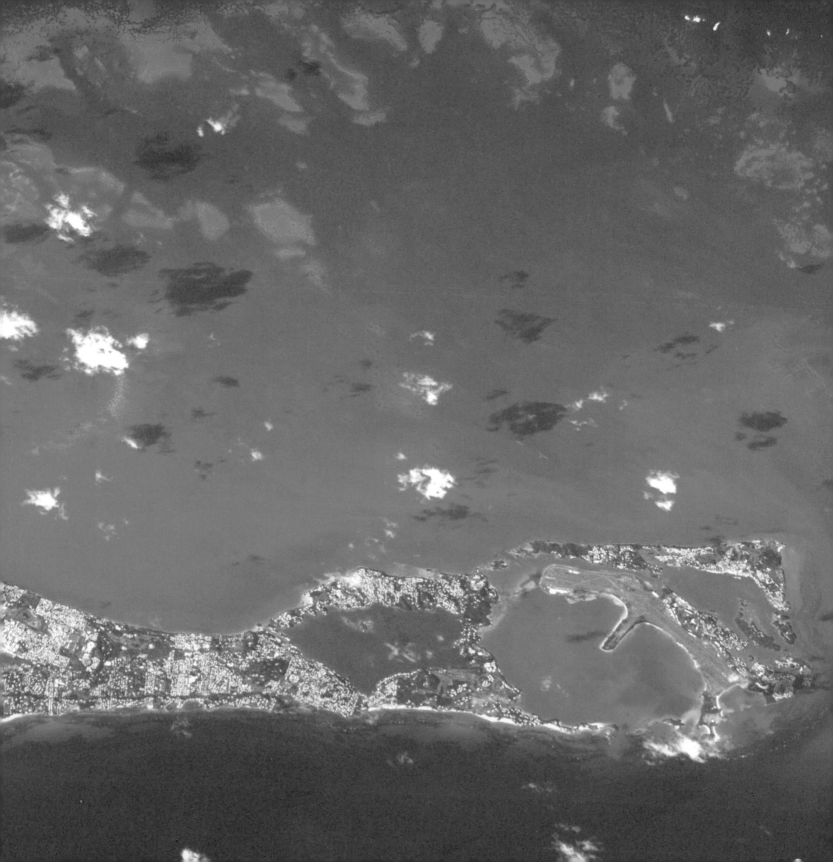

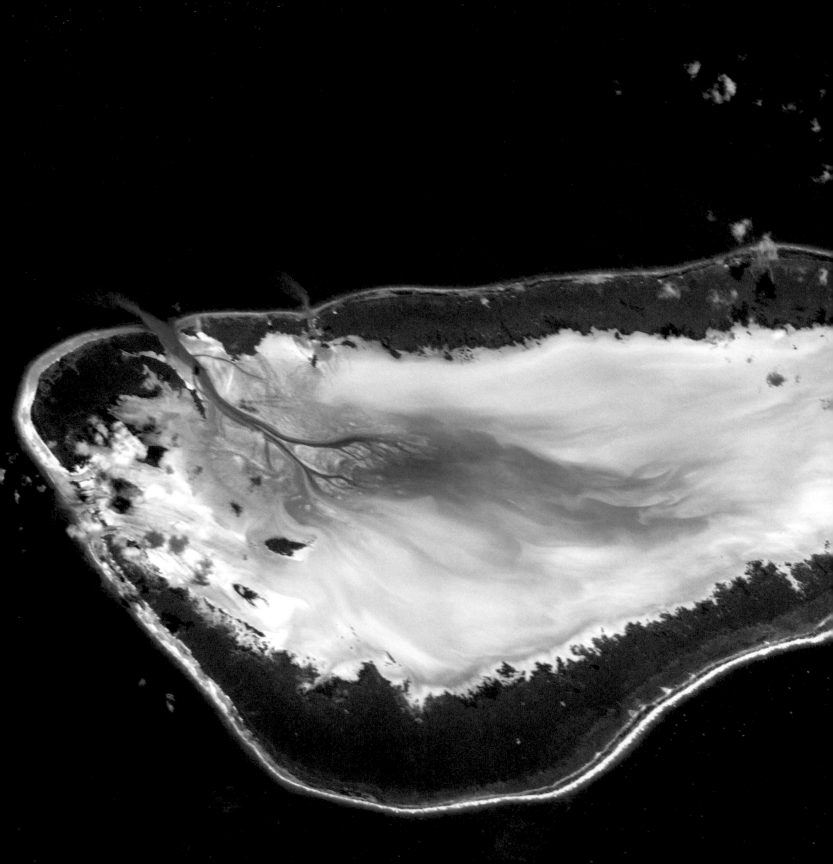

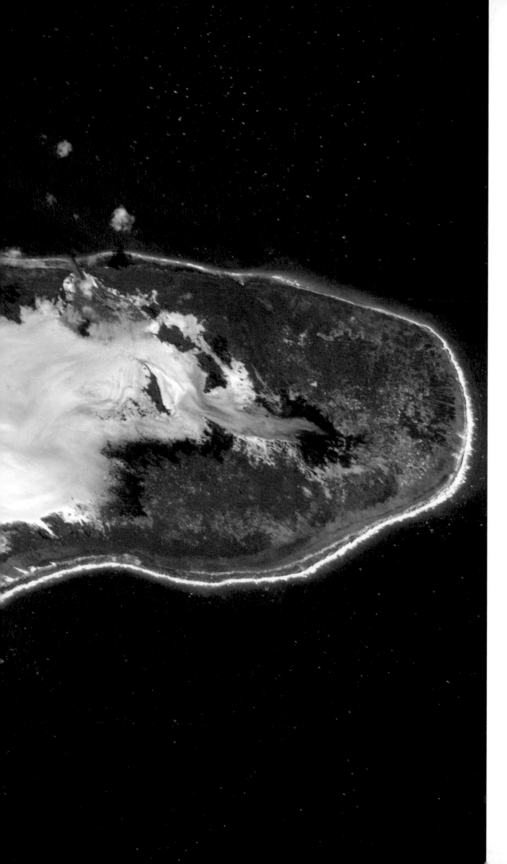

"Holiday Island.'
Towards the end of
the mission, as we
were starting to think
more of home, we
began planning our
dream holidays.
Each astronaut
would pick their
ultimate getaway
island. This was mine.'

11 JUNE 2016

Aldabra Islands, Seychelles

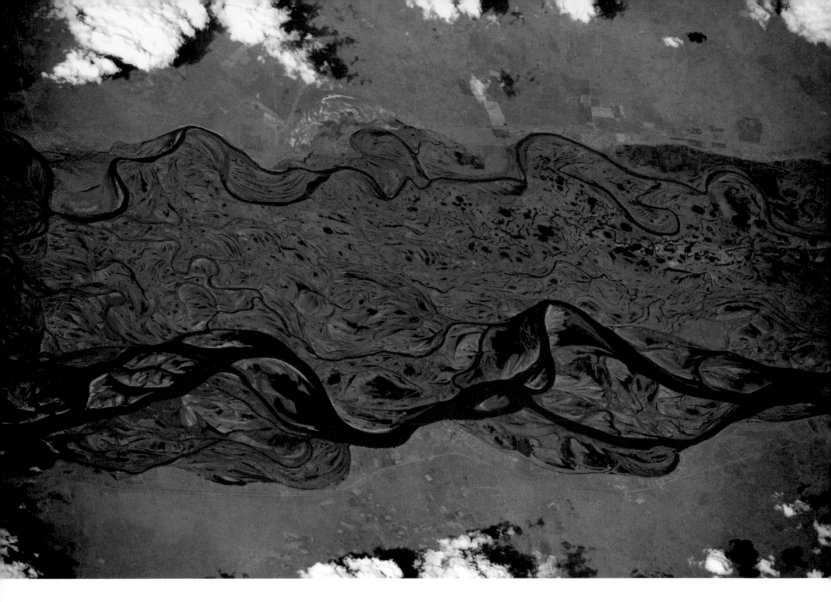

'Europe's longest
river — The Volga.'

The River Volga drains
most of western Russia
and flows into the
Caspian Sea. Seen here
are the multiple network
of waterways, just
downstream of the city
of Volgograd, Russia.

11 JUNE 2016

Volgograd, Russia

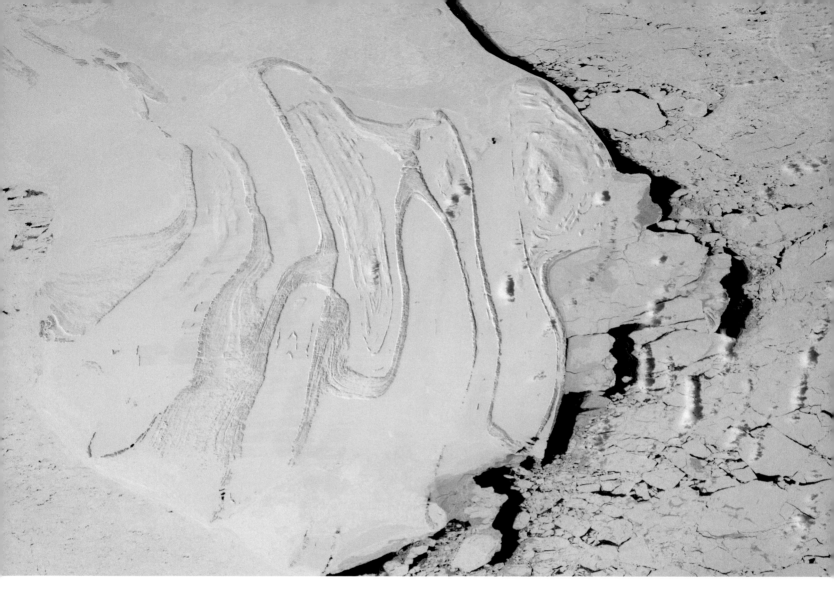

Melting sea ice in James Bay, Canada.

'Ink on ice? A frozen work of art.'

Charlton Depot, Nunavut, Canada

MOUNTAINS AND DESERTS

From the frozen pinnacles of the Andes to the scorching sand dunes of the Sahara,
often it is the most inhospitable of places on Earth that cry out their beauty the loudest.

'I love orbiting over
Africa – it is like flying
over a canvas of art.'

27 FEBRUARY 2016

Illizi, Algeria

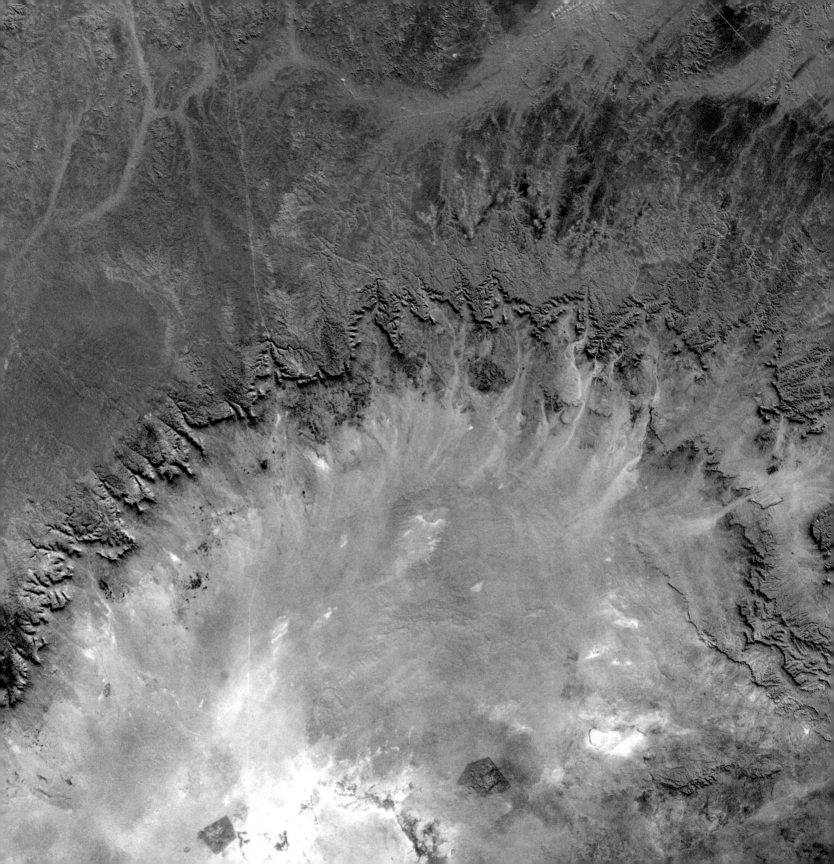

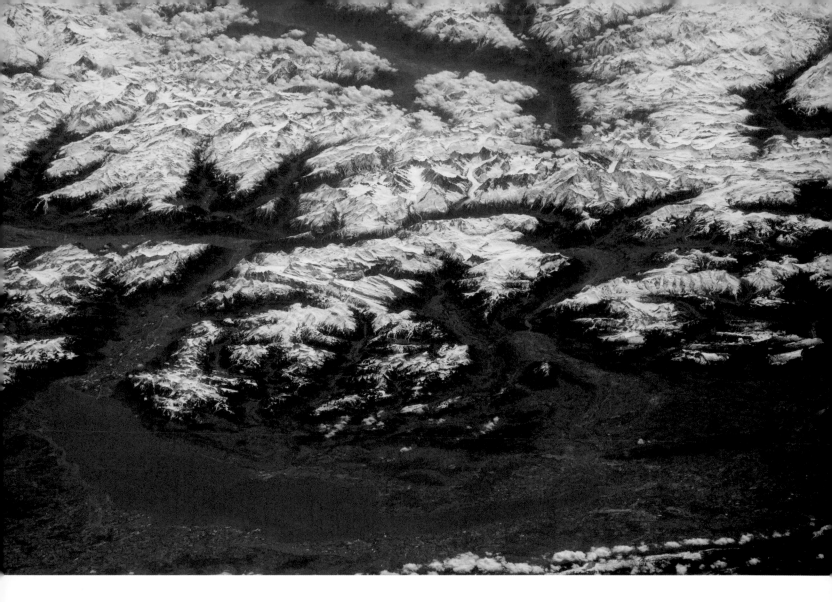

'Sun-drenched Alps.'

Lake Geneva and the French-Swiss Alps. Mont Blanc right of centre, Lausanne bottom left and Geneva at right.

29 APRIL 2016

Geneva, Switzerland

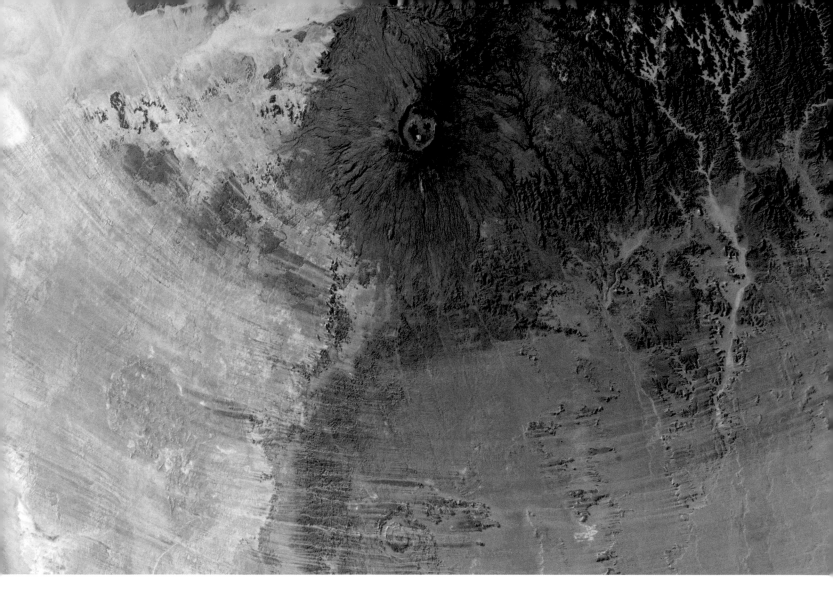

Goumeur, Borkou Region, Chad

**Emi Koussi volcano (top),
the highest mountain in
the Sahara, and the
345 million year old
Aorounga impact crater
in Chad (bottom).**

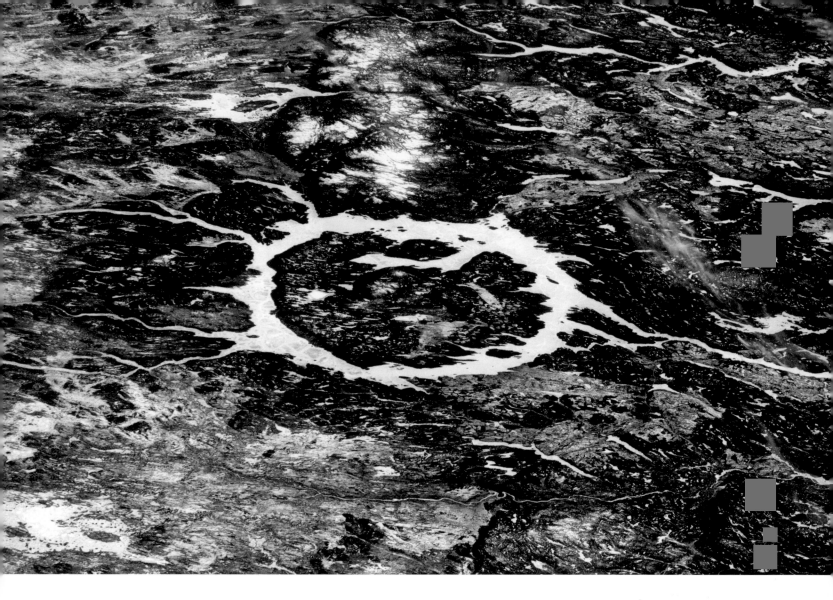

'The largest visible impact crater on earth.'

Canada's 210 million-year-old Manicouagan impact crater.

5 MAY 2016

Manicouagan, Quebec

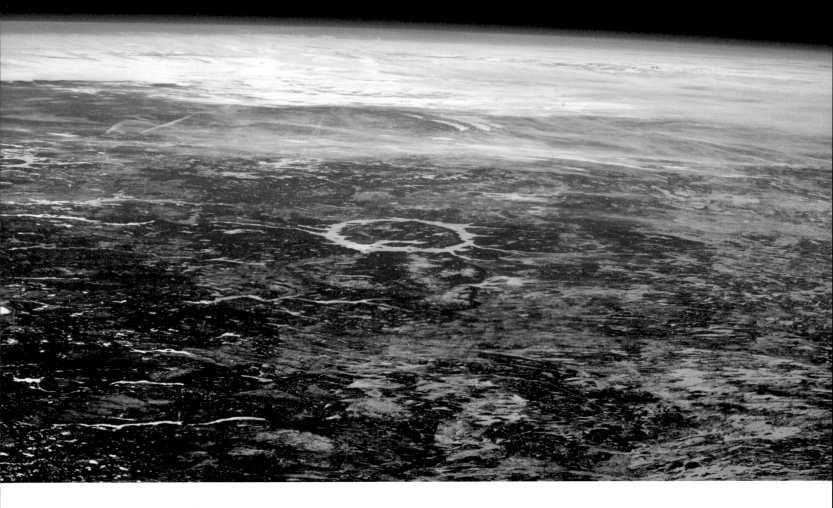

Looking west over Quebec and Ontario, Manicouagan impact crater is about 100 km across and thought to be the result of a 5 km asteroid hitting earth.

5 MAY 2016

Manicouagan, Quebec

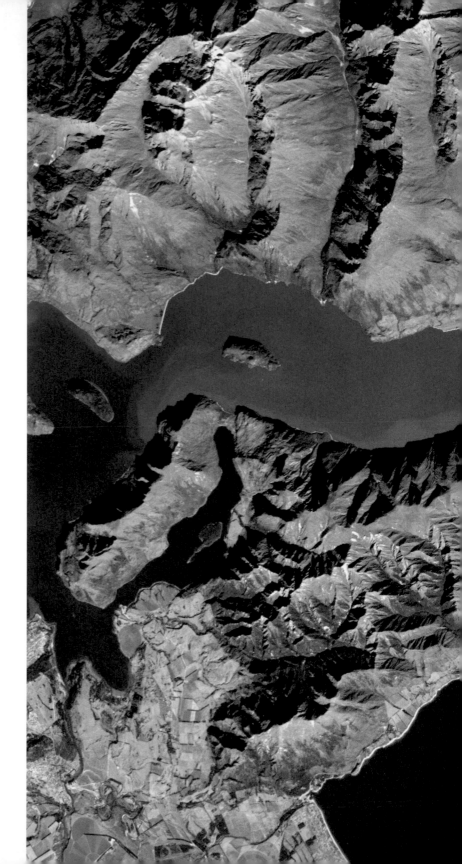

'New Zealand looking stunning in the sunshine!'

South Island. Looking down on Lake Wanaka with Lake Hawea below. North is to the right.

31 JANUARY 2016

Hawea, New Zealand

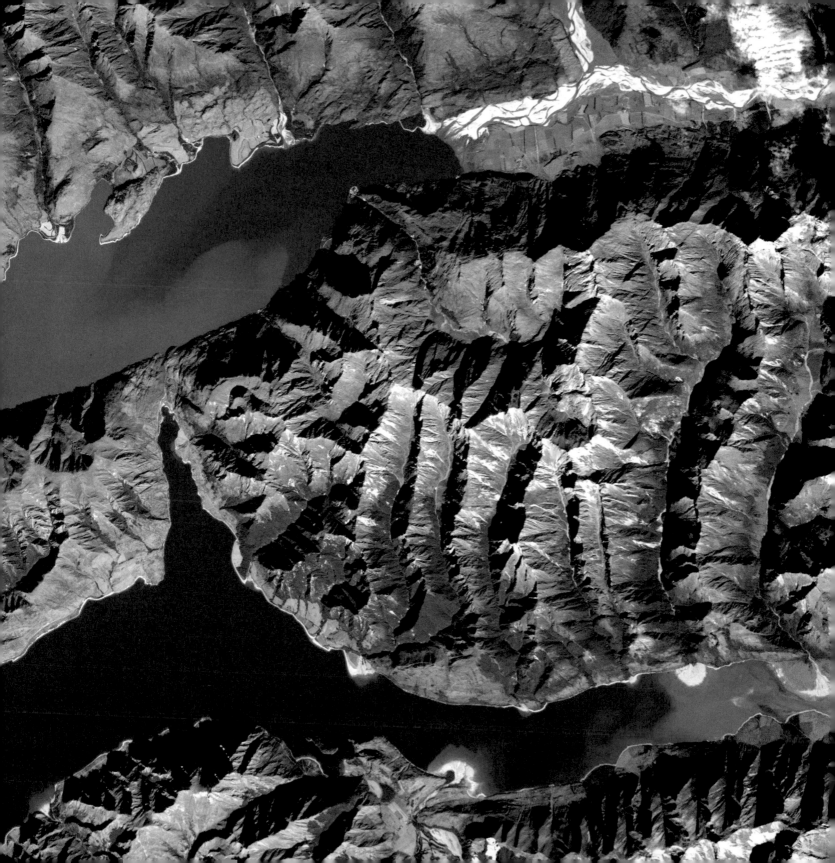

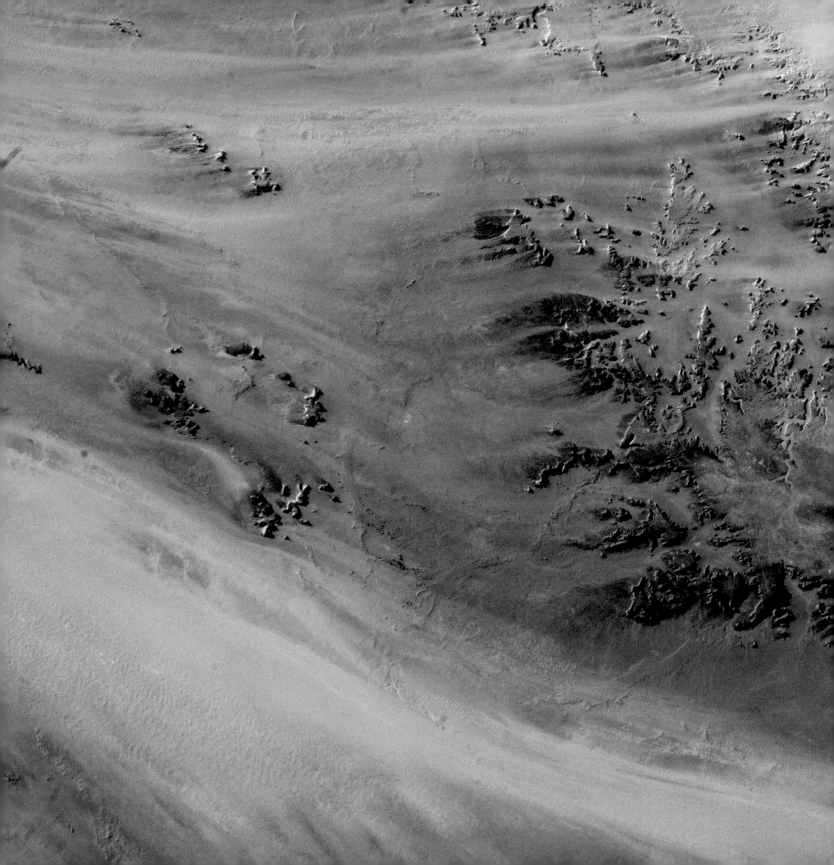

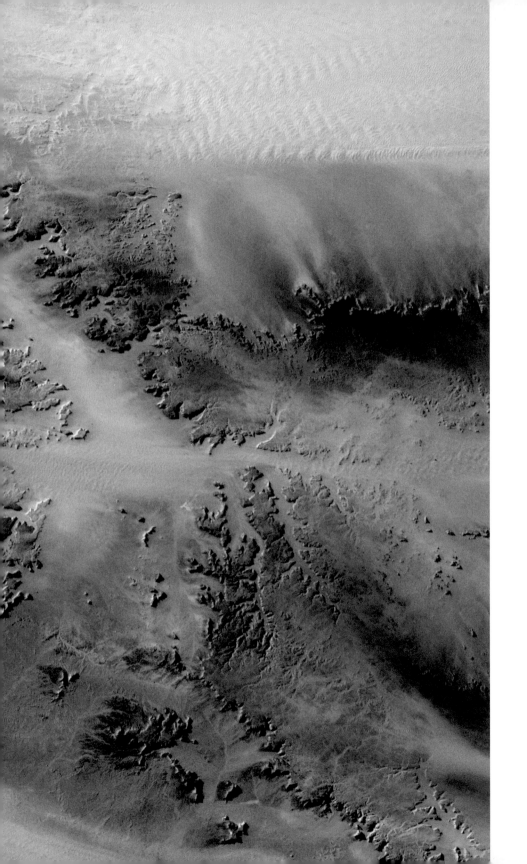

'From space it's easy to see how nature has sculpted the landscape. This is Ennedi, in Chad.'

27 FEBRUARY 2016

Ounianga Serir, Ennedi, Chad

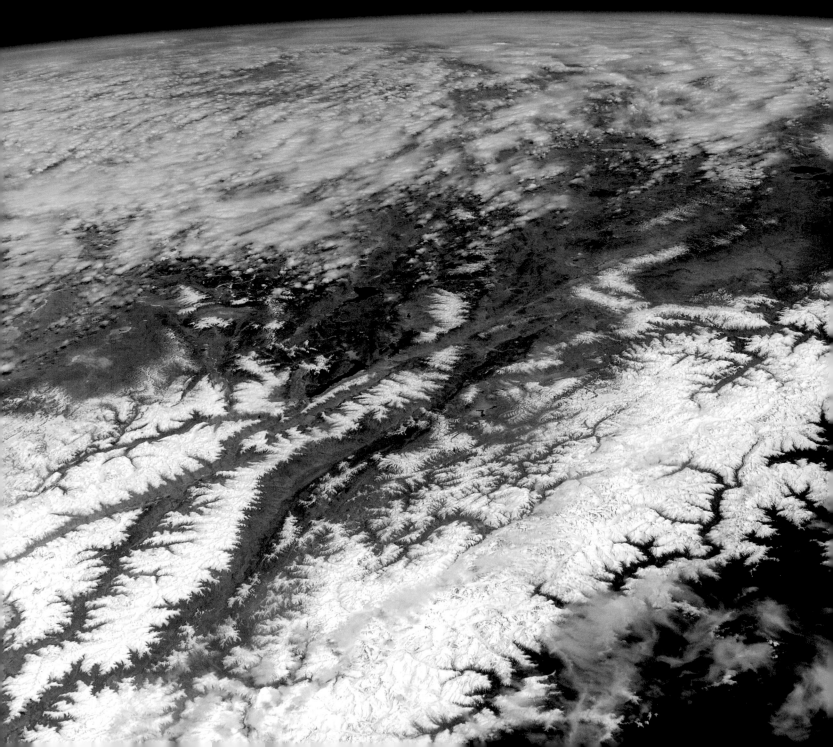

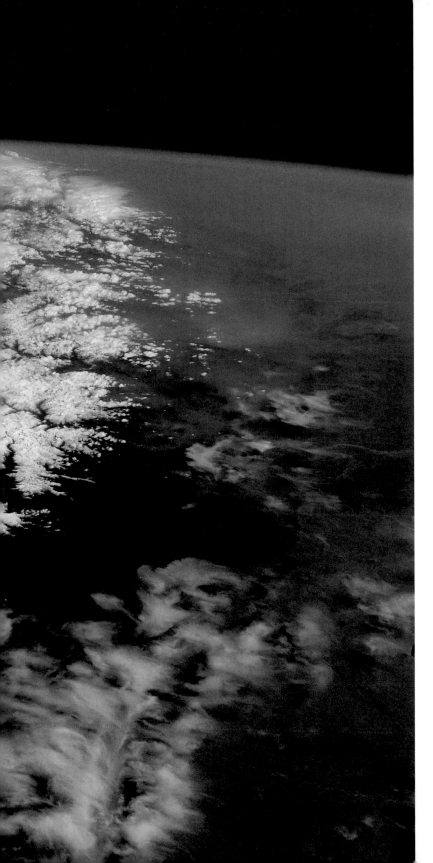

'The beautiful frosted topping of the Himalayas.'

Looking east towards Nepal with India to the right and Tibet to the left.

14 APRIL 2016

The Himalayas

Andes looking north. The light brown area in the foreground is the Paracas National Park in Peru's southern coastal desert area. The Pacific is on the left and the vast Amazon rainforest is under cloud on the right.

13 APRIL 2016

Nazca, Peru

Overleaf:
Mount St. Helens volcano, missing its side since the 1980 eruption.

1 MAY 2016

Washington State, USA

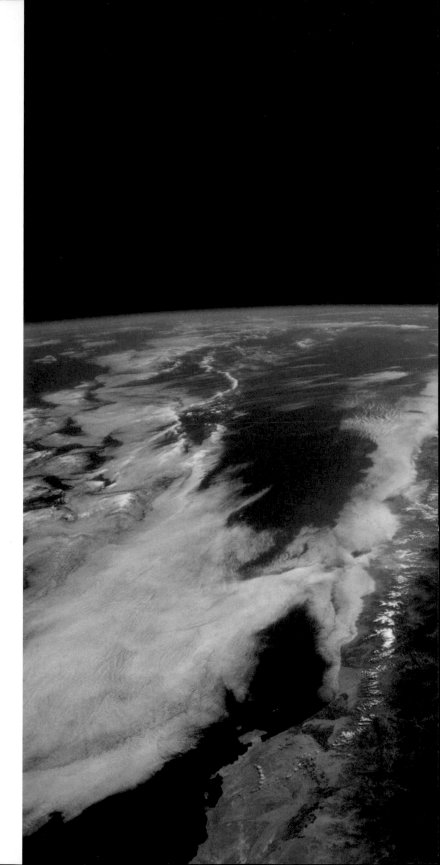

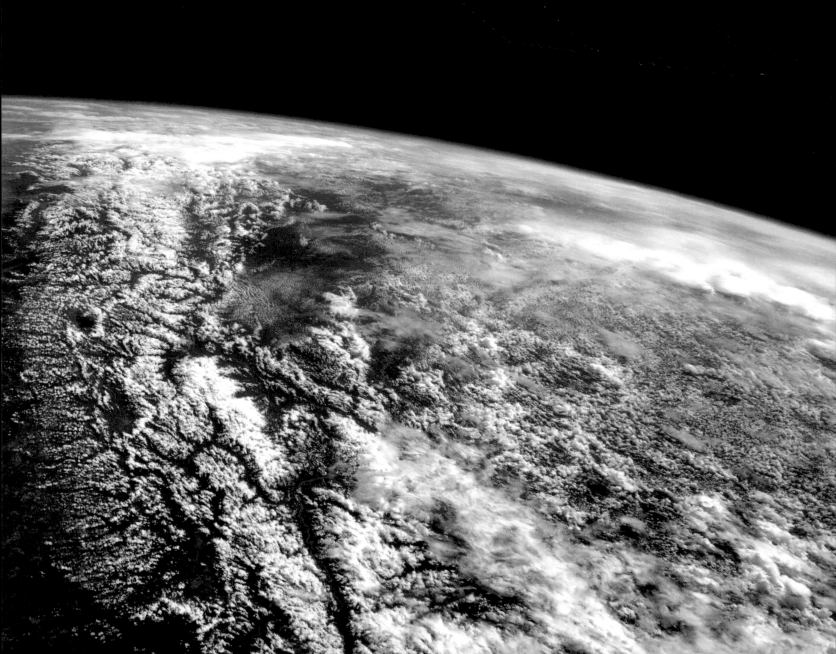

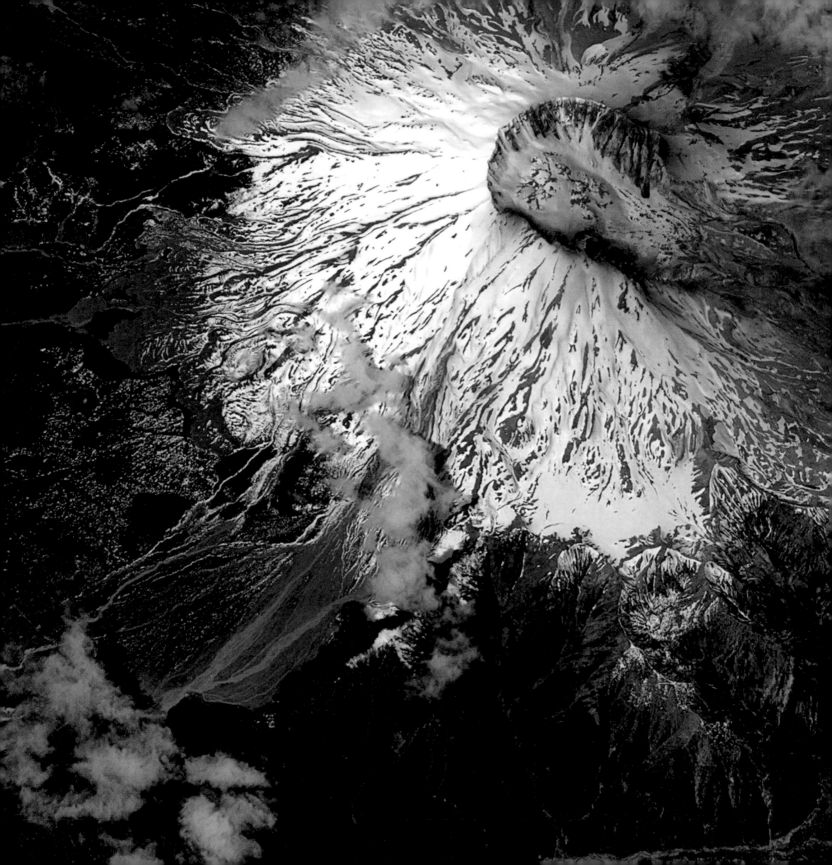

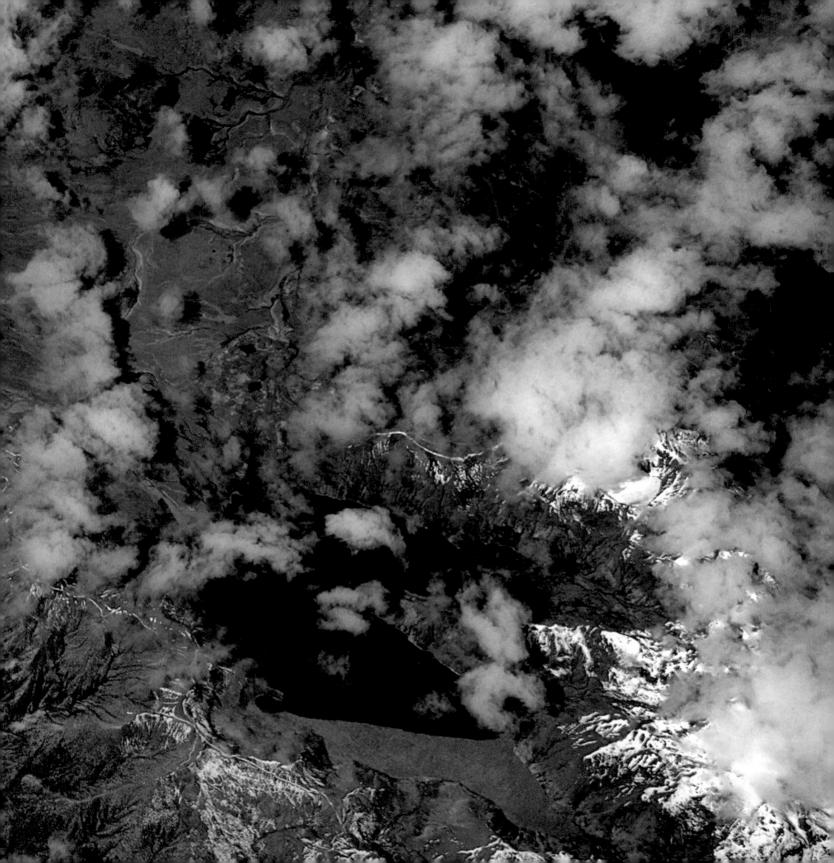

'Spotted a volcano smoking away on Russia's far east coast this morning – heat has melted snow around the top.'

These particular volcanoes are on the Kamchatka peninsula. The smoking one is Klyuchevskaya Sopka, the highest mountain on Kamchatka and the highest active volcano of Eurasia.

18 APRIL 2016

Kamchatka, Russia

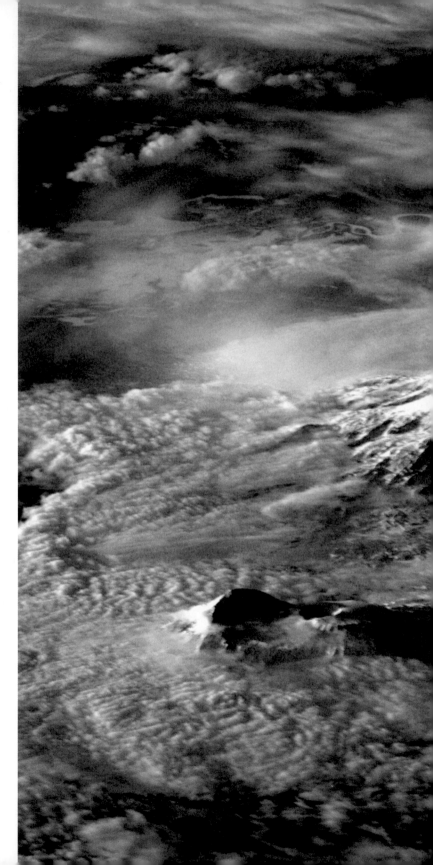

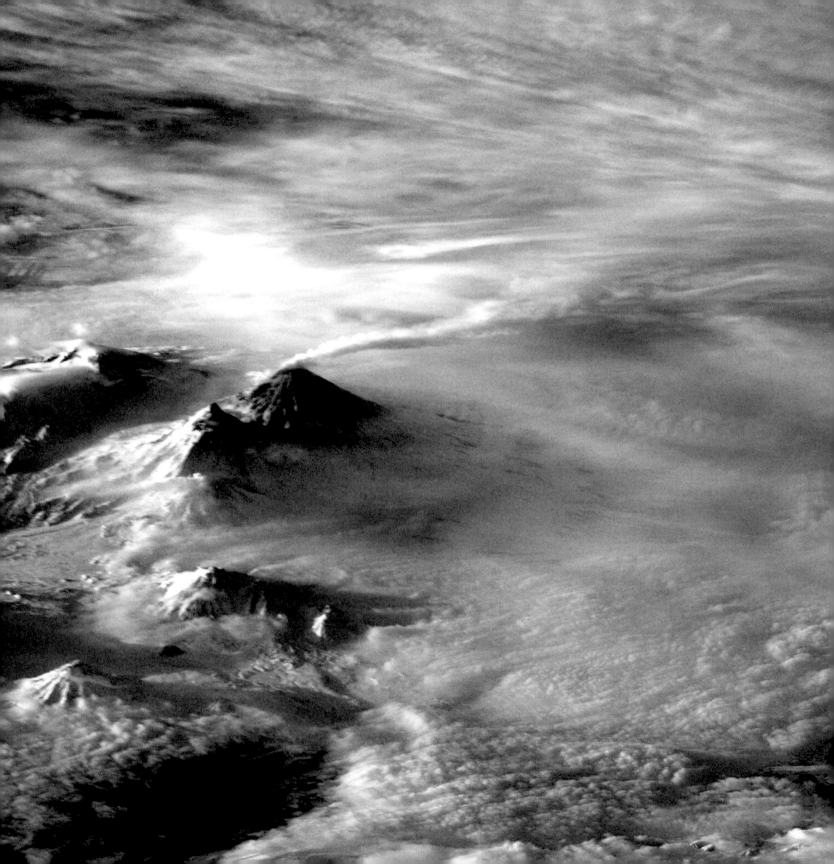

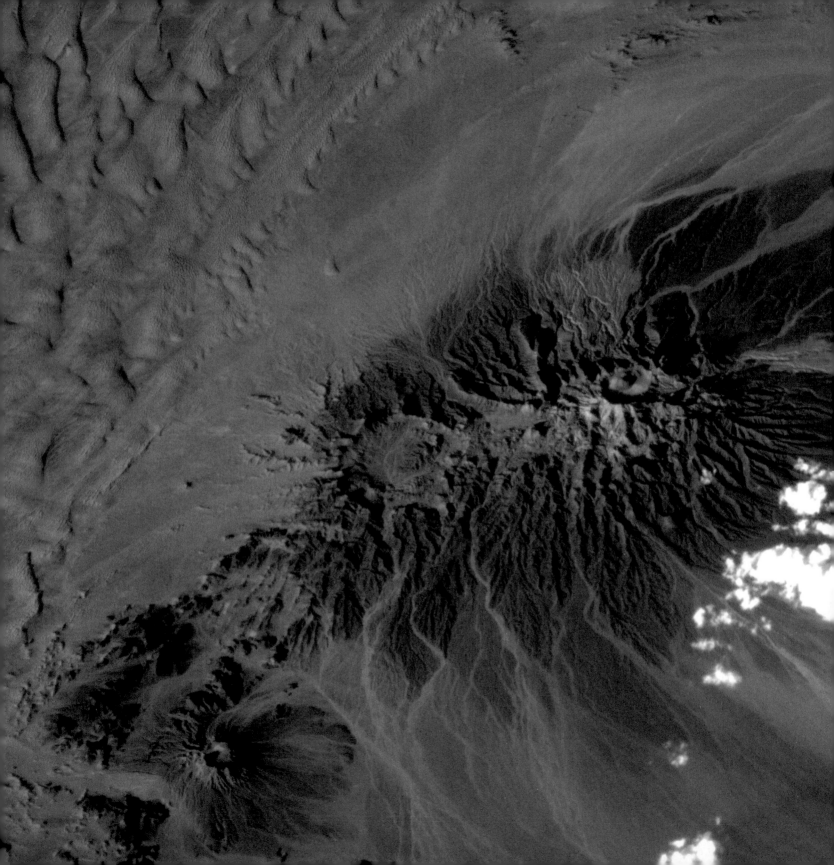

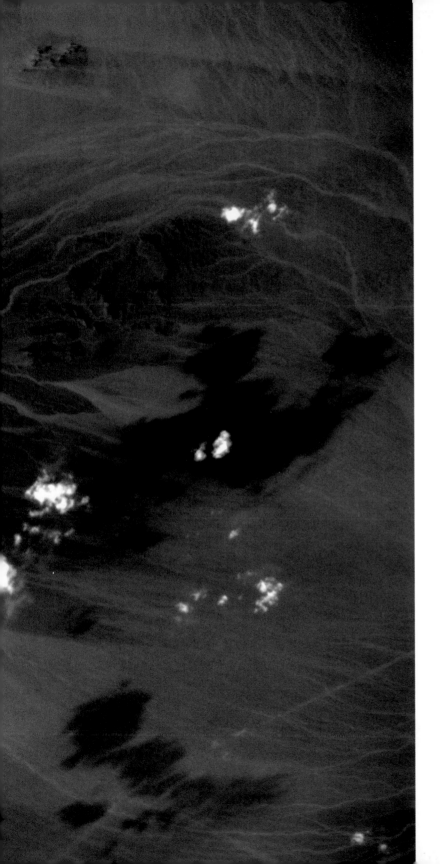

'Ancient volcanoes near the Afghanistan/Pakistan border.'

Pakistan's Balochistan province has a diverse landscape. Among many geological wonders, it is well known for its 18 mud volcanoes, two of which are seen here.

26 APRIL 2016

Nok Kundi, Pakistan

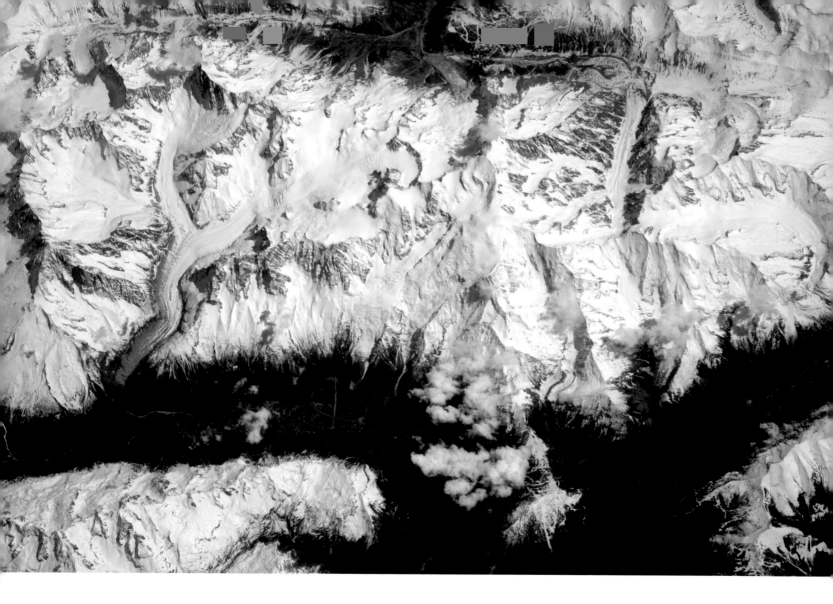

'Birds eye view of Chamonix/Mt Blanc.'

Fond memories of skiing from the Aiguille du Midi (centre) down the Mer de Glace into Chamonix valley (bottom left).

DATE 2016

Chamonix, France

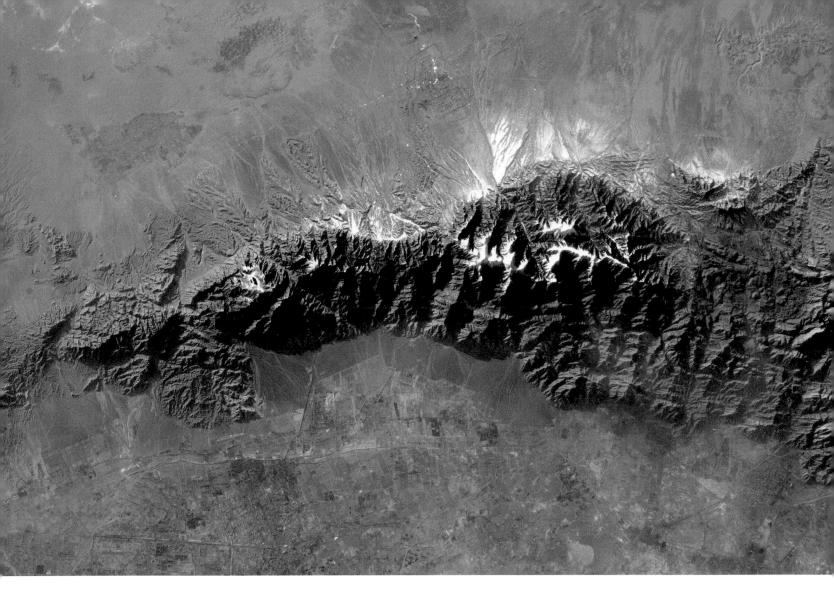

**Snow on the mountains
next to Yinchuan, China.**

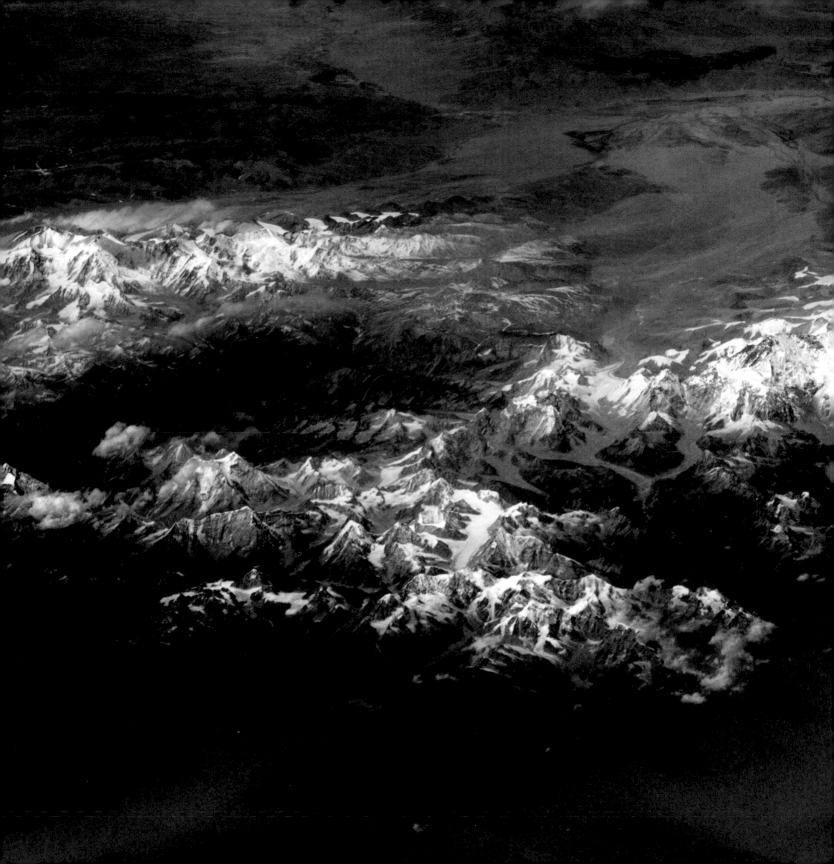

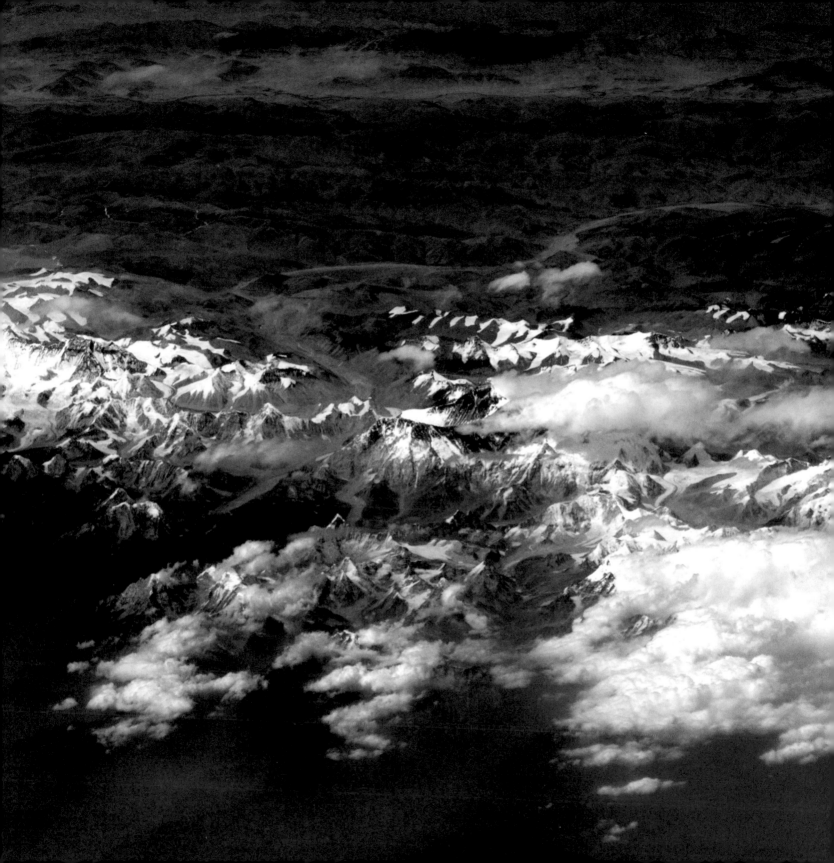

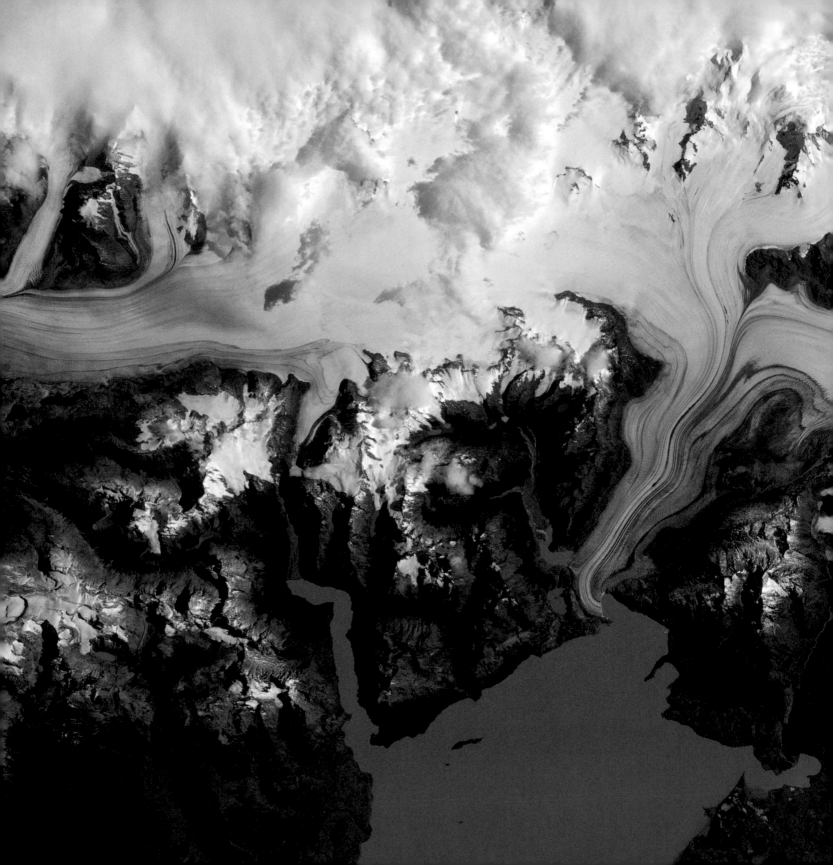

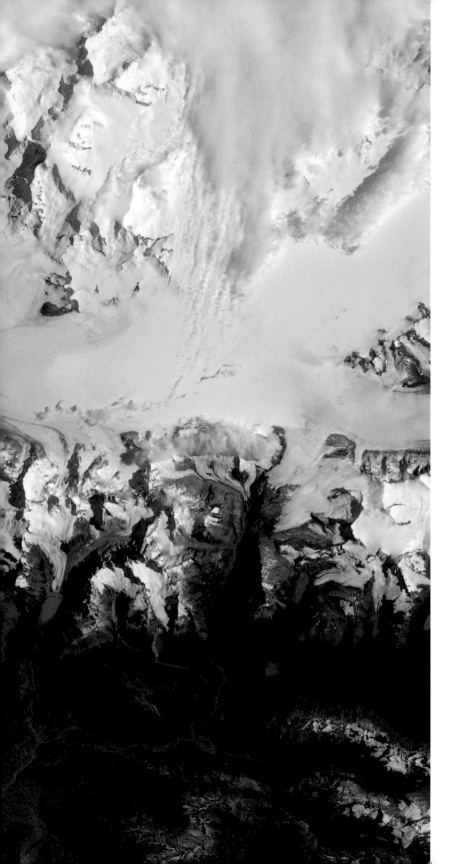

Previous:
Looking north from India, Mount Everest is in the middle right (the one with a cloud just off the summit). There's a ridge that comes across which is Lhotse. Cho Oyu in China is in the centre.

12 APRIL 2016

Namche Bazar, Nepal

'Stunning Viedma glacier in the Southern Patagonian Ice Field.'

24 MARCH 2016

El Chaltén, Santa Cruz Province, Argentina

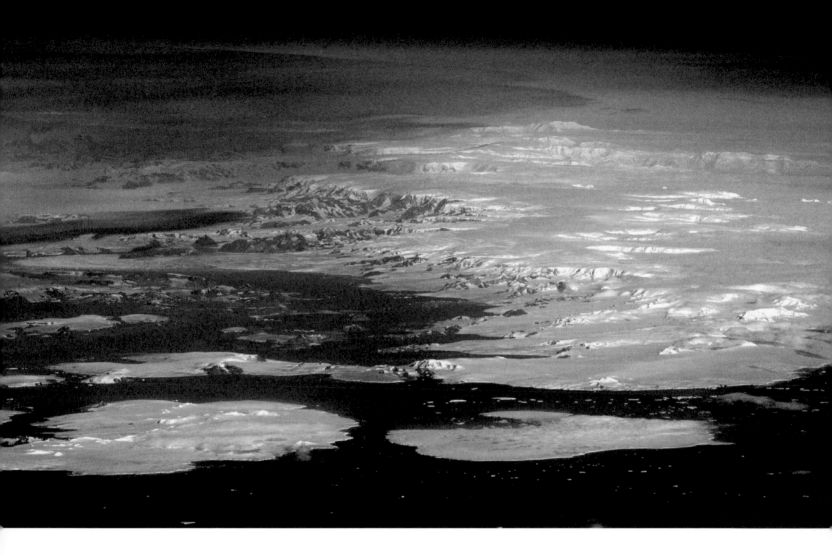

'I had to wait a couple of days but finally caught sight of the elusive Antarctica — worth the wait!'

This is hard to spot so far south of our orbit and it is usually covered in cloud! In the foreground are Joinville and D'Urville Islands, with Grahamland on the Antarctic Peninsula and Jame Ross Island behind.

29 MARCH 2016

Southern Atlantic Ocean

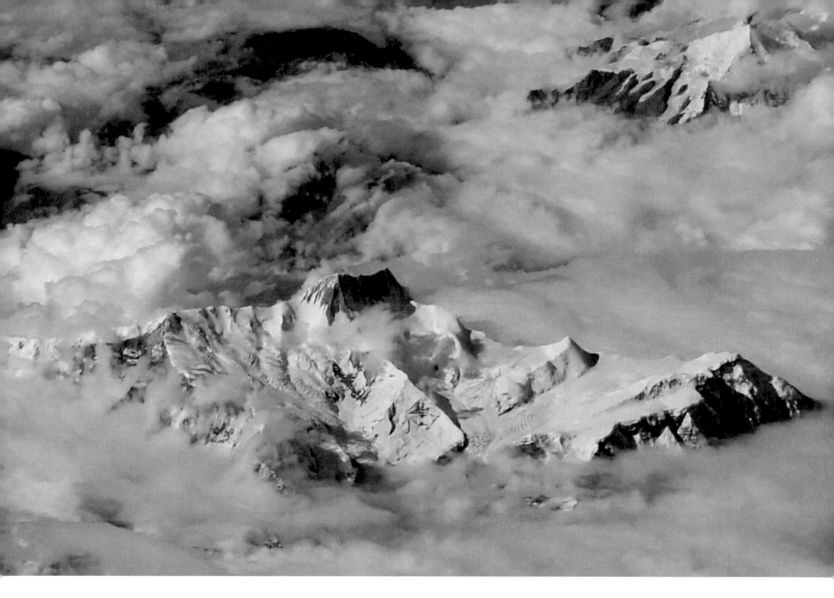

A 500mm lens and greater stand-off distance gave a nice oblique view of these Himalayan mountain peaks poking through the clouds.

5 JUNE 2016

Central India

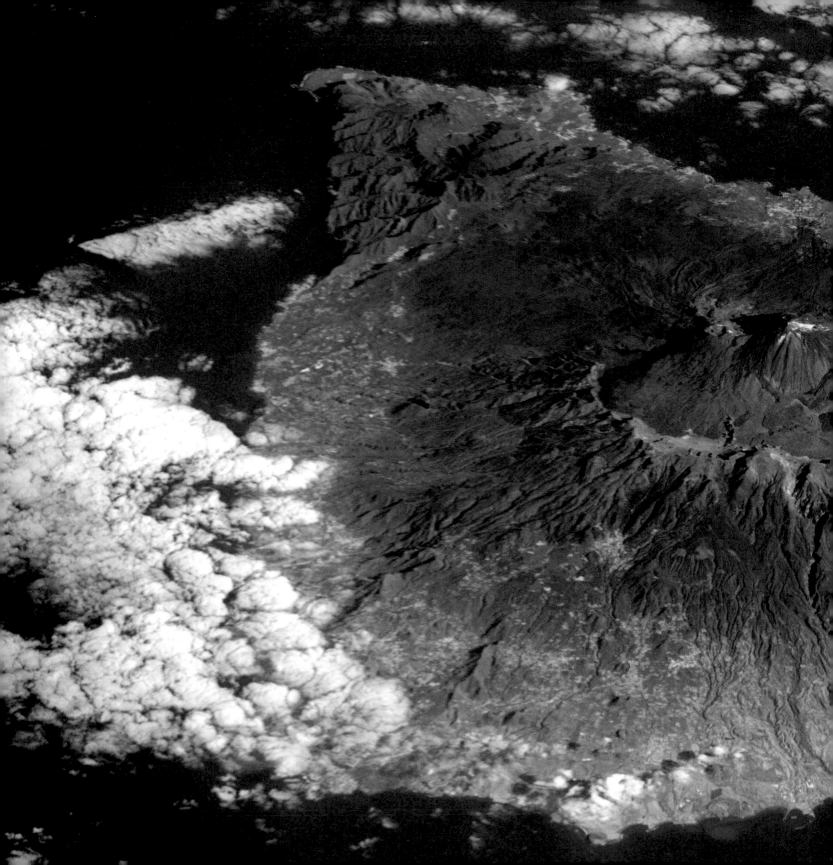

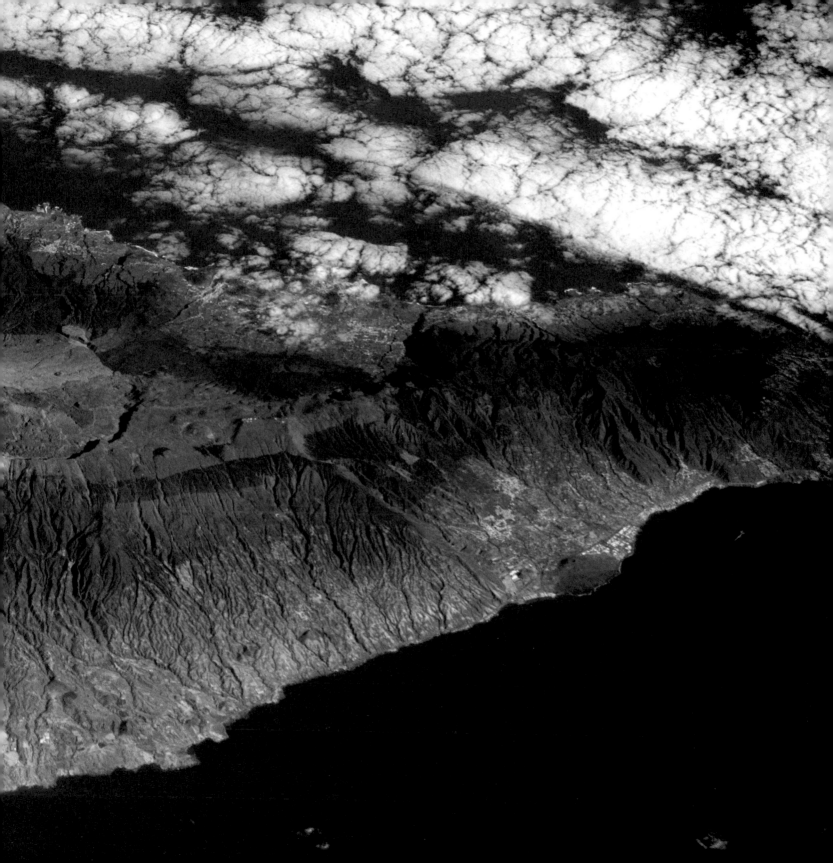

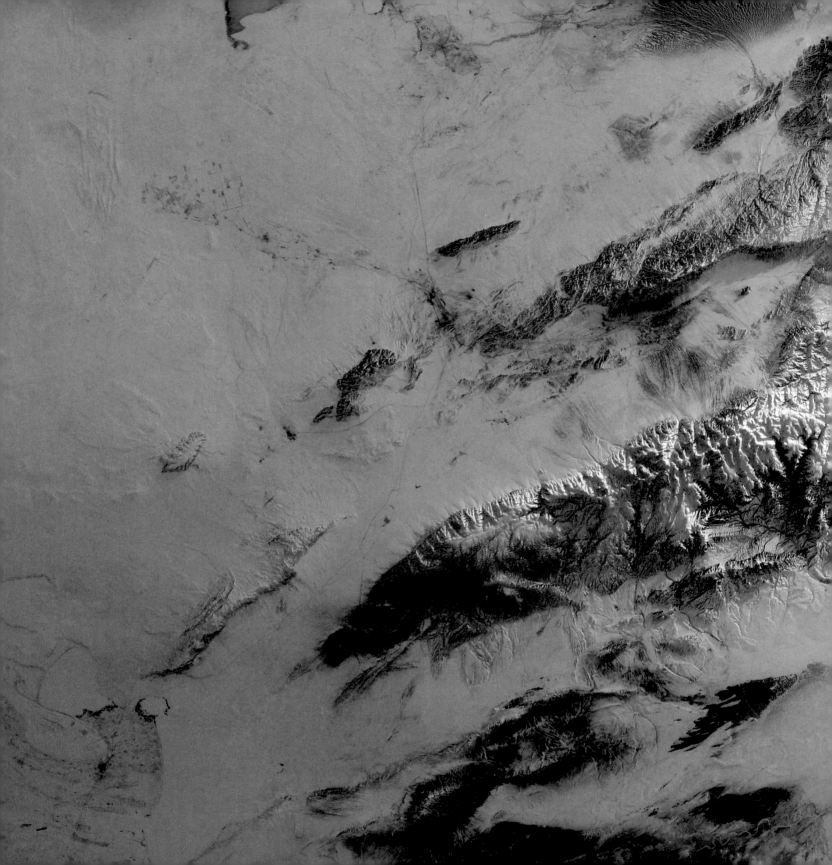

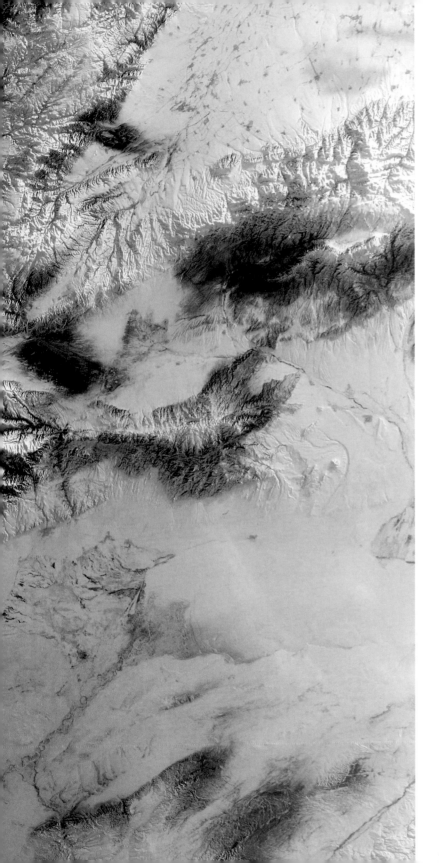

'Winter landscape spanning the border between Kazakhstan and China, a beautifully remote part of our planet.'

21 FEBRUARY 2016

Korgas, Xinjiang, China

This is a dune field in the Sahara Desert crossed by the border of Algeria and Tunisia.

Illizi, Algeria

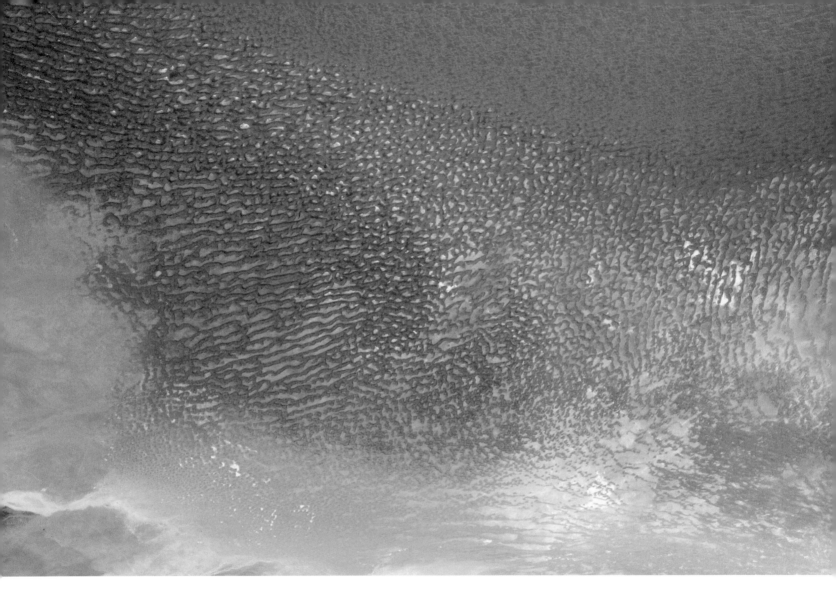

7 MAY 2016

Ubar, Oman

'Great texture in these huge sand dunes on the border of Saudi Arabia and Oman.'

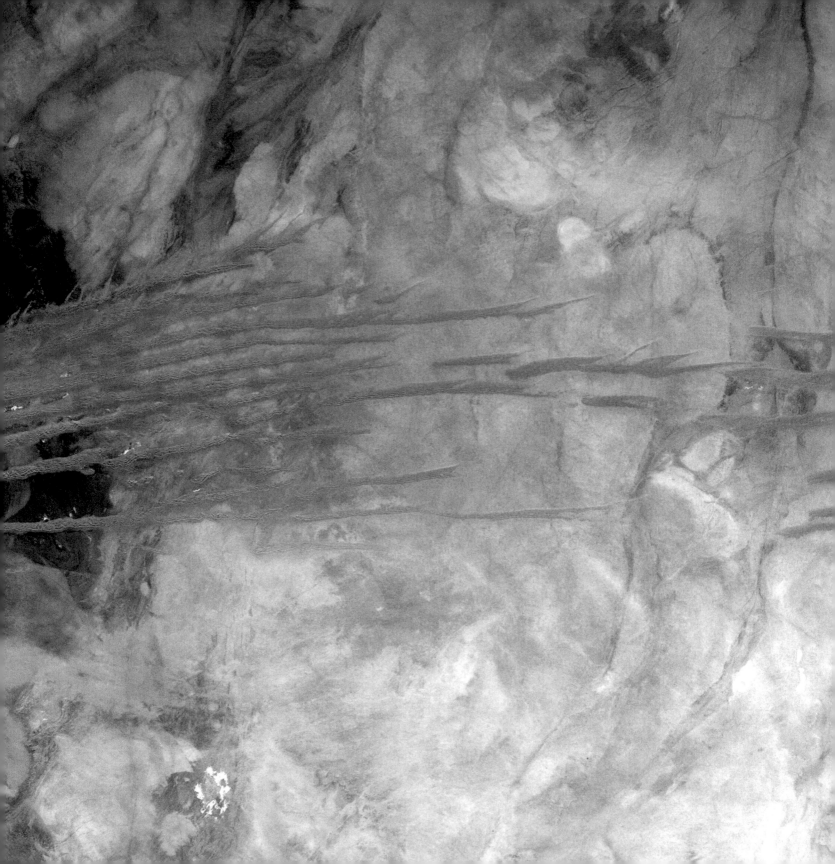

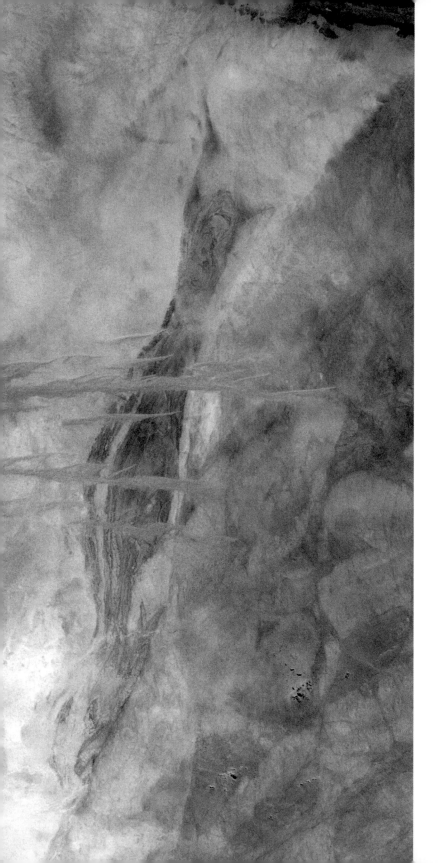

'Is it just me or do I see some rocket flames down there?'

These strange land features are in the Erg Iguidi desert, with its yellow stripes of sand stretching from Algeria to northern Mauritania in the Sahara.

22 FEBRUARY 2016

Chegga, Tiris Zemmour Region, Mauritania

'I was lucky enough to fly a helicopter in these mountains once – I'm a bit higher this time!'

This picture was taken over the west coast of Canada, and shows the Coast Range of mountains, with King Island and Burke Channel in the centre. The Pacific Ocean is visible at the bottom, north is to the left.

31 DECEMBER 2016

British Columbia, Canada

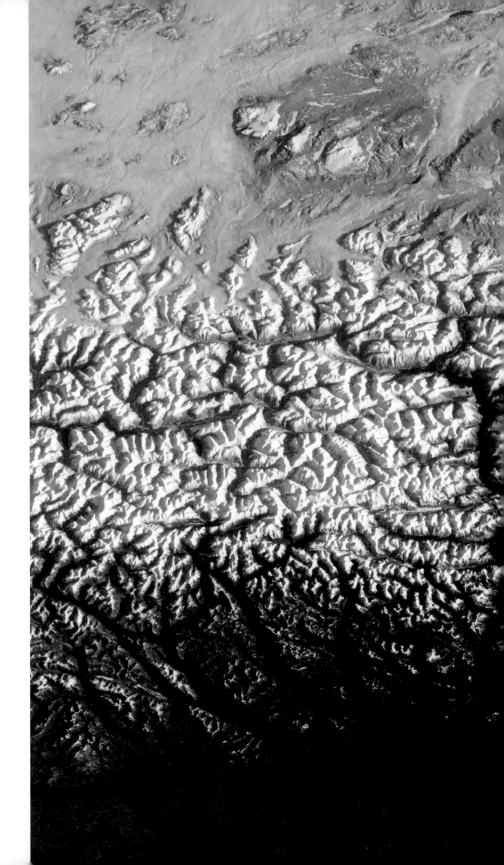

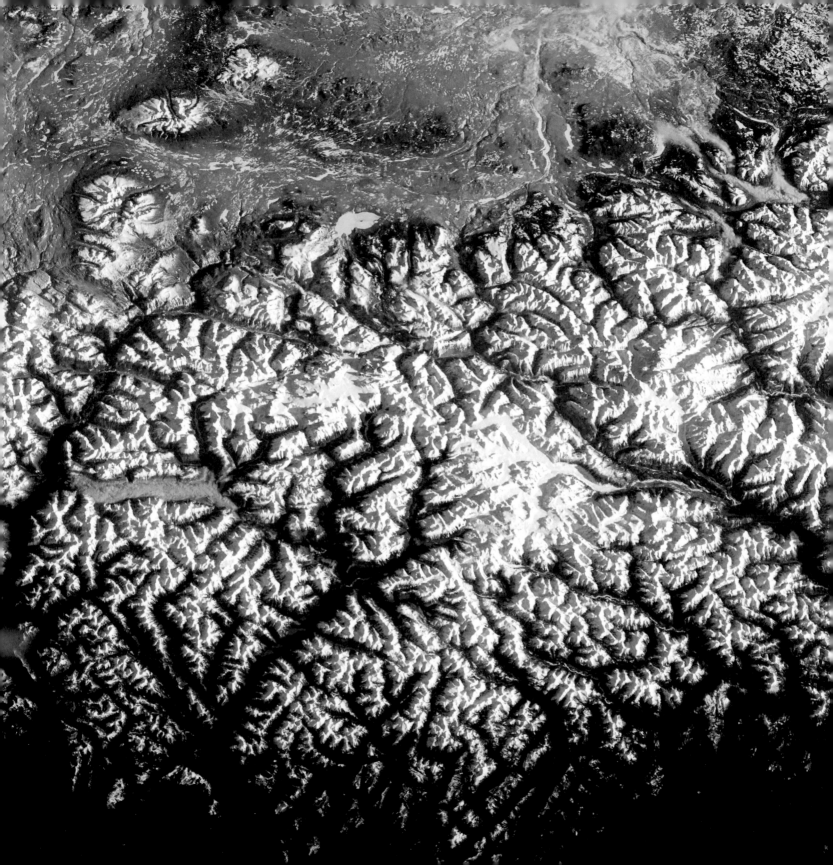

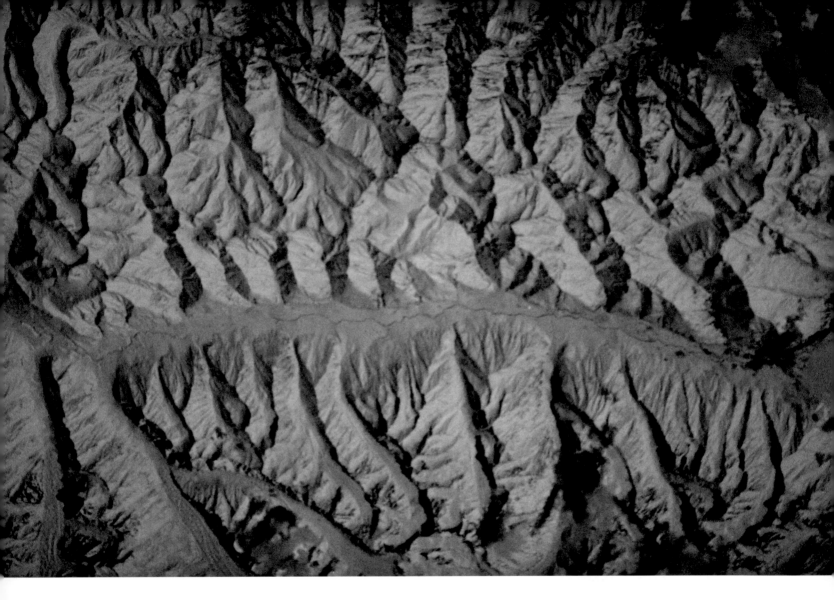

'Himalayan valley under a full Moon.'

Indus River. The Zanskar mountains are part of the Himalayan range. The settlement at right is Padum, the only town in Zanskar.

23 MARCH 2016

Jammu and Kashmir, India

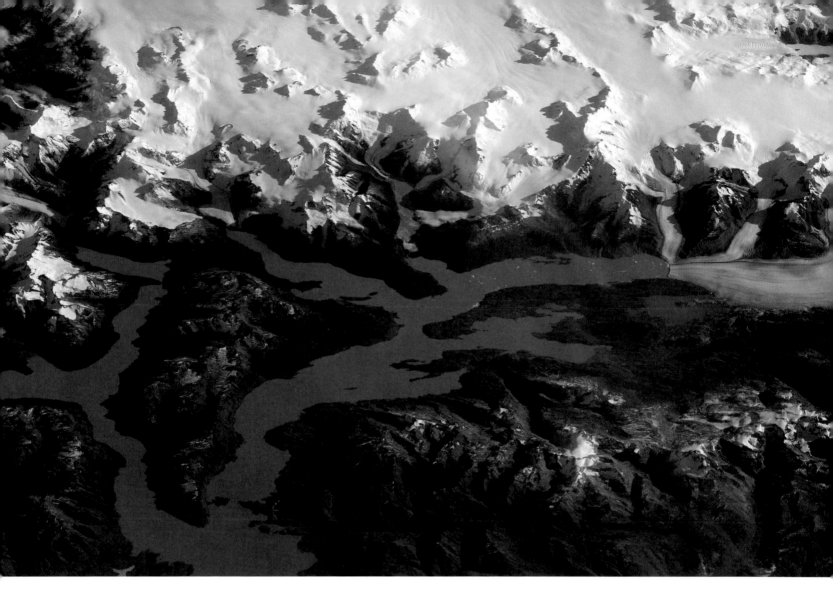

22 MAY 2016

Lake Argentino, Argentina

The Uppsala Glacier on the right, in Argentina's Los Glaciares National Park, flowing from the Southern Patagonian Ice Field into Lake Argentino in the foreground.

143

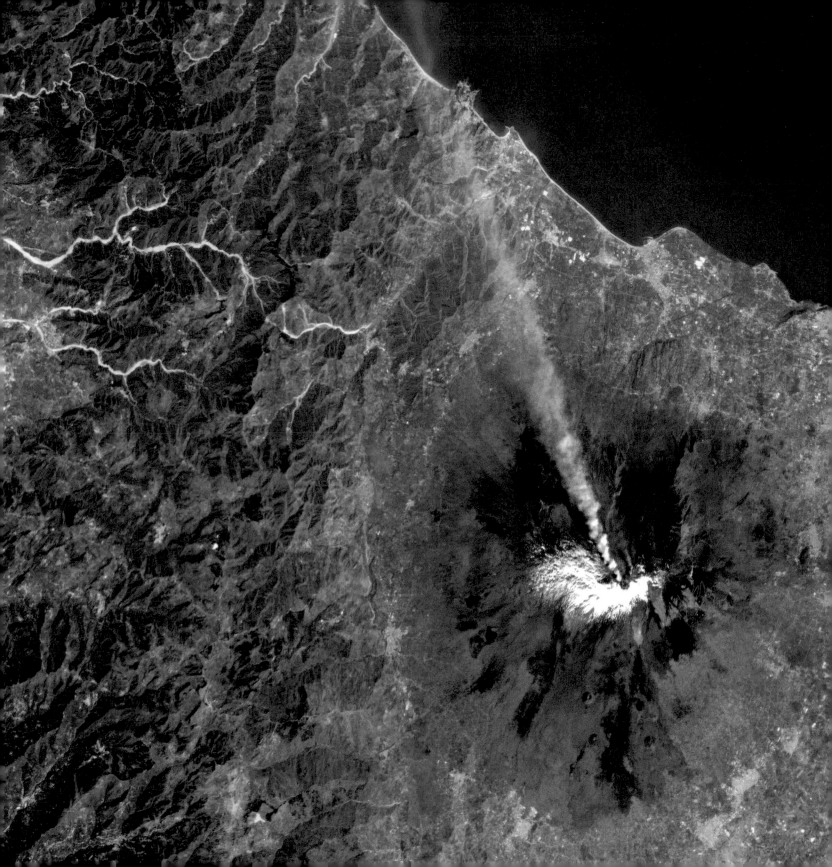

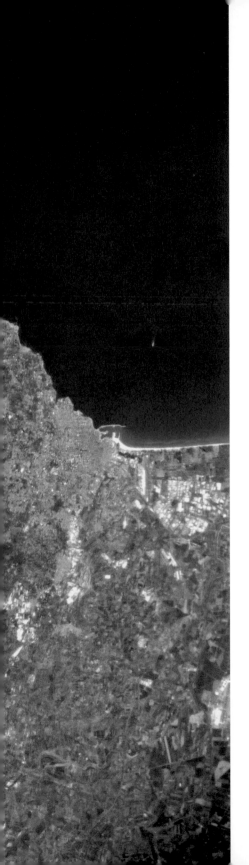

'Caught Mount Etna having a cheeky smoke the other day!'

Mount Etna is one of the most active volcanoes in the world. Visible at the foot of the mountain is the city of Catania on the island of Sicily, Italy.

15 APRIL 2016

Catania, Italy

'Africa art. Gemeri Lake is the golden brown body of water at the top of the photograph. It is home to many species of birds.'

29 FEBRUARY 2016

Gemeri Lake, Ethiopia

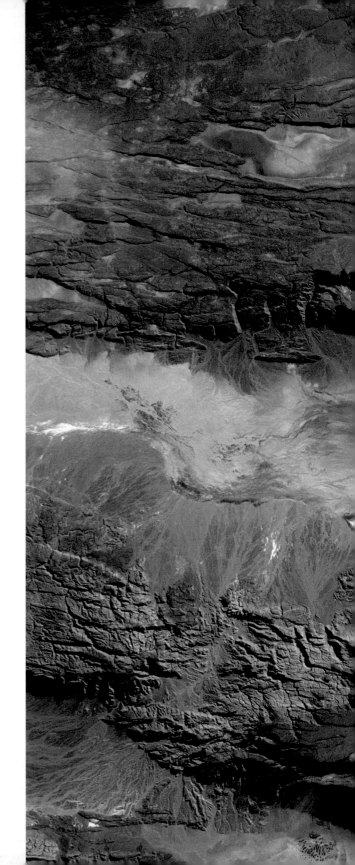

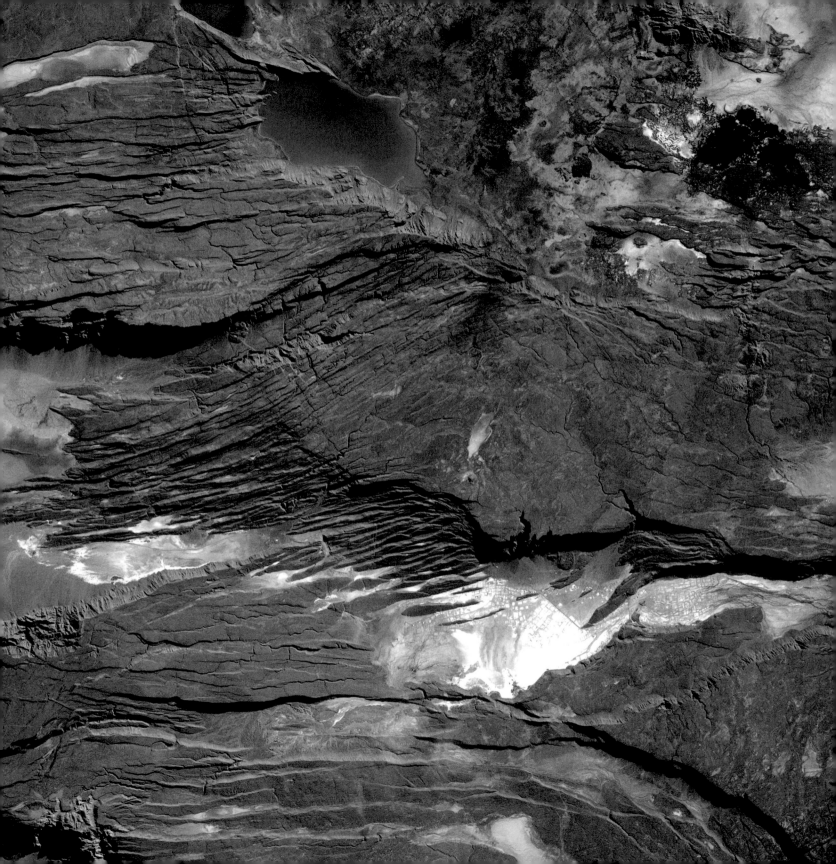

TOWNS AND CITIES

By day, towns and cities are quite difficult to view from space. I often missed them at first glance, overshadowed by Earth's natural features. But take a closer look, and our demarcation lines and urban settlements come sharply into focus.

The beautiful city of Vancouver is situated in the bottom right of the photo. Water and mountains encroach on all sides.

1 MAY 2016

Vancouver, Canada

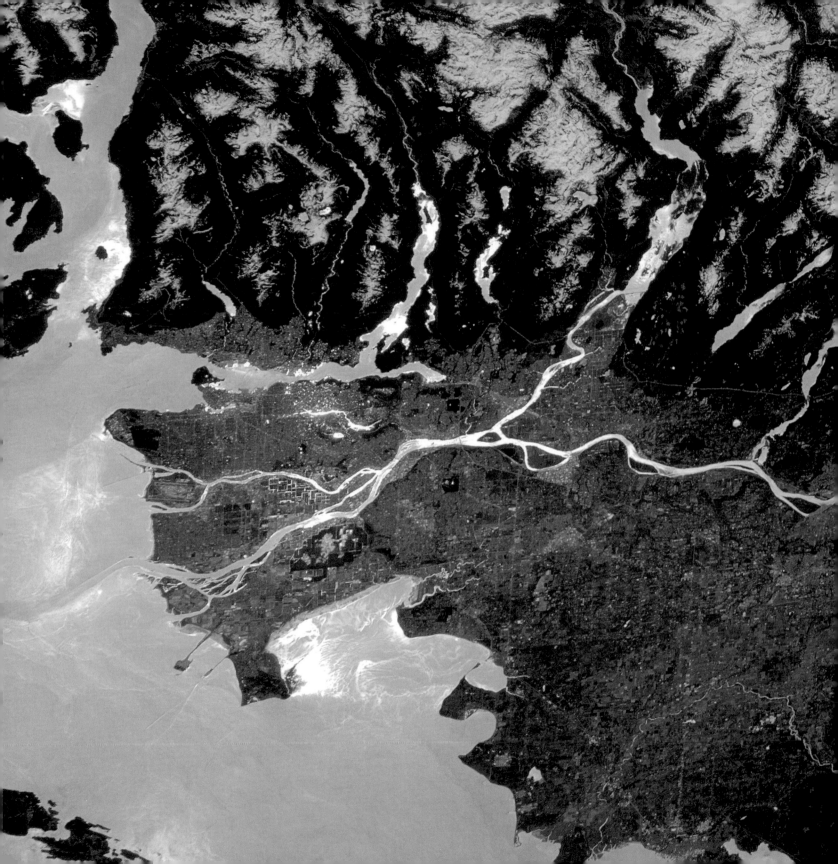

'There's a lot of silicon in
that valley ...'

23 APRIL 2016

San Francisco, San Jose and the Bay Area, USA

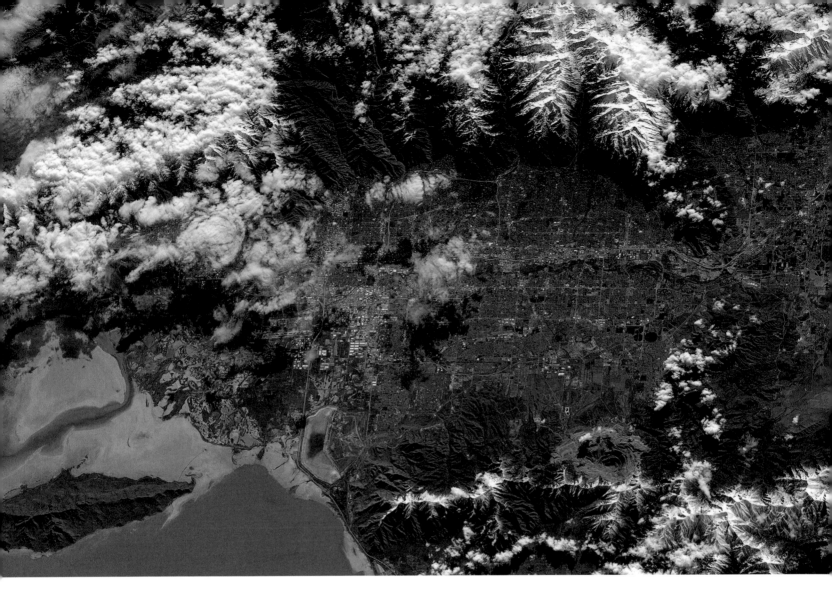

The Great Salt Lake of Salt
Lake City, Utah, can be
seen bottom left. North is
to the left and mountains
border the city to the east
and west.

2 MAY 2016

Salt Lake City, USA

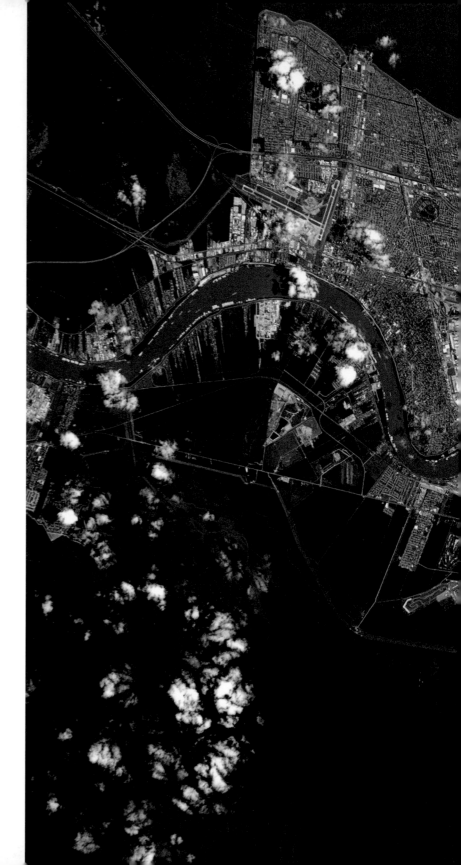

'Does anywhere party harder than this city? New Orleans.'

The Industrial Canal is a 9 km waterway that meanders through New Orleans. The canal connects the Mississippi River to Lake Pontchartrain.

8 MAY 2016

New Orleans, USA

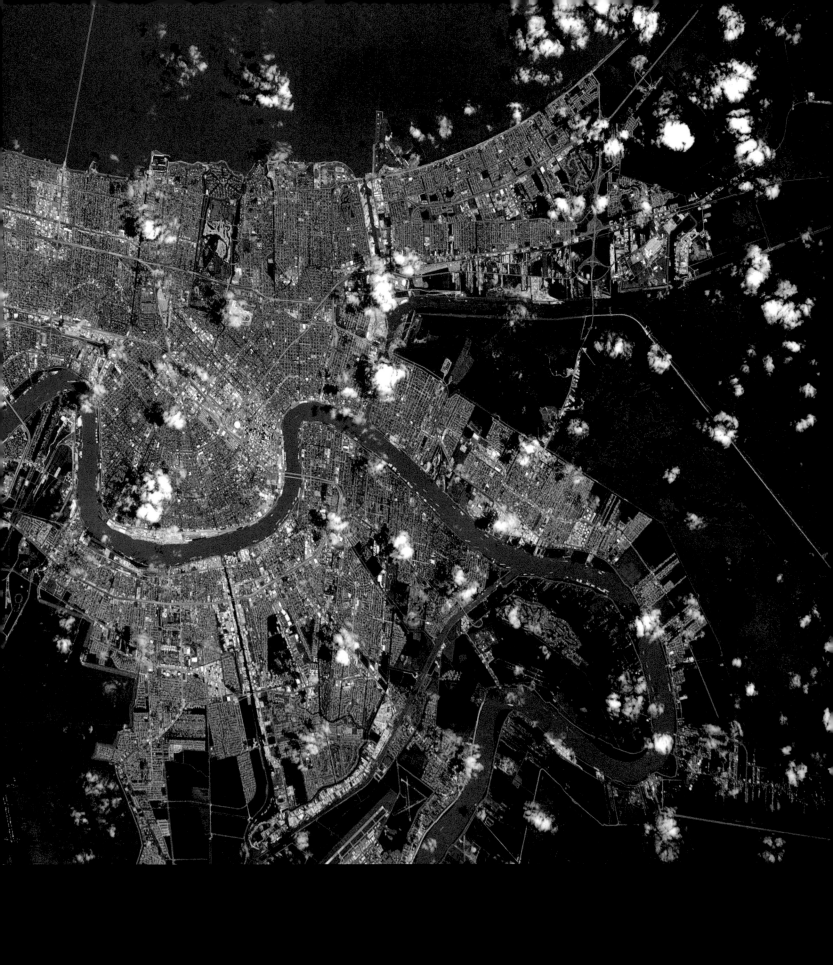

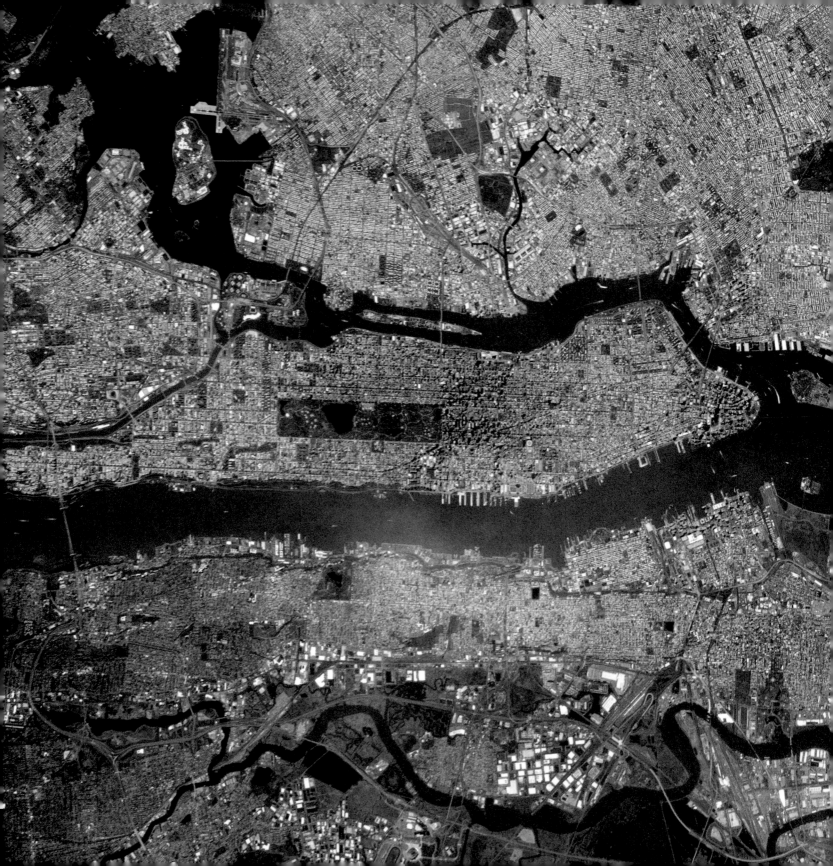

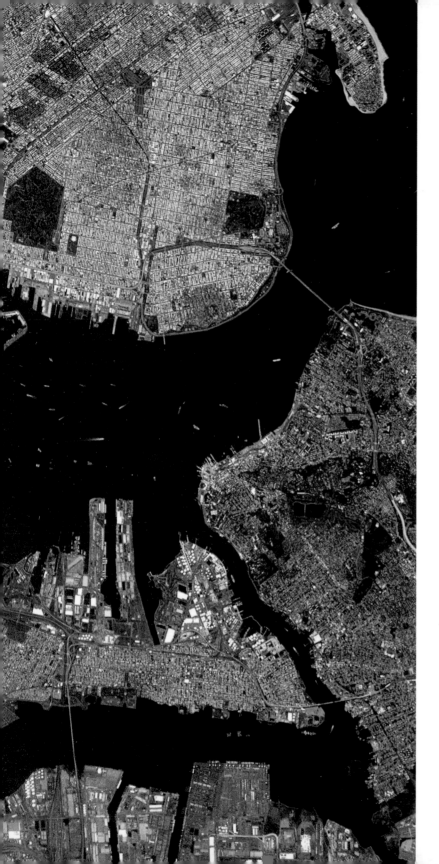

'These little town blues . . .'

Manhattan Island in the middle, north is left. The rectangular Central Park is very visible. Jersey City and Newark Bay to the bottom.

9 MAY 2016

New York City, USA

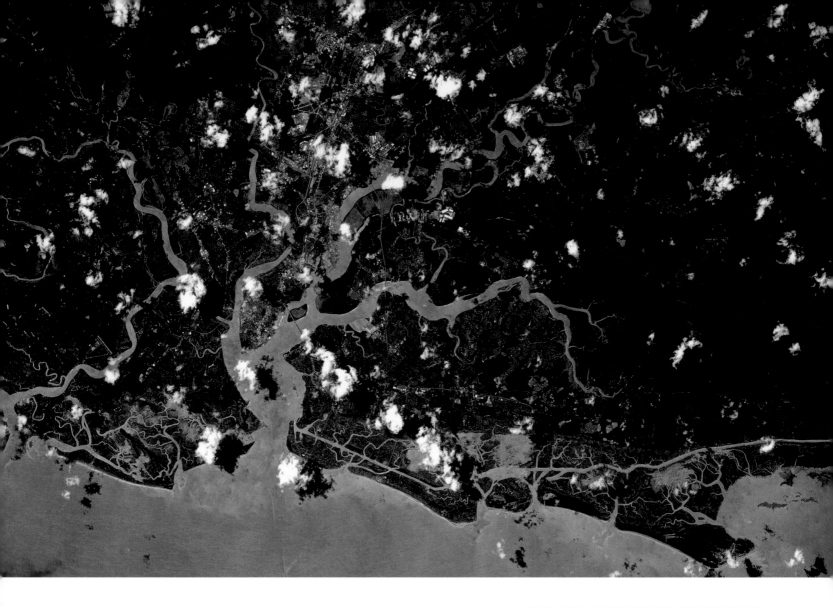

'The waterways of
Charleston – the oldest
city in South Carolina.'

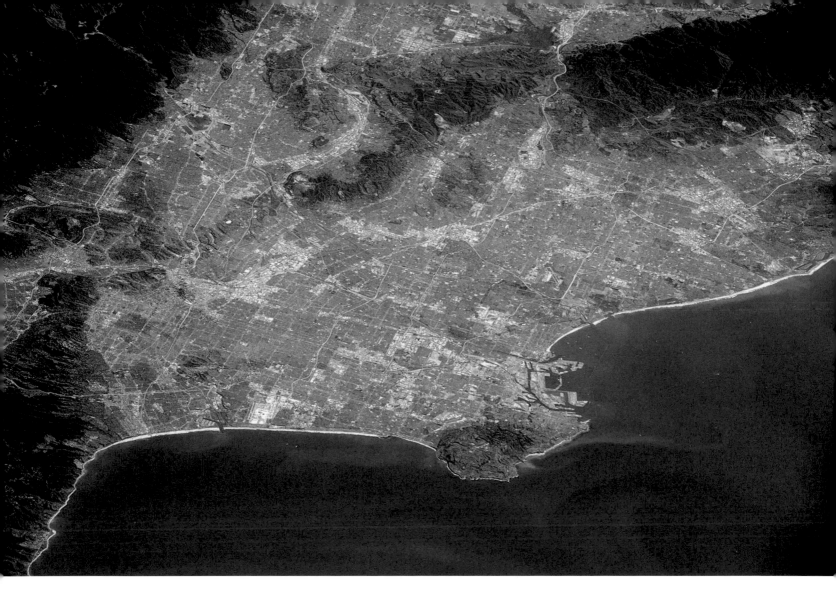

The white sands of LA's beaches stand out against the Pacific blue. Santa Monica, Beverly Hills and Hollywood are bottom left.

'City of Angels.'

16 MARCH 2016

Los Angeles, USA

159

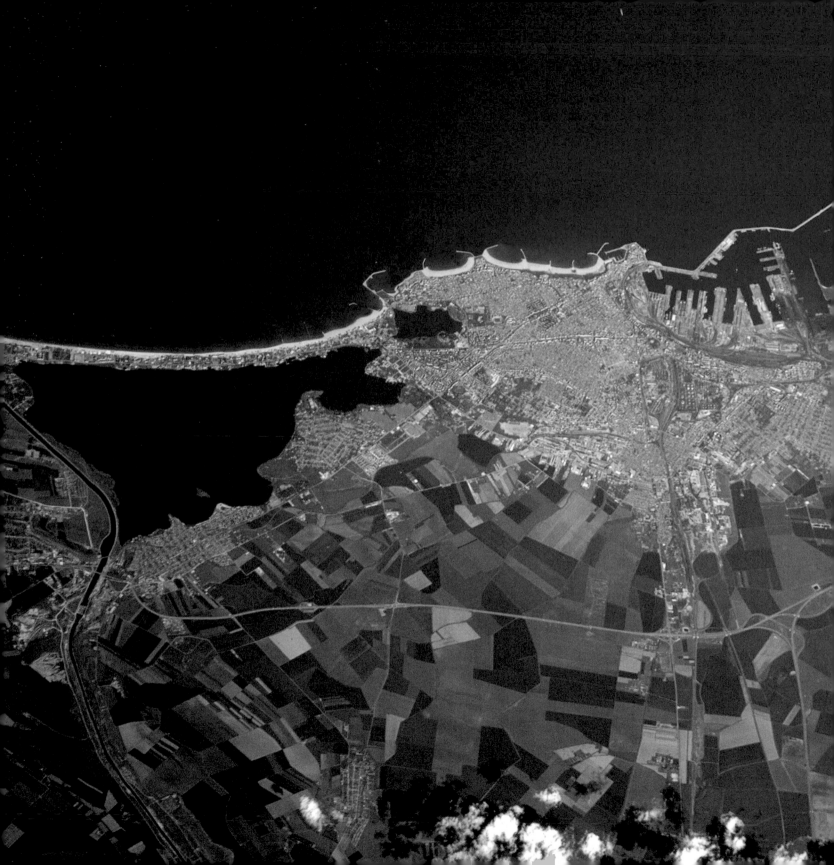

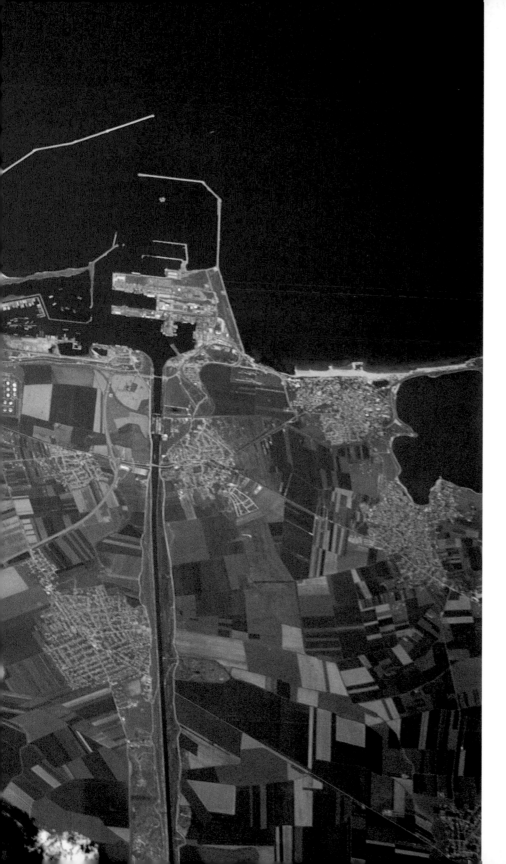

'The most distinctive harbour wall in the Black Sea.'

Constanta, the oldest continuously inhabited city in Romania.

Constanta, Romania

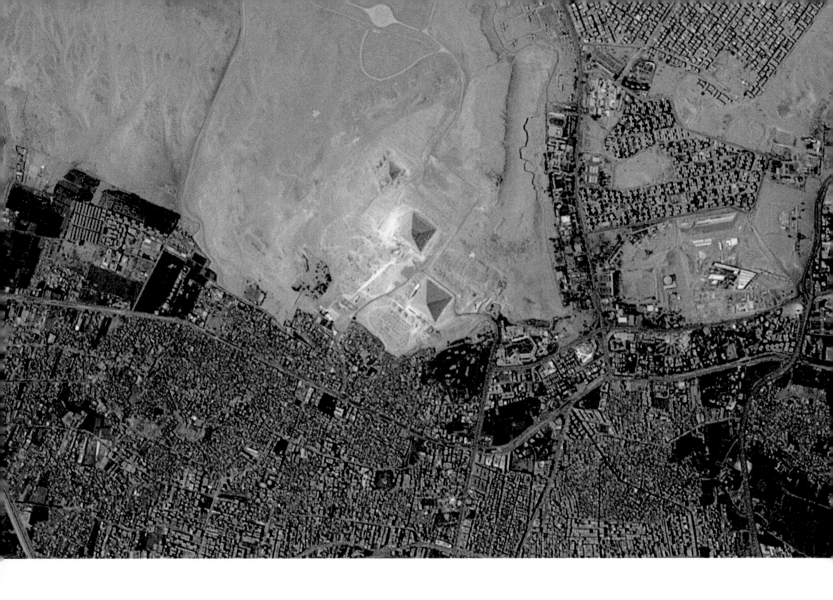

'You can't see the pyramids
with the naked eye from space
but this is the view through
an 800 mm lens.'

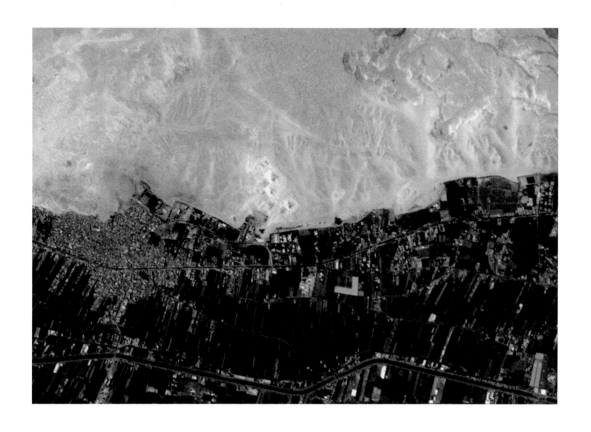

19 APRIL 2016

El Giza, Egypt

Above:
Pyramids of Abusir, south of Giza.

Left:
The three pyramids in the centre of this photo (from largest to smallest, and from closest to the city to the desert) are: The Great Pyramid at Giza (the oldest of the Seven Wonders of the Ancient World), the Pyramid of Khafre and the Pyramid of Menkaure.

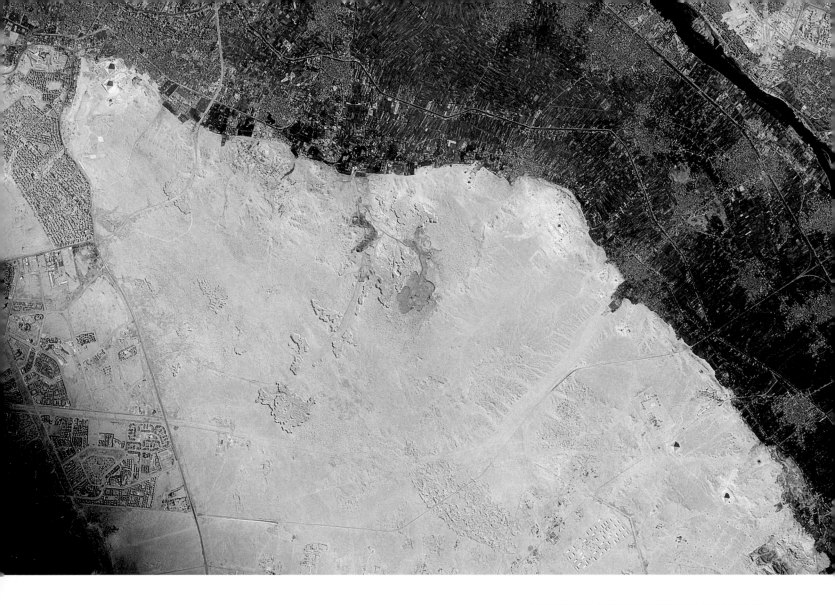

'Competition time –
how many pyramids do
you spot in this pic?'

El Giza, Egypt

The answer: There are between 118-138 Egyptian pyramids but in this picture I can only spot 24.

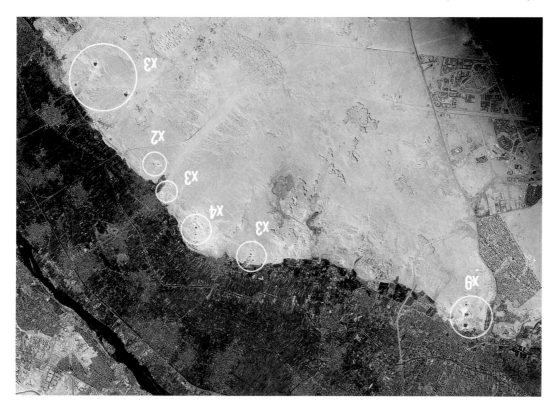

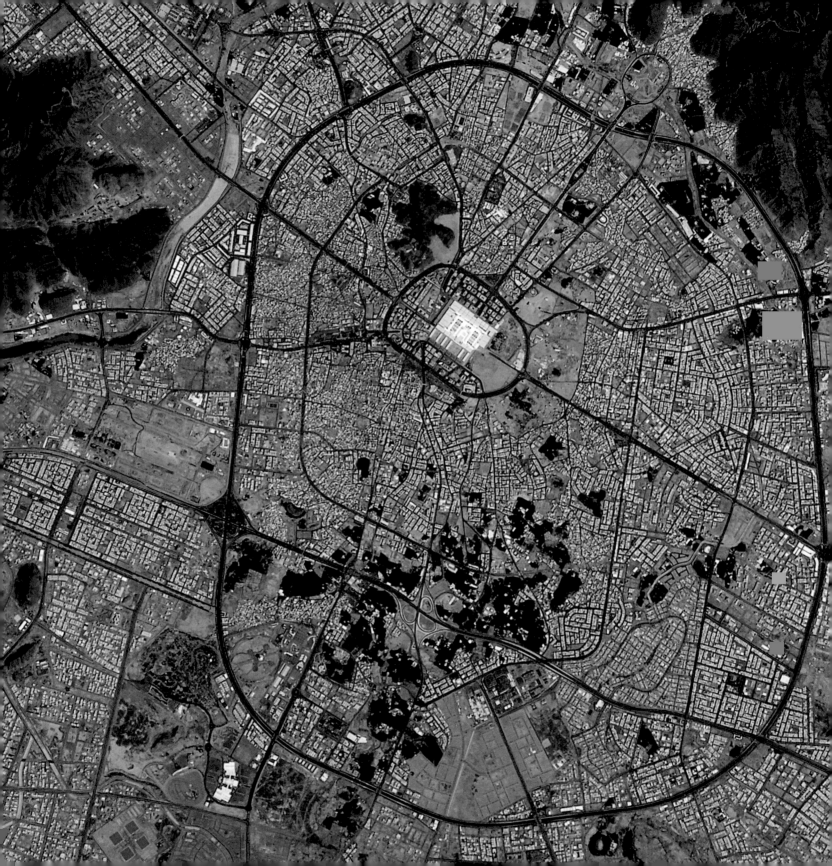

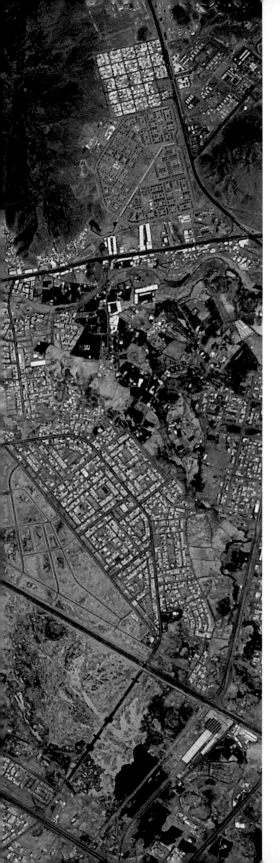

'The distinctive ring road of Medina stands out against the hills and mountains.'

Medina is the second-holiest city in Islam after Mecca and the burial place of the prophet Muhammad.

16 MAY 2016

Medina, Saudi Arabia

'Munich – home of Europe's
Mission Control Centre.'

**Munich airport northeast
(top right) with the Columbus
Control Centre (Col-CC) at
Oberpfaffenhofen west (left)
near the lake.**

7 MAY 2016

Munich, Germany

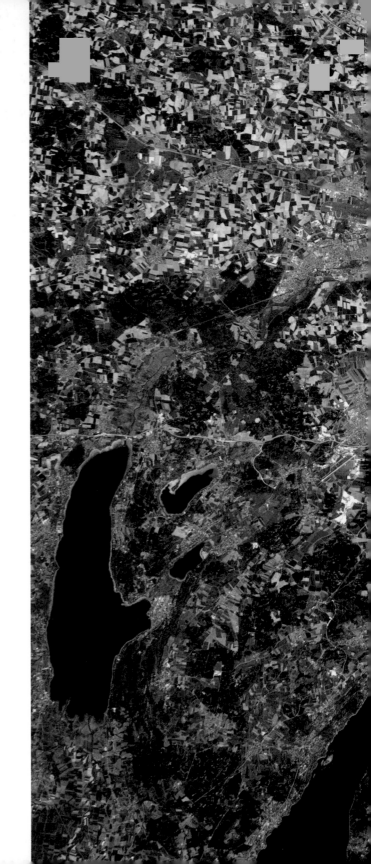

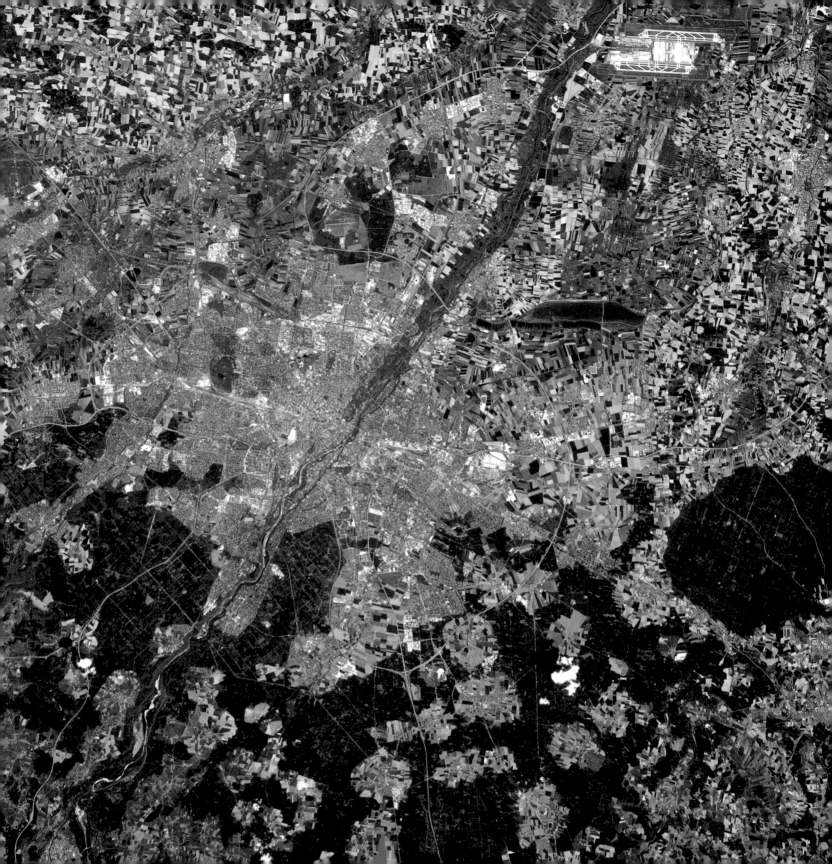

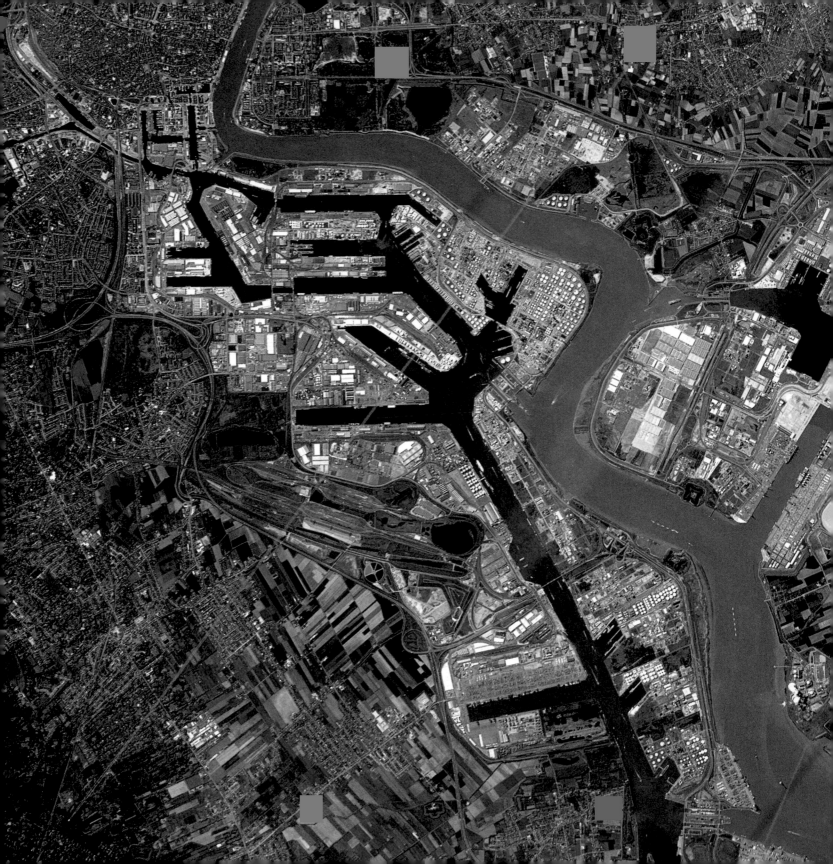

'The busy port of Antwerp – spot the aircraft photobomb bottom left?'

Often, the only way we can spot aircraft from space is by following their contrails.

5 MAY 2016

Antwerp, Belgium

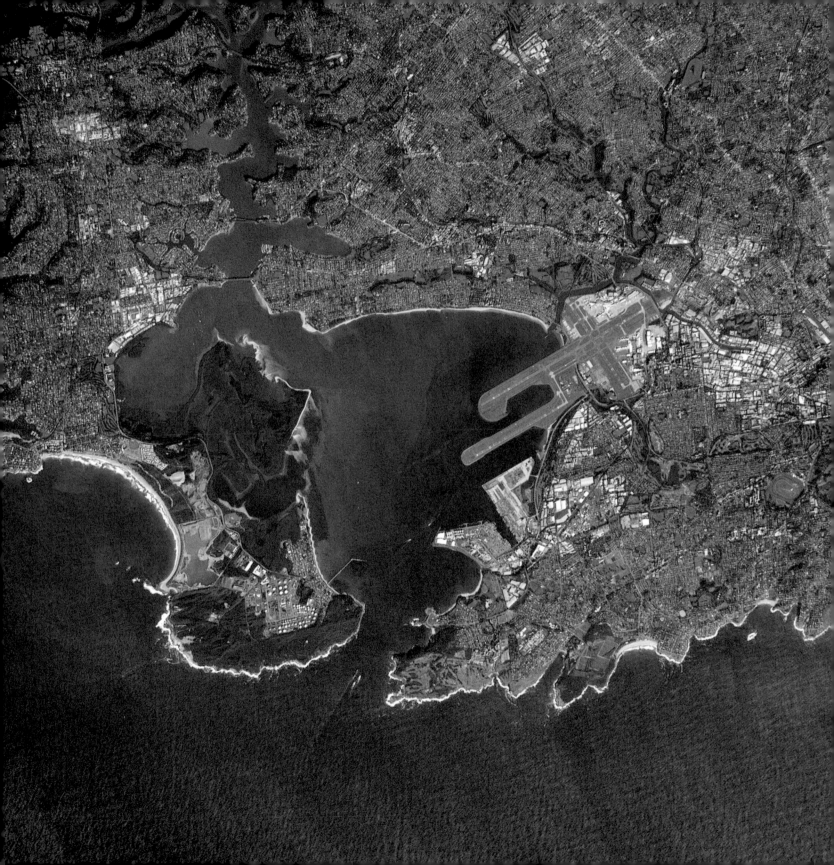

'G'day Sydney. Surf's up!'

Bondi beach, famous for its surfing, is situated in the small cove to the right of centre. Sydney Harbour Bridge and the Opera House are down there too but you may need a magnifying glass!

29 MARCH 2016

Sydney, Australia

173

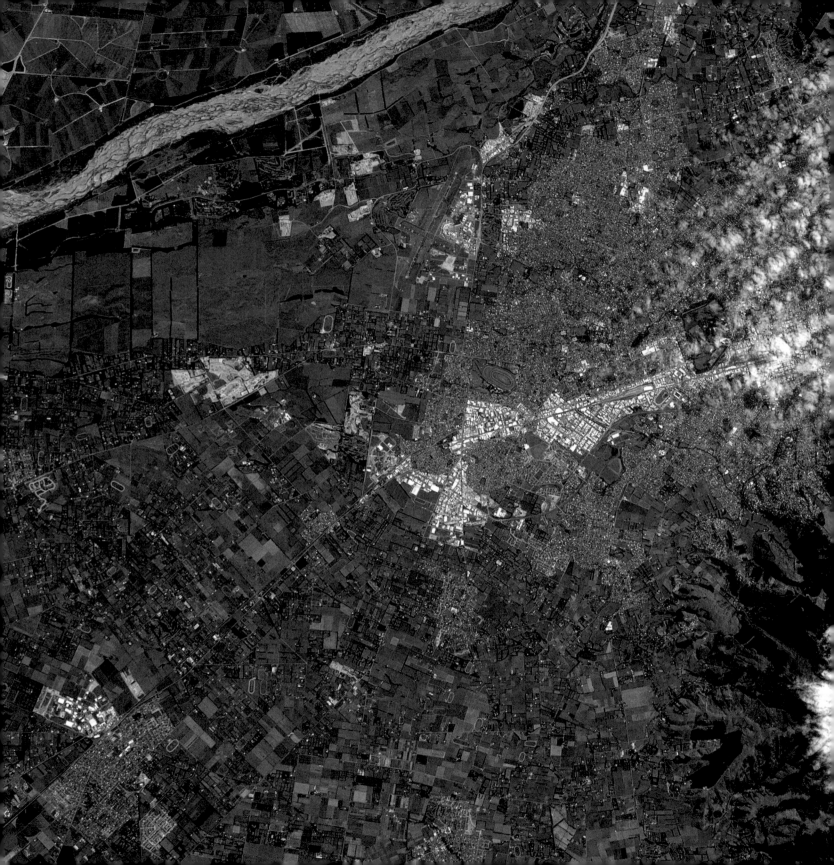

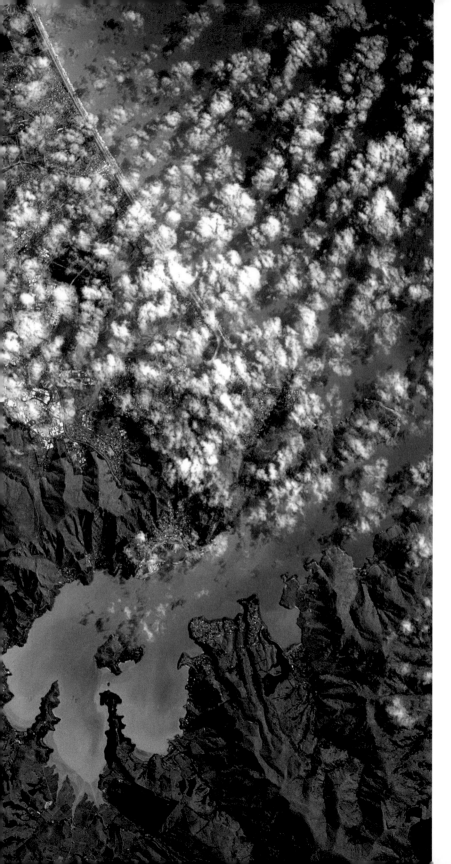

'Christchurch and the beautiful colours of Lyttelton Harbour.'

Christchurch lies on the east coast of New Zealand's South Island. Whenever we passed overhead, I couldn't get over the rich variety of the country's landscape, which changes from town to mountain to crystal clear water in a matter of miles.

31 JANUARY 2016

Christchurch, New Zealand

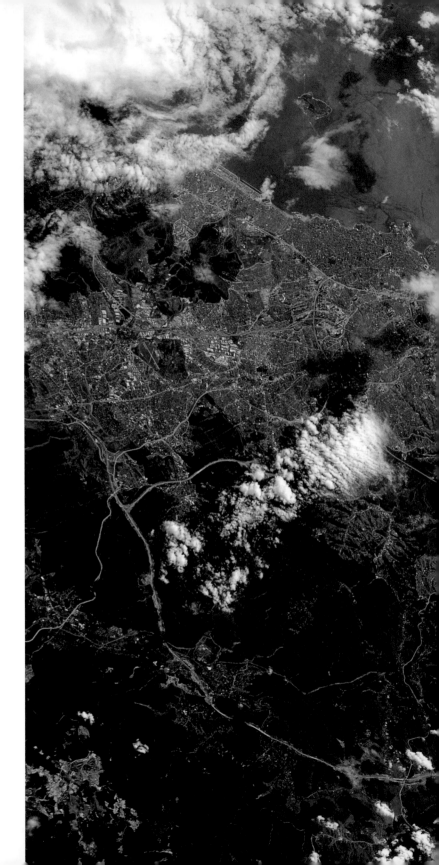

'Istanbul – gateway
to the Black Sea.'

In the centre of the
photograph, looking south
through the Bosphorus Strait,
you can see the three bridges
that connect the continents of
Asia (left) and Europe (right).

25 APRIL 2016

Istanbul, Turkey

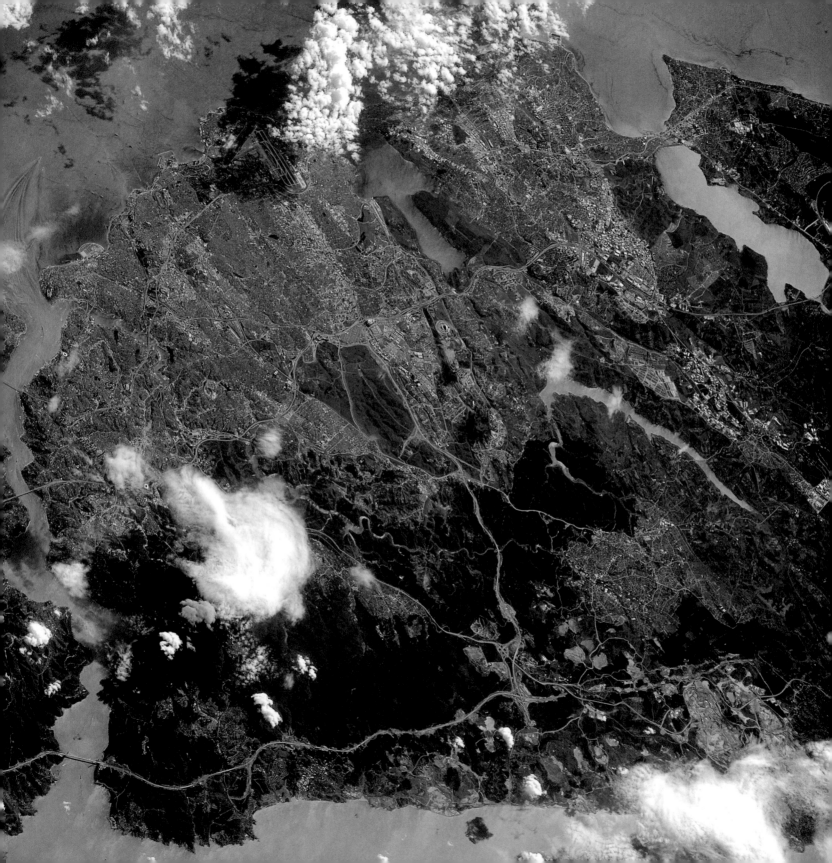

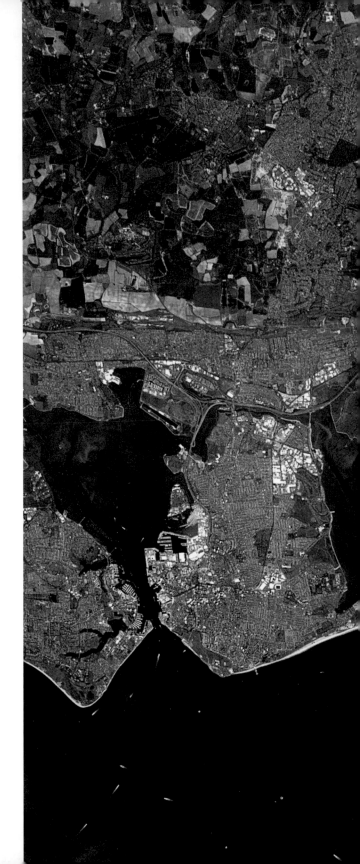

'Home turf – where I grew up (not that I really ever grew up!)'

Portsmouth and Hayling Island are the two islands in the centre of the image. The colourful land mass jutting out into the sea at the right of the picture includes West Wittering on the coastline, and Chichester harbour. Farther north-east going inland, you will see Chichester, my home city.

5 MAY 2016

South Coast, UK

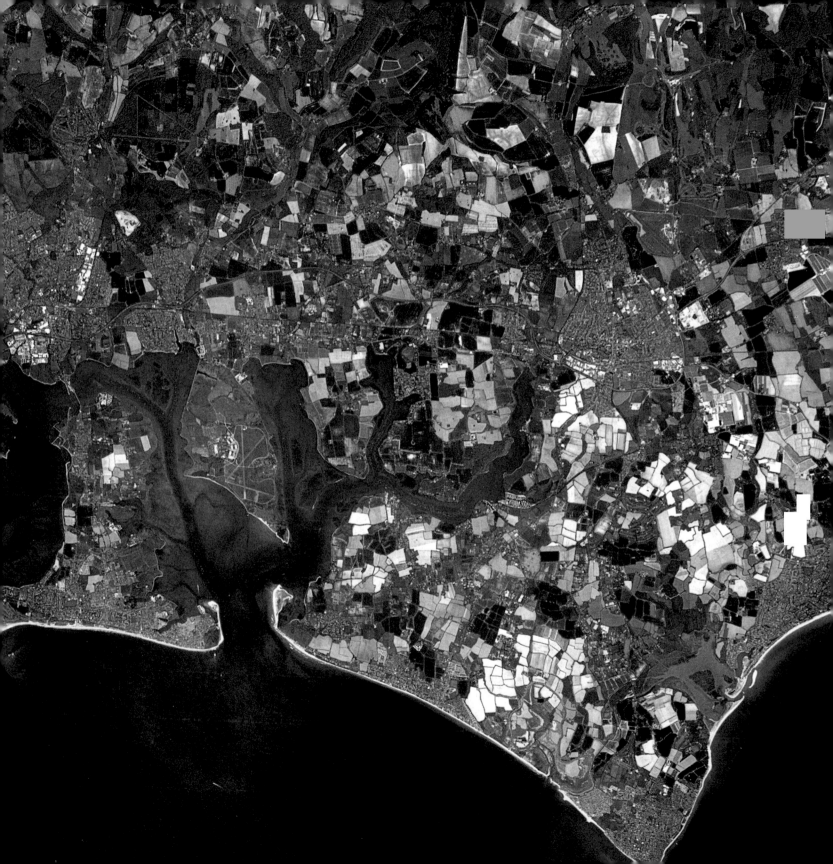

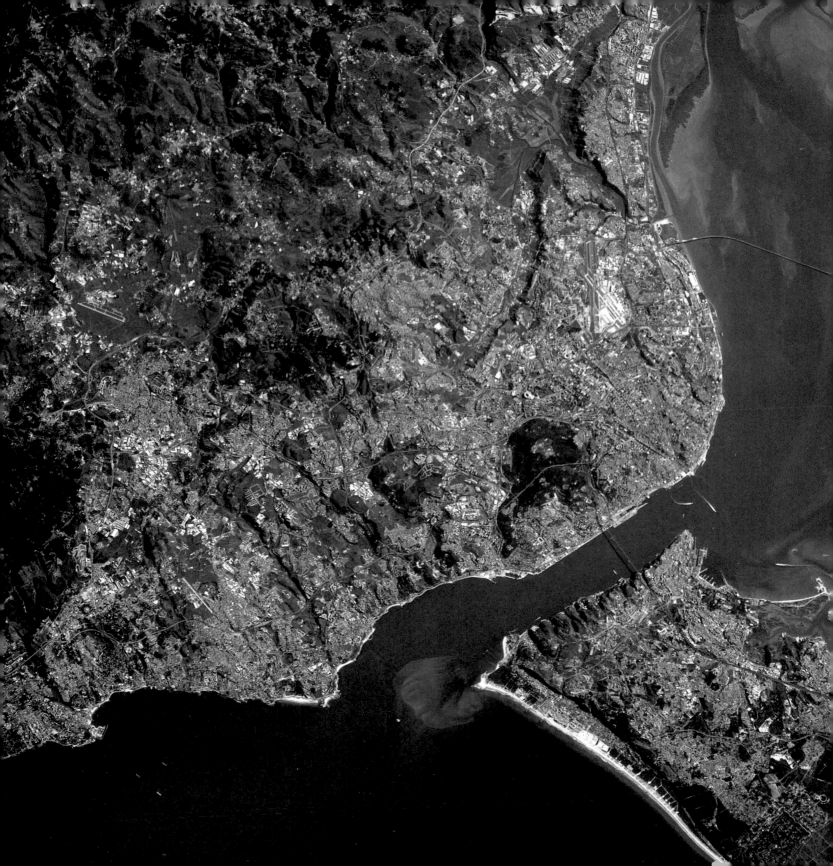

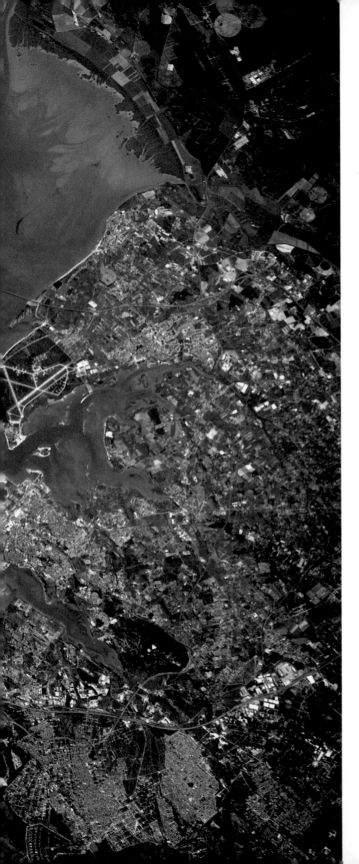

'Lisbon – continental Europe's westernmost capital city.'

Lisbon is one of Europe's leading cruise ports and you can just make out a few boats moving in the harbour. It is also home to Europe's longest bridge – the Vasco da Gama which can be seen spanning the River Tagus.

2 MAY 2016

Lisbon, Portugal

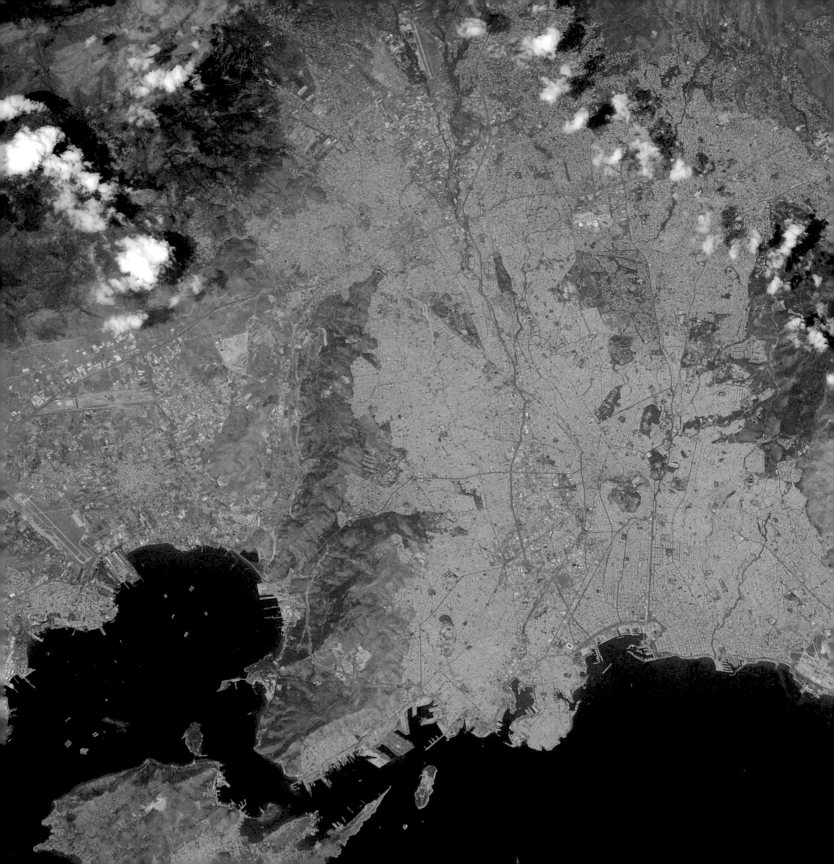

'One of the world's oldest cities – Athens.'

The city of Athens is in the centre of this image, marked by the roads and the densely populated cluster of buildings. Ancient buildings such as the Acropolis cannot be seen with the naked eye from space, but the arid landscape was still evocative to me of the ancients.

11 JUNE 2016

Athens, Greece

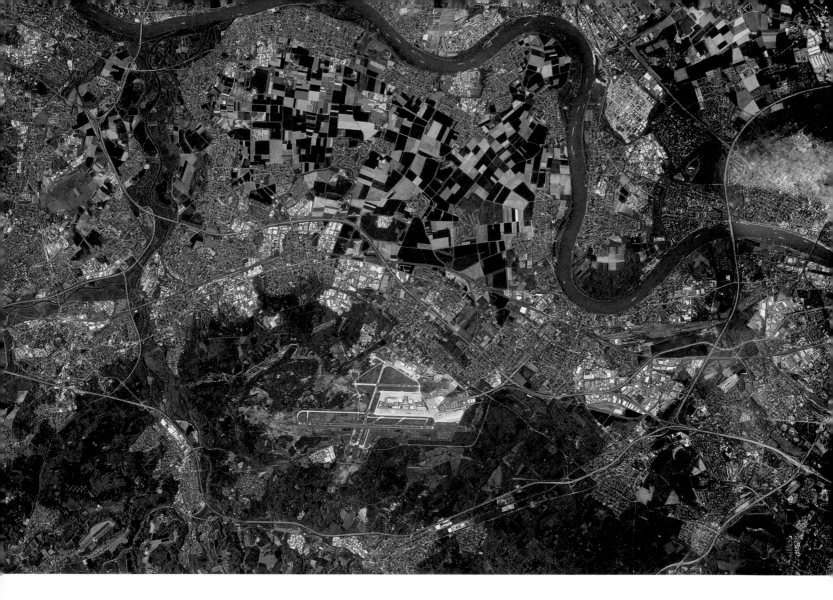

'My Earthly place of work: European Astronaut Centre near Köln-Bonn airport.'

The city of Cologne and north is to the right. Multiple barges can be seen ferrying cargo up and down the Rhine.

2 MAY 2016

Cologne, Germany

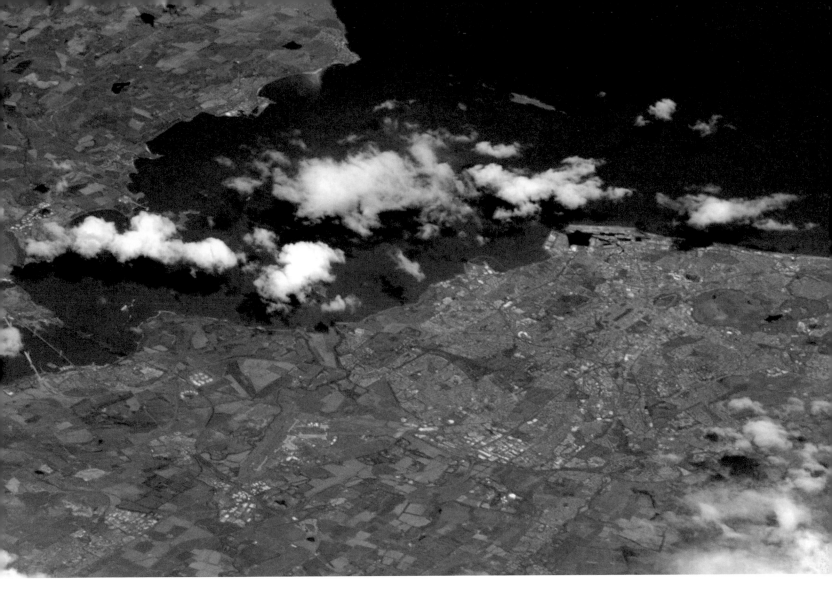

Edinburgh has 112 parks and more trees per person than any other city in the United Kingdom. You can see the difference in the amount of green.

'The great city of Edinburgh catching some good weather today.'

25 APRIL 2016

Edinburgh, Scotland

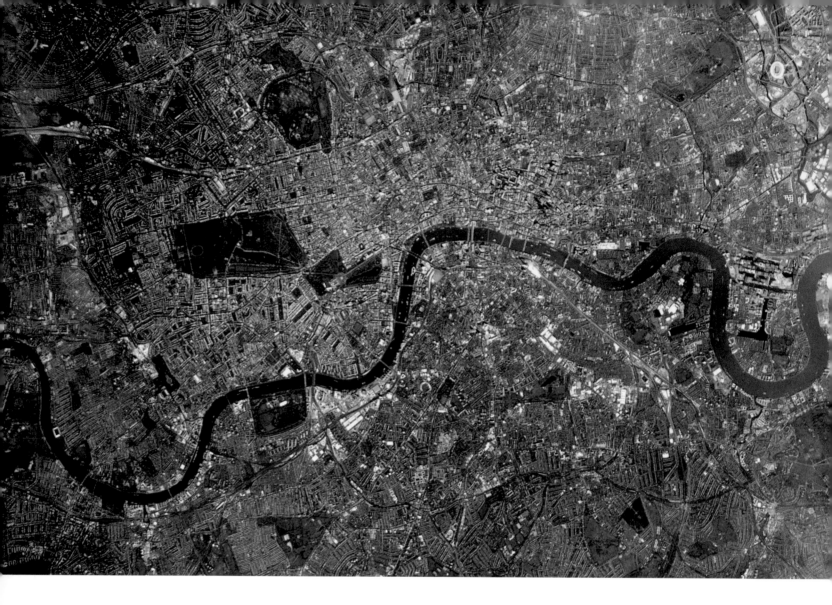

'A superb view of London today.'

London's great parks stand out from above. Look closely to see the distinctive red hue of The Mall leading to Buckingham Palace.

5 MAY 2016

London, England

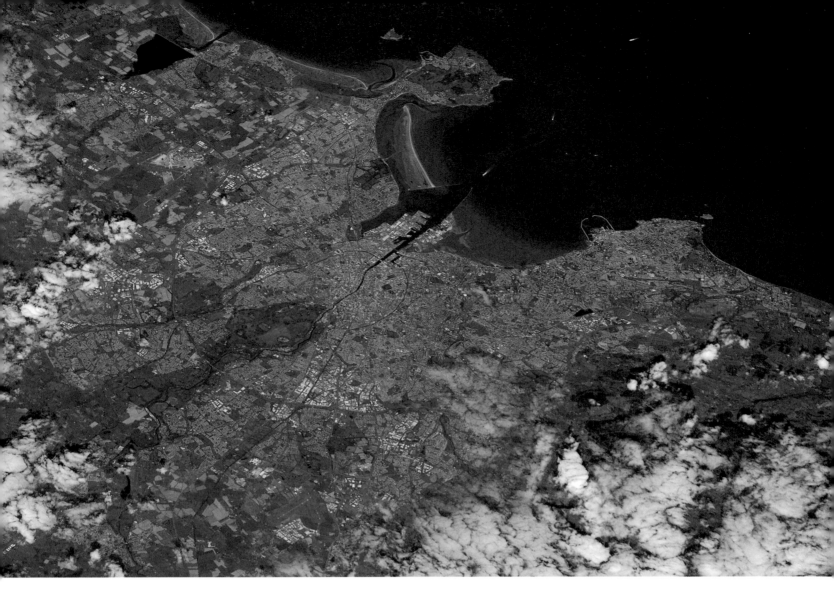

The River Liffey flows
through Dublin's city
centre, past the port and
Bull Island into Dublin Bay.

'Looking good down
there Dublin!'

19 APRIL 2016

Dublin, Ireland

'A sunny UK south coast.'

The Isle of Wight is England's largest island, home to over 140,000 people. The heathland of the New Forest is also clearly visible to the left of the busy port of Southampton (centre).

5 MAY 2016

South Coast, UK

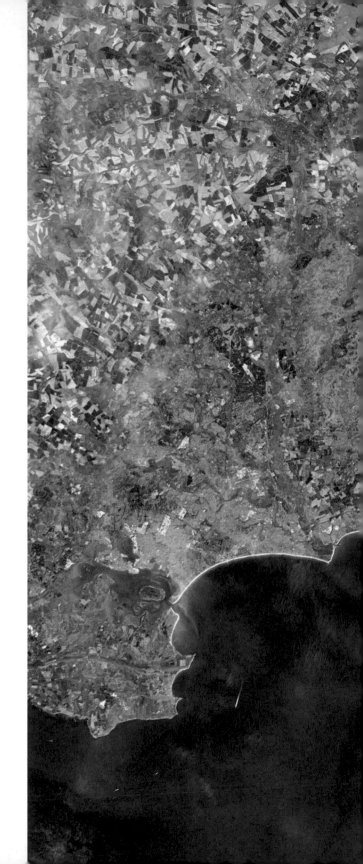

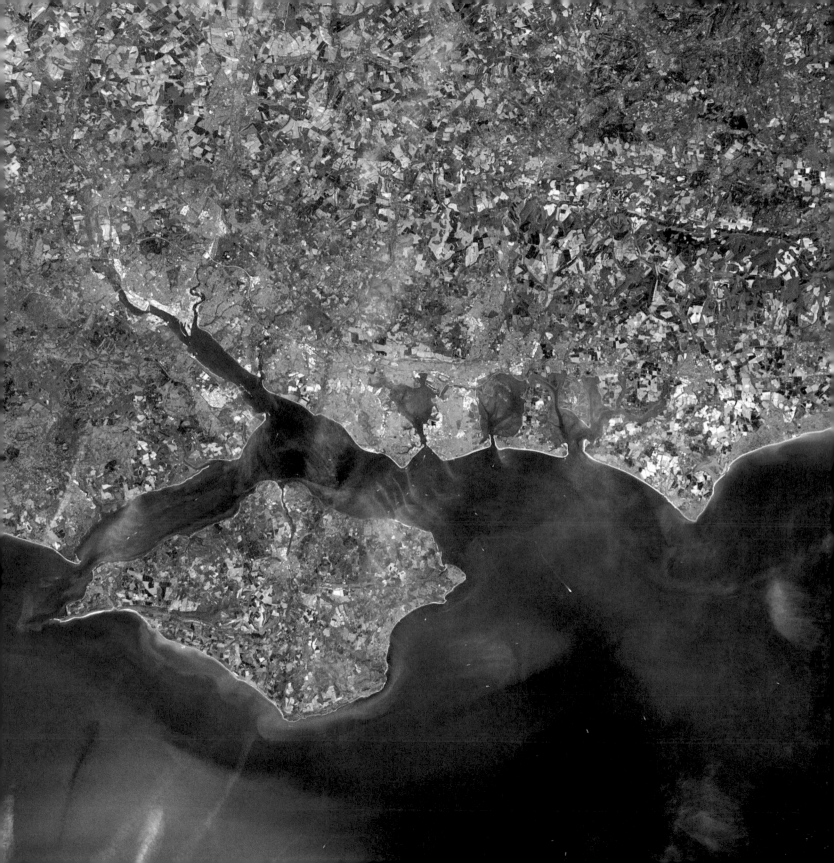

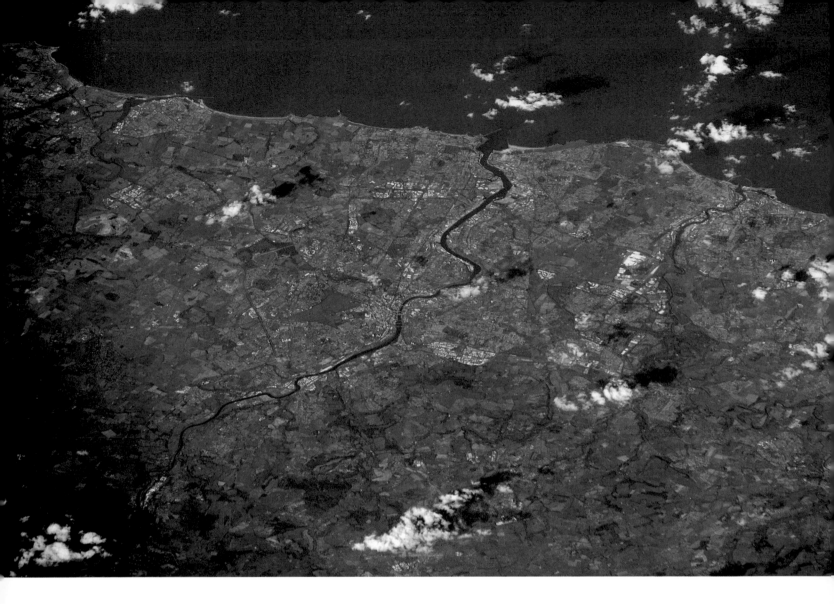

'Good weather over
the Toon today!

**The snaking River Tyne,
which you can see in the
middle of the image,
flows for 100 km into
the North Sea.**

18 APRIL 2016

Newcastle upon Tyne,
England

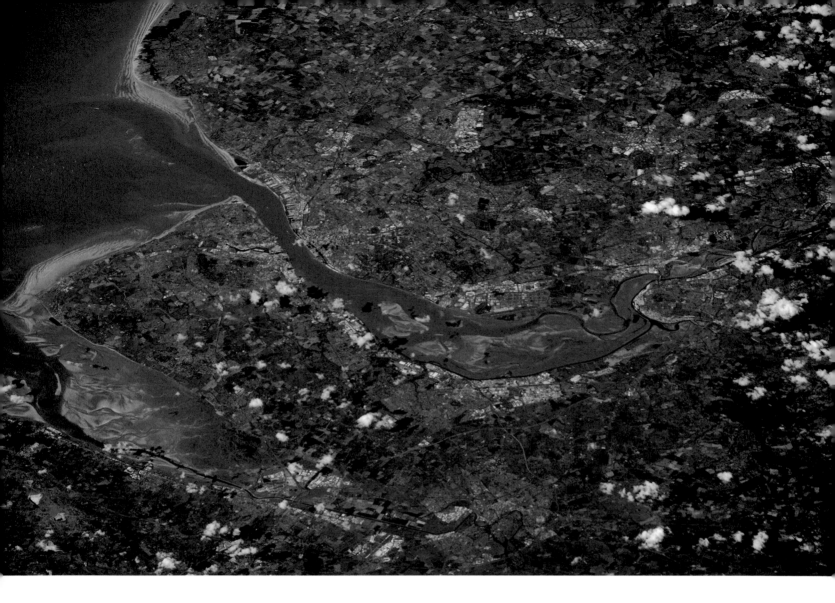

The River Mersey cuts its way through Liverpool's city centre and out into the Irish Sea.

'Liverpool. The Beatles – where it all began.'

SPACE
AND HOME

During my spacewalk it felt intimidating being on the farthest edge of the Space Station with just the vast blackness of space over my right shoulder. There is nothing quite like that dark abyss to make you appreciate just how precious is this rocky planet that we call 'home'.

'Sunglint striking Vancouver Island.'

Taken from over the Gulf of Alaska, you can see the snow-covered mountains of Jasper National Park on the left, the Rockies, and Seattle on the right.

12 MAY 2016

North Pacific Ocean

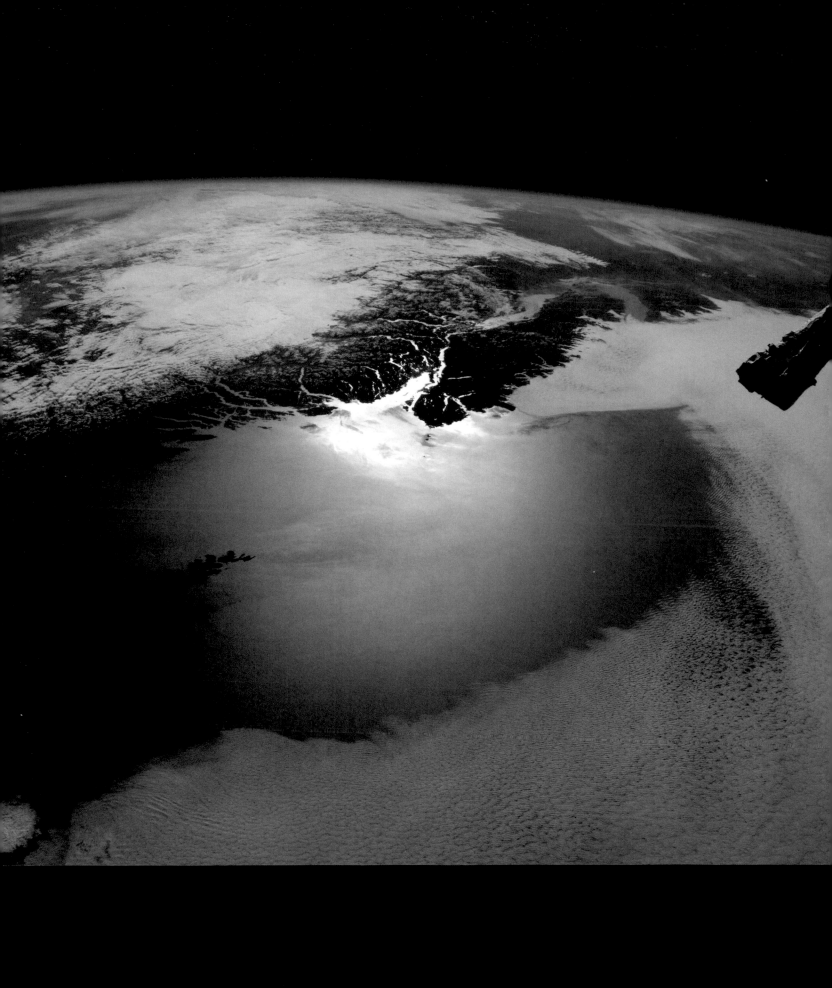

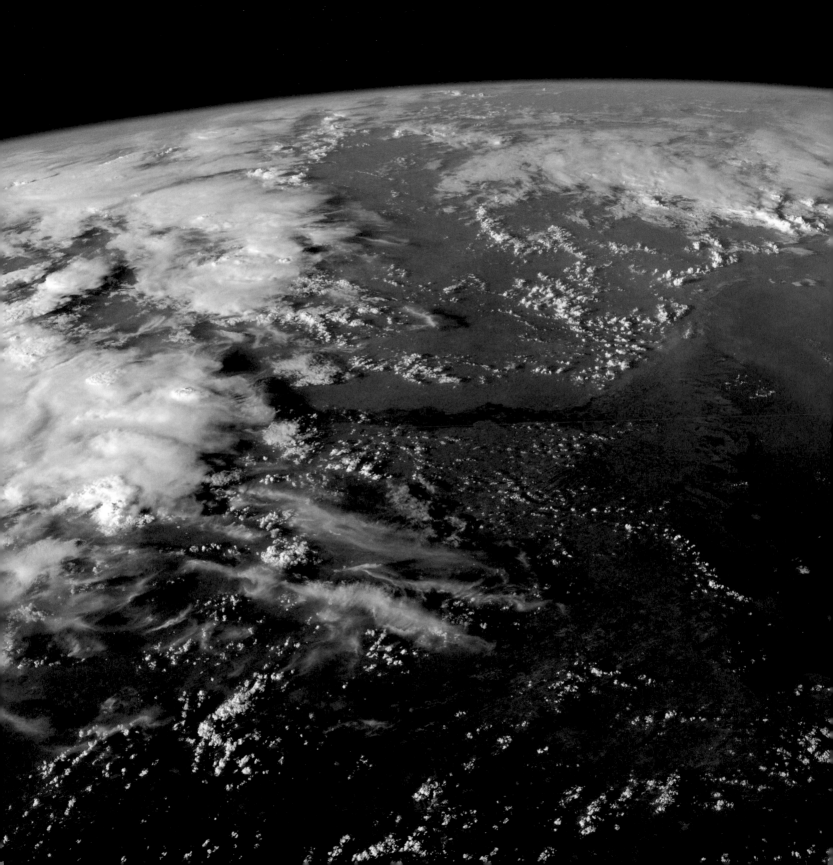

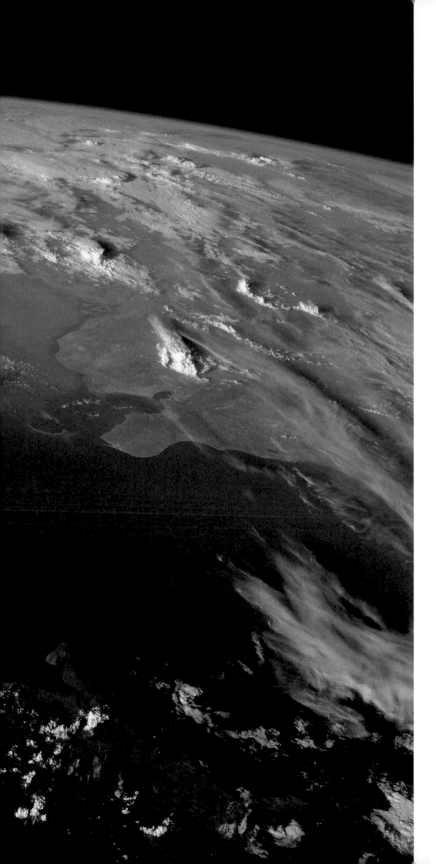

'River Volga spilling out into the Caspian Sea.'

The Volga delta is the largest river delta in Europe. The green regions in the Caspian Sea are a mixture of diluted mud, phytoplankton and algal blooms.

6 JUNE 2016

Astrakhan, Russia

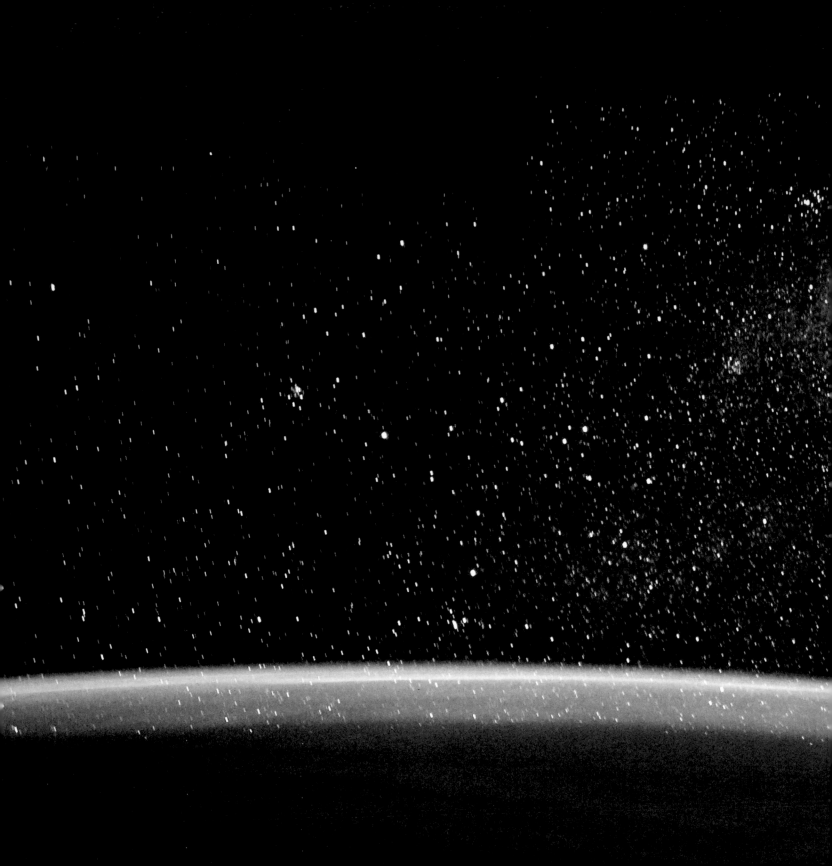

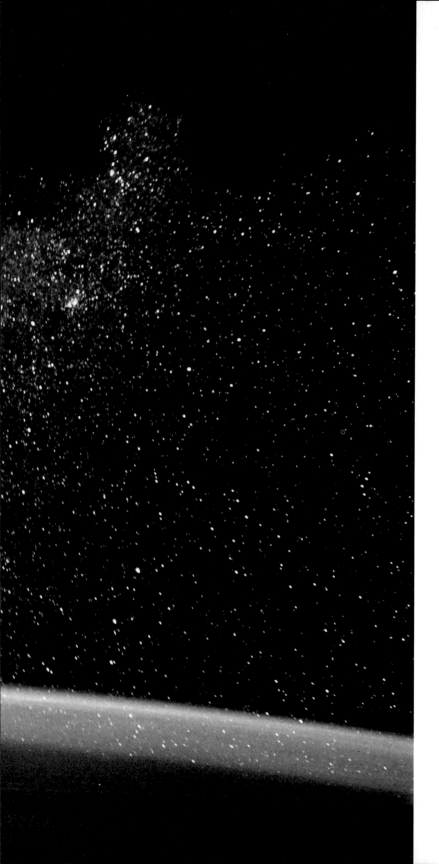

'Milky Way rising . . .'

The phenomenon of 'airglow' in Earth's atmosphere, backdropped by millions of stars and dark clouds of gas in the Milky Way.

6 JUNE 2016

Indian Ocean, off Mogadishu, Somalia

'Gateway to the the Mediterranean.'

The narrow Strait of Gibraltar at the bottom, with Marbella and Malaga on the left, Tangier on the right, looking south over the Atlas mountains with the vast Sahara desert in the distance.

13 MARCH 2016

Cadiz, Spain

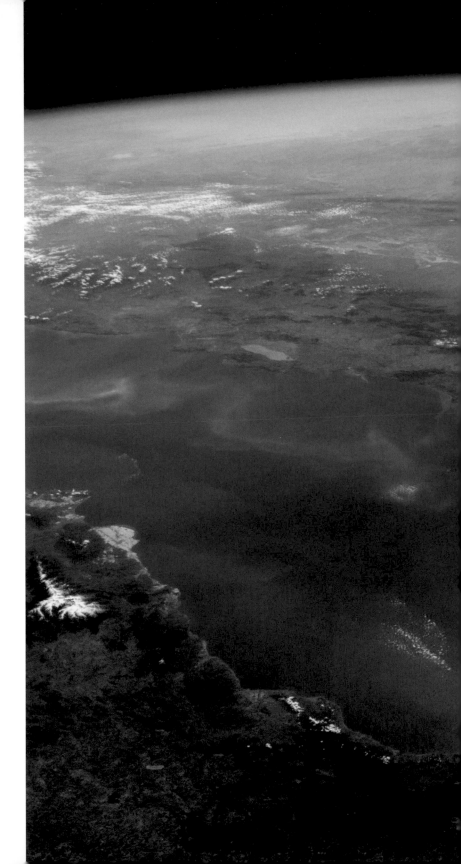

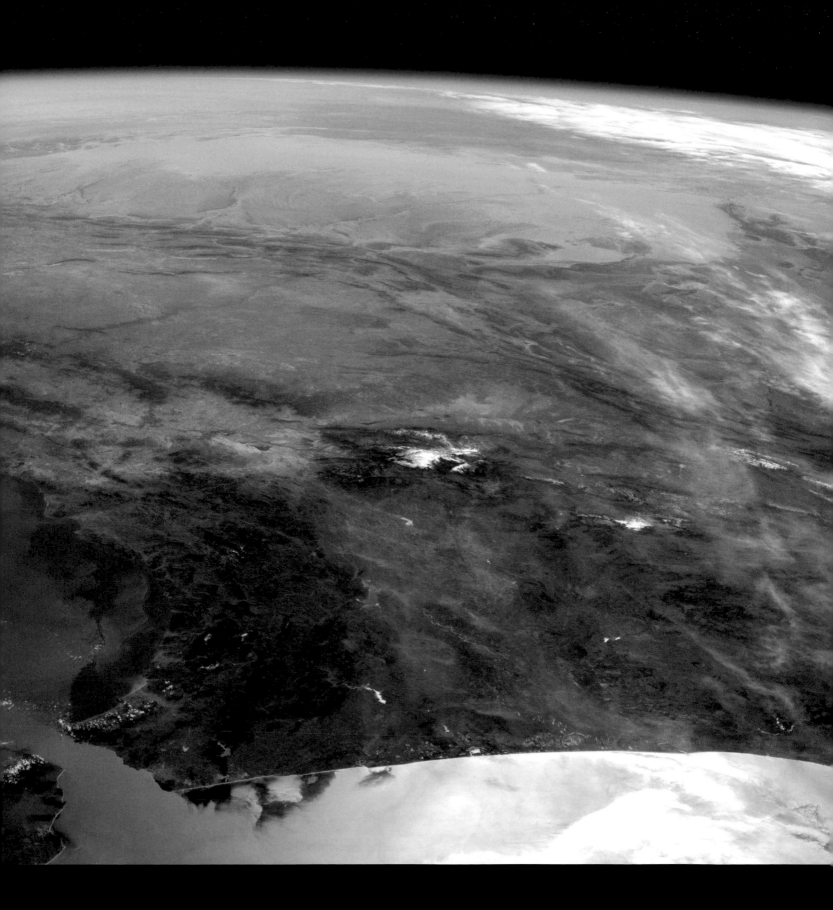

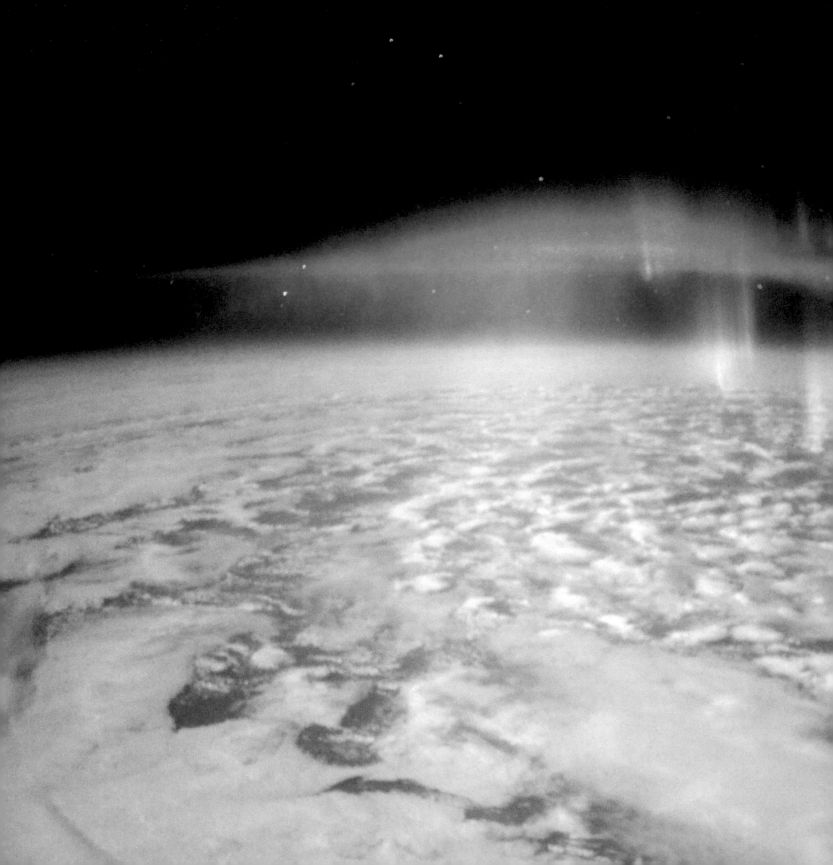

'Thick green fog of aurora.'

The top of the visible aurora can reach up to 400 km – the same altitude as the ISS. It was like flying through a beautiful mist.

23 FEBRUARY 2016

Southern Indian Ocean

Overleaf: A magnificent aurora australis.

12 JUNE 2016

Southern Indian Ocean

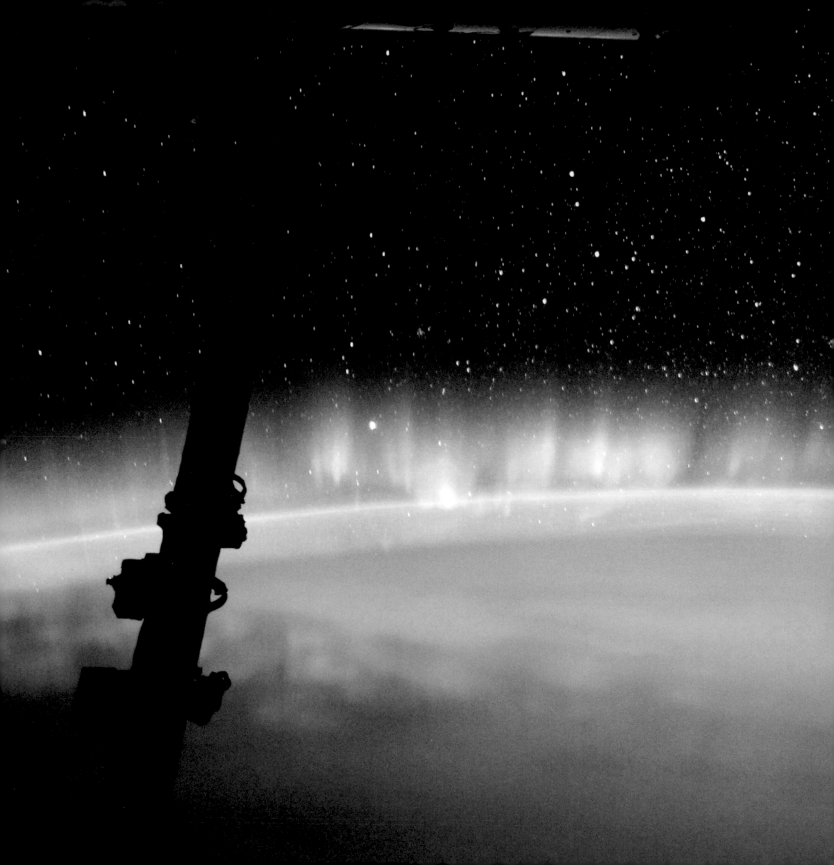

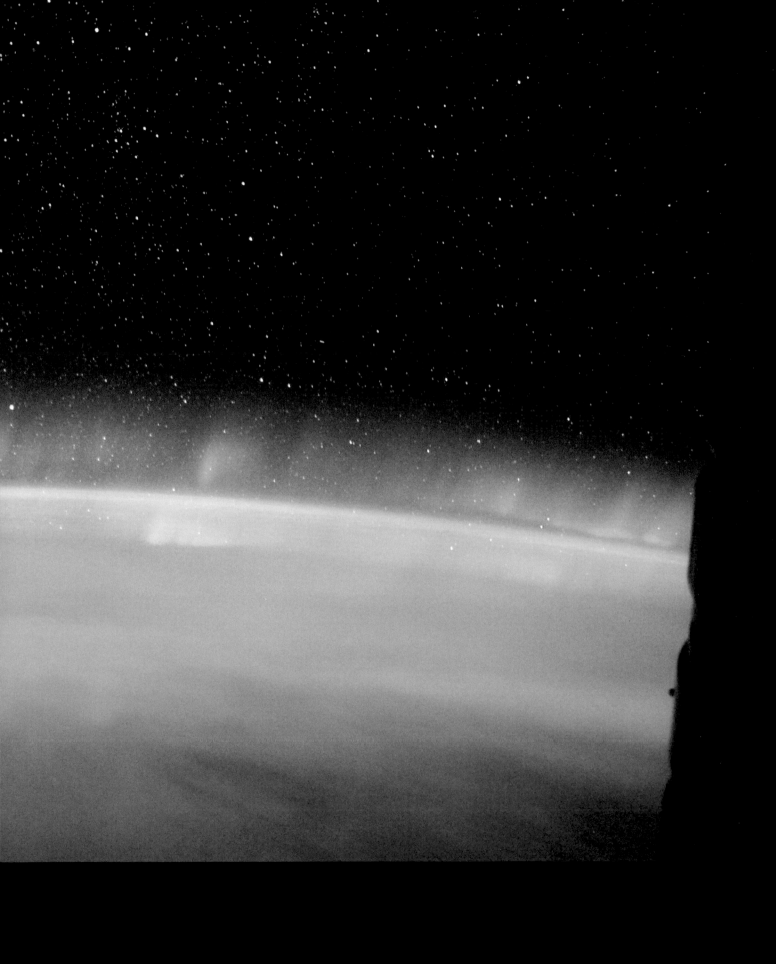

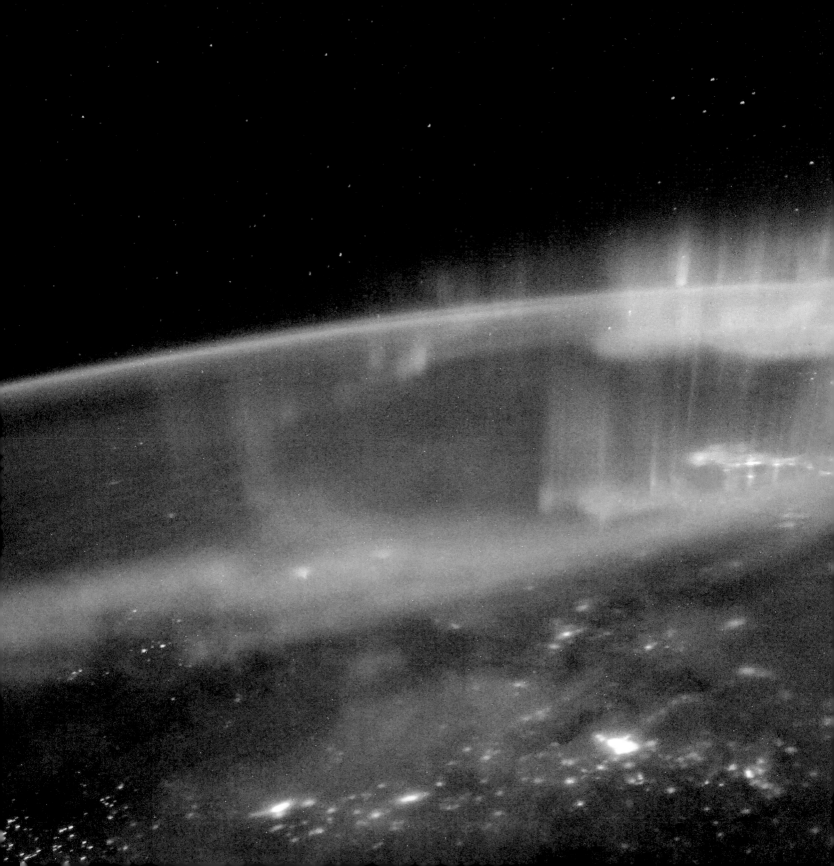

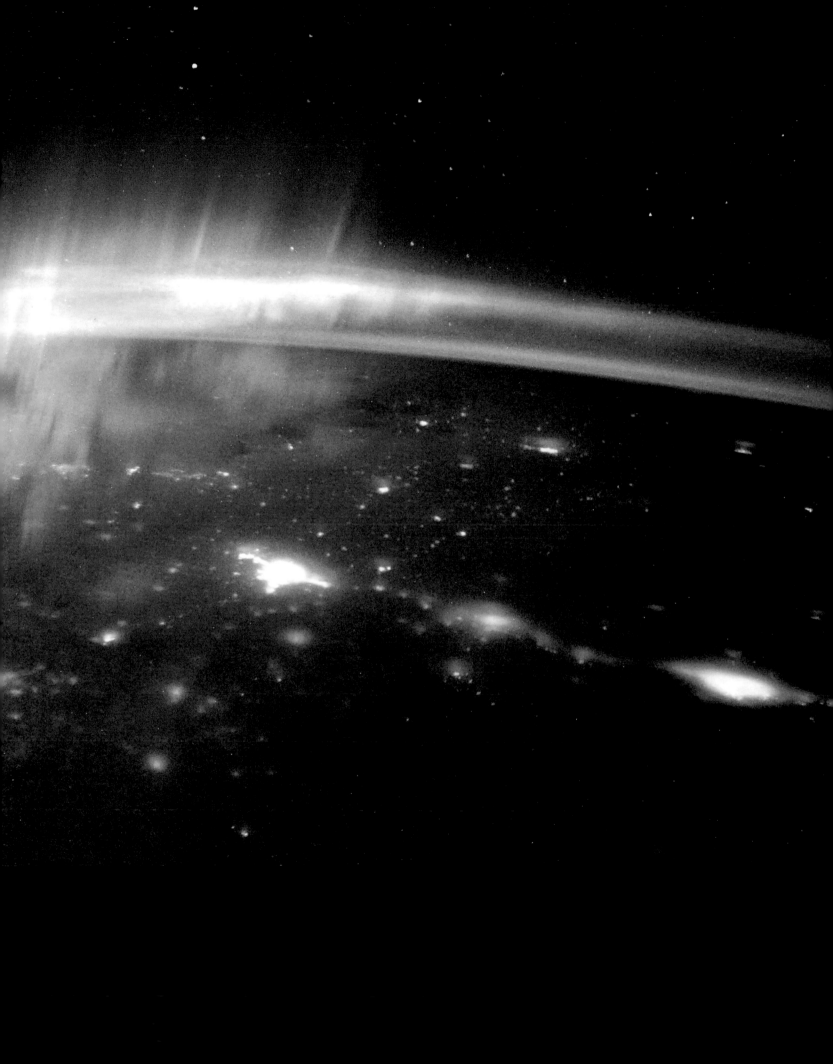

Previous:
The aurora over northern Canada. The red
hue visible is a result of excited atomic
oxygen at higher altitudes and more intense
solar activity.

20 JANUARY 2016

Edmonton, Canada

'Went to close the shutters last
night and saw this amazing
aurora australis.'

17 APRIL 2016

Southern Indian Ocean

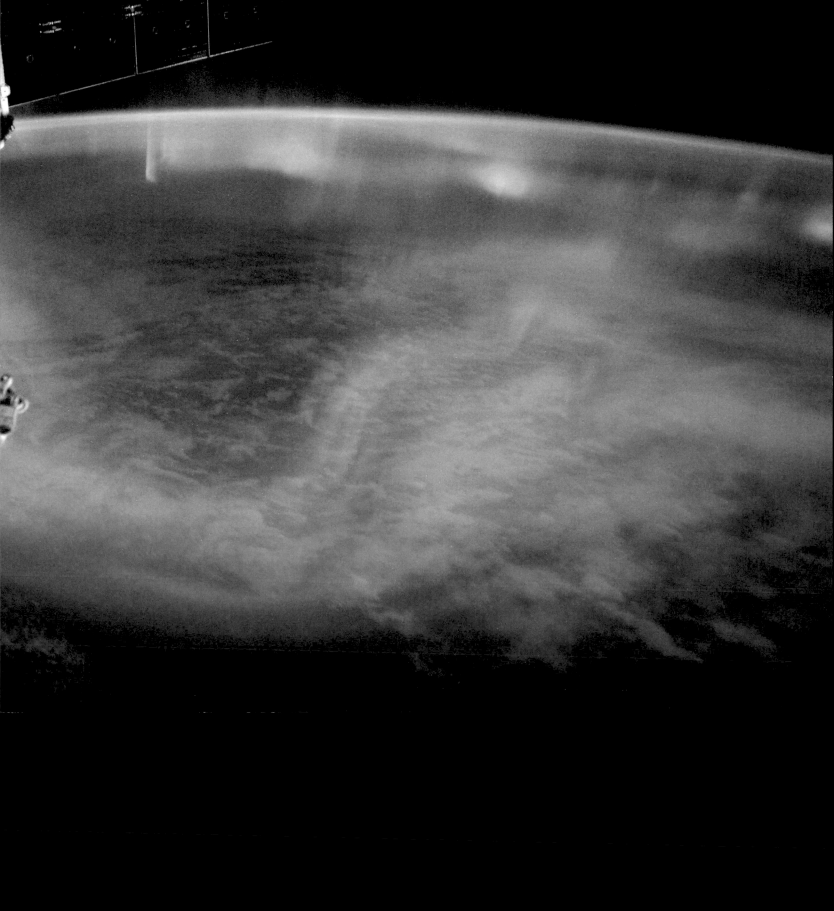

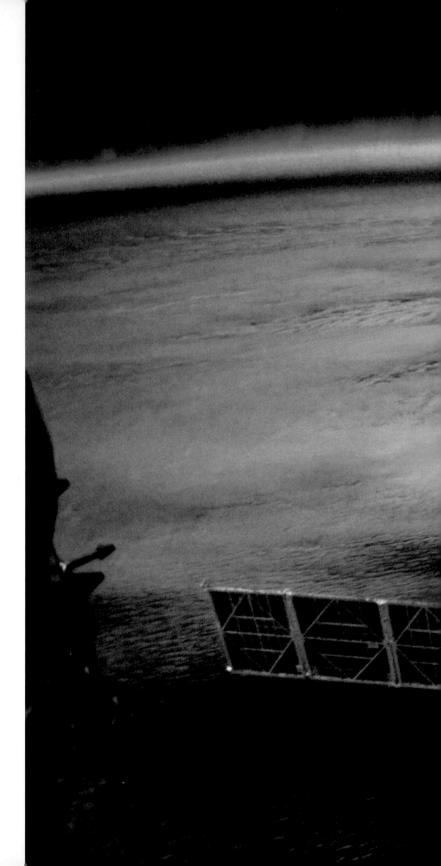

'My ride home.'

Our Soyuz TMA-19M spacecraft looking as good as the day she was launched into orbit. This was our lifeboat for 6 months had we needed to return to Earth in a hurry. The Progress cargo spacecraft (right) is also docked to the ISS and looks very similar to a Soyuz.

26 APRIL 2016

Indian Ocean

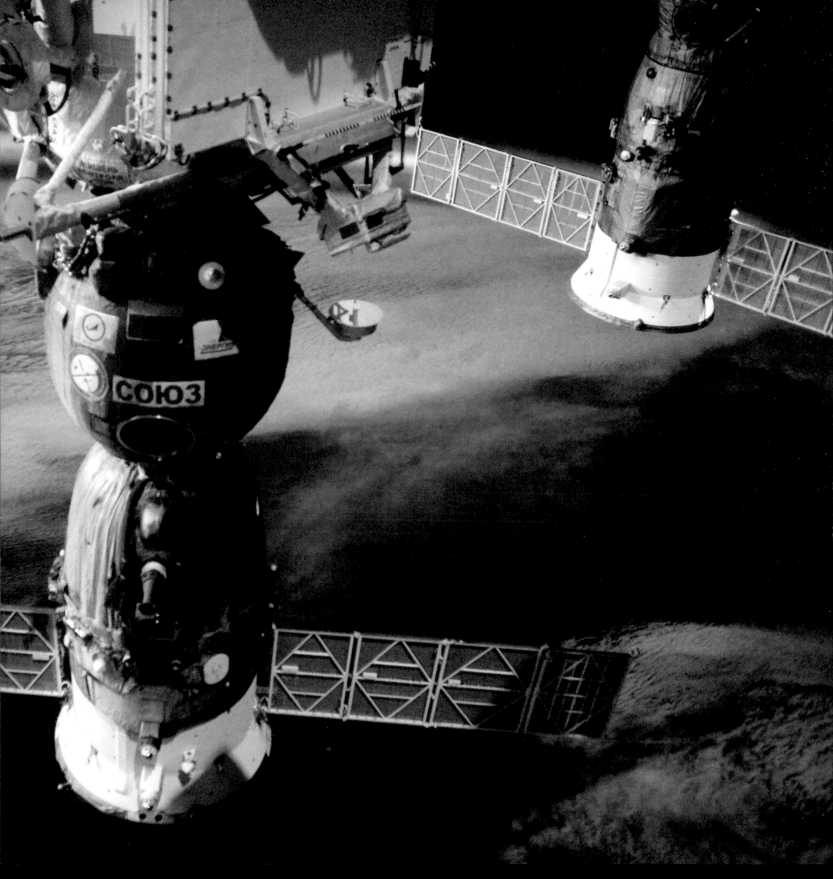

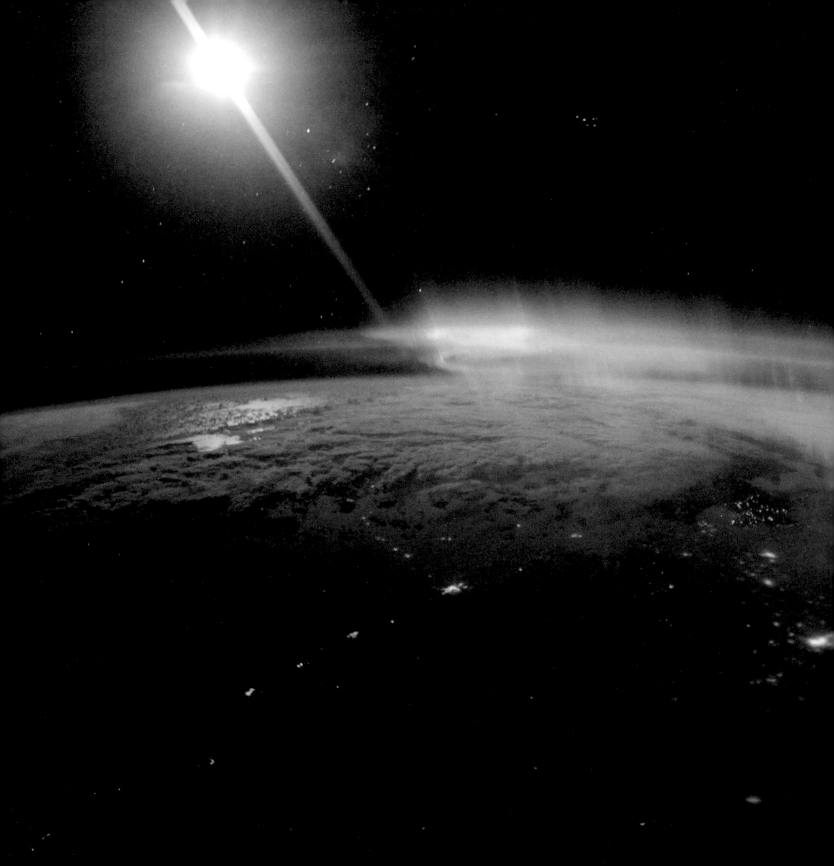

'Magical aurora.'

Moonlight reflected in the ISS solar panels as an aurora dances over northern Canada.

20 JANUARY 2016

Calgary, Canada

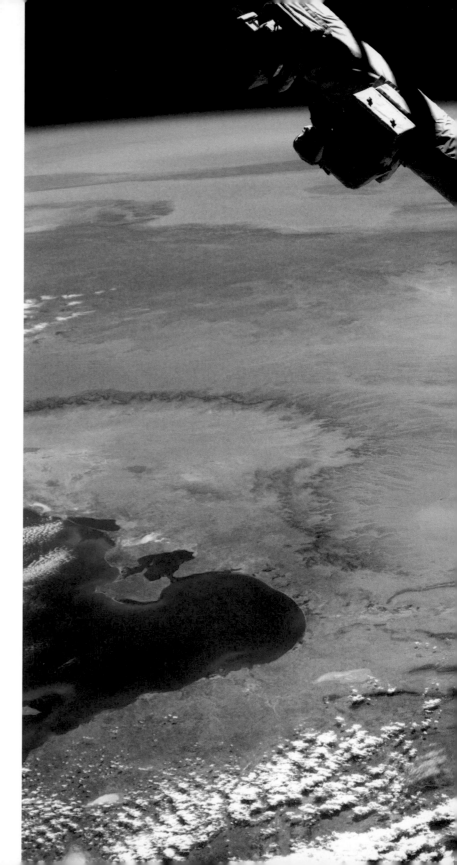

'I never imagined a desert could look so magnificent.'

Taken over Tunisia, looking south-east towards Libya. The ISS robotic arm in the foreground is extended ready for cargo vehicle operations.

6 MARCH 2016

Tunisia, Africa

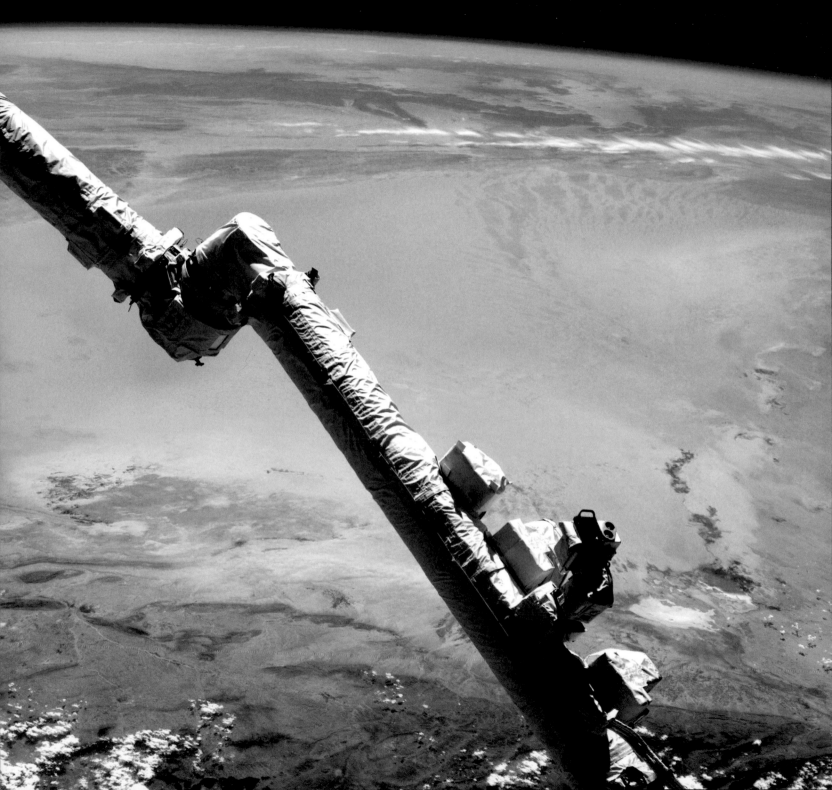

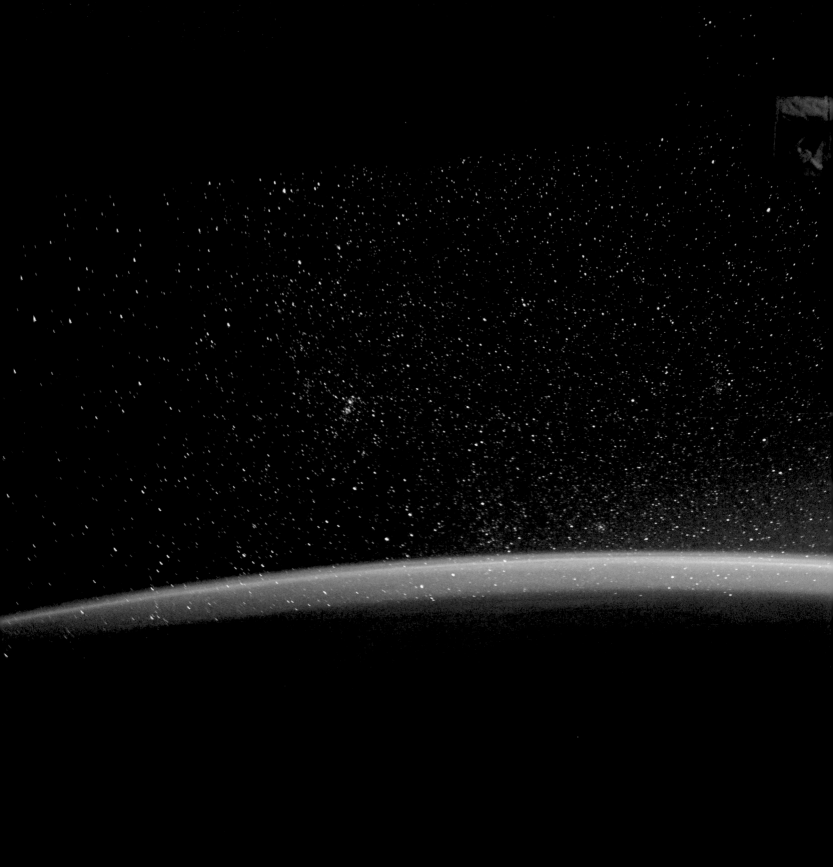

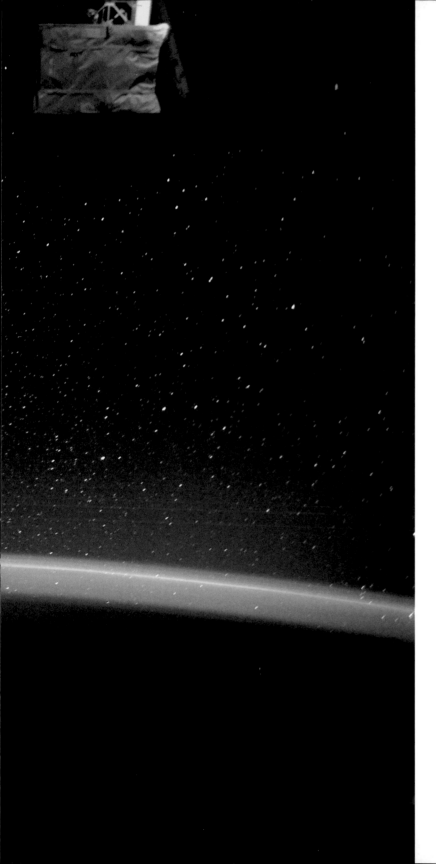

'Listening to Coldplay's *A Sky Full of Stars*... it sure is!'

Sometimes the stars were so bright it was hard to make out familiar constellations.

6 JUNE 2016

Indian Ocean, off Mogadishu, Somalia

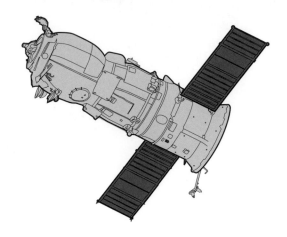

'So excited to watch Progress ride into orbit today… right beneath us!'

This is the exhaust plume from the launch of the Progress MS-02 spacecraft from the Baikonur Cosmodrome in Kazakhstan. It's carrying fuel, water and supplies for our six-person crew on the Space Station.

31 MARCH 2016

Karaganda, Kazakhstan

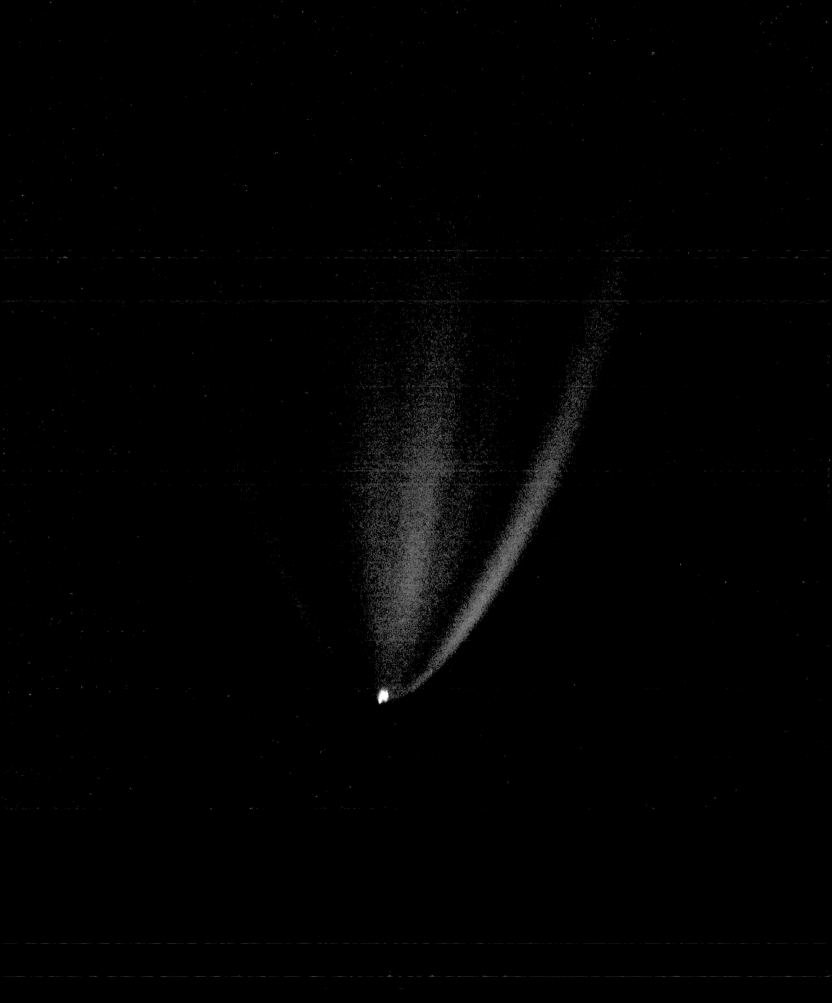

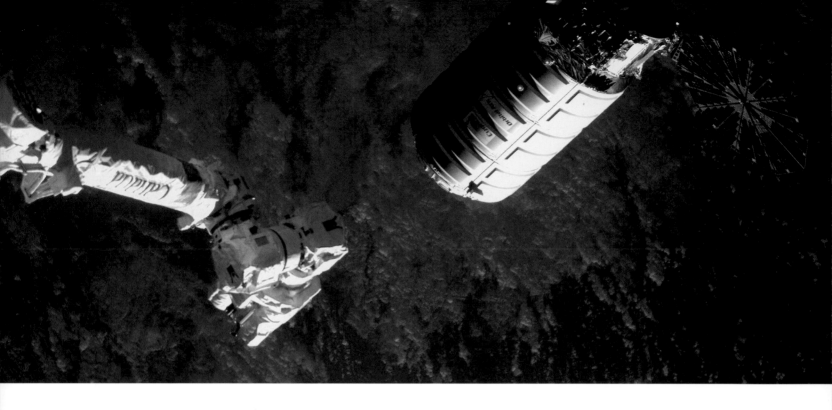

'Cygnus OA-6
resupply spacecraft
approaching the
ISS – nearly ready
for capture.'

26 MARCH 2016

Cordoba, Argentina

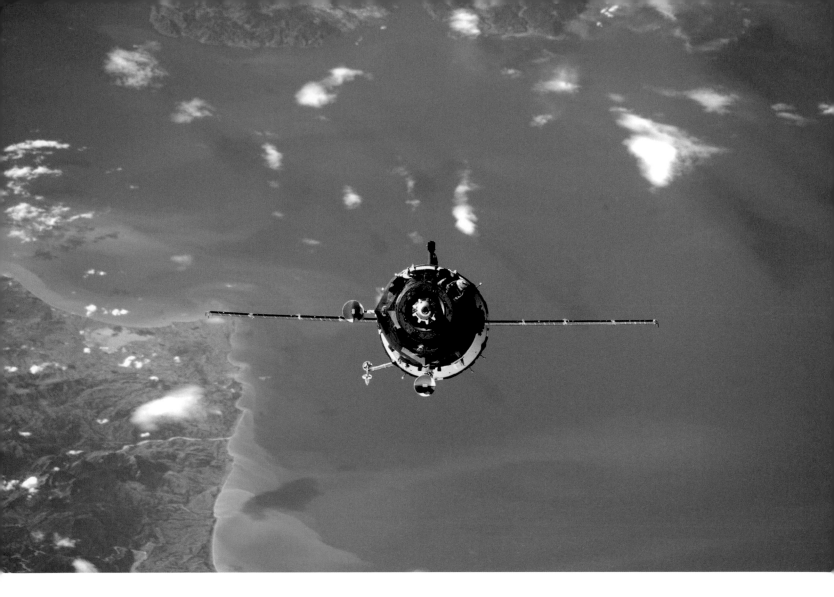

Christchurch, New Zealand

Seen over the Cook Strait, between north and south islands of New Zealand, the Soyuz TMA-20M spacecraft is arriving at the International Space Station. Wellington is at top left.

'Congratulations on a successful launch Alexei, Oleg and Jeff - welcome to space!'

'This cloud looks
good enough to surf!'

**Image taken at sunset and just
prior to crossing the terminator
from day into night.**

Maine, USA

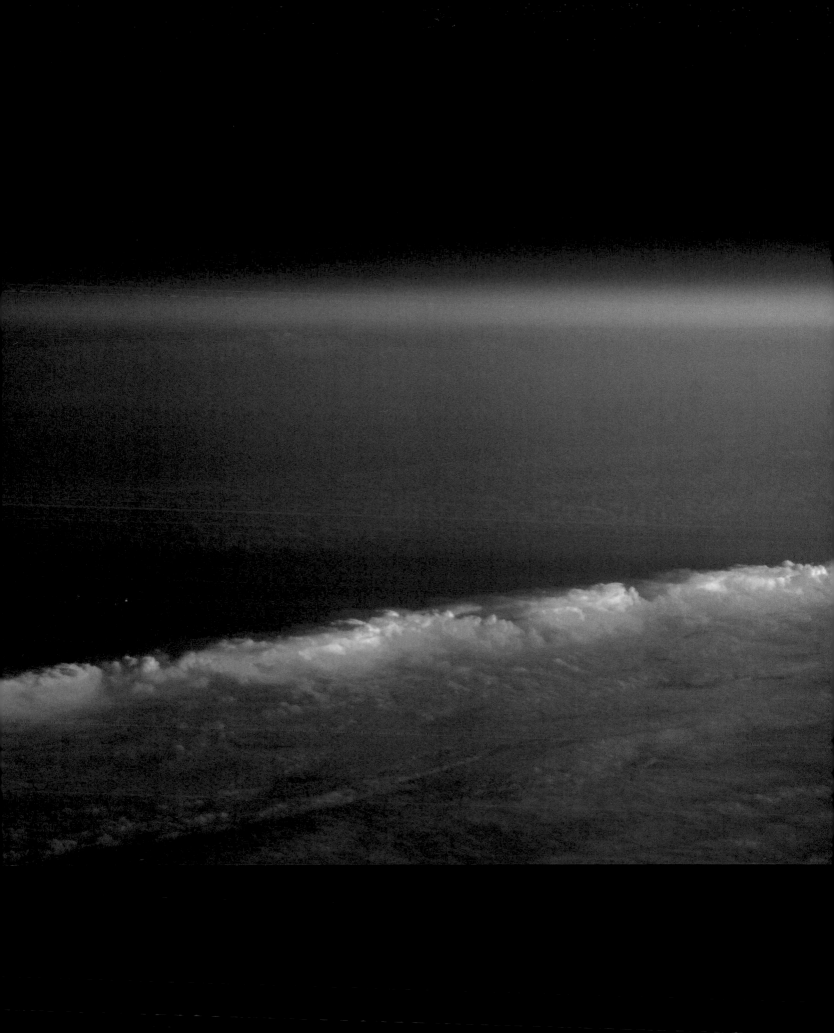

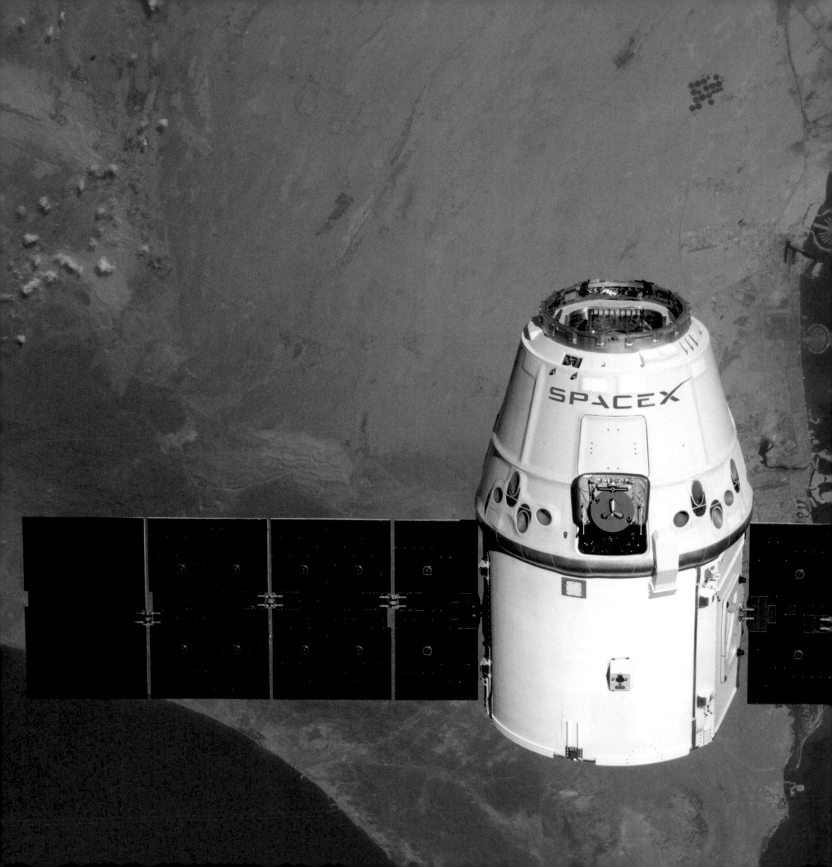

'Dragon photobomb.'

I had been waiting to get a pic of The Palms, Dubai, and then this happened just prior to capture. A few moments later I was at the controls of the Station's robotic arm to capture SpaceX CRS-8 and her valuable cargo.

10 APRIL 2016

Dubai, United Arab Emirates

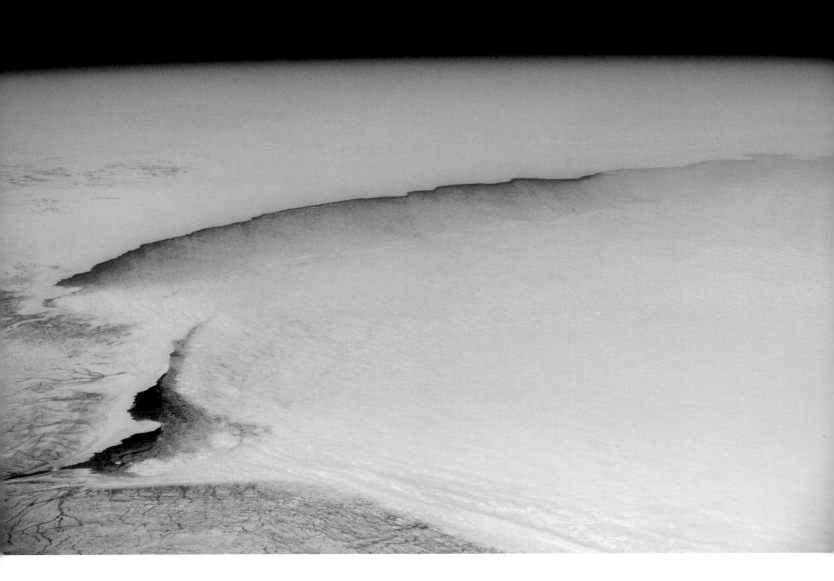

'Sea ice finally starting to melt in the Hudson Bay.'

24 APRIL 2016

Ontario, Canada

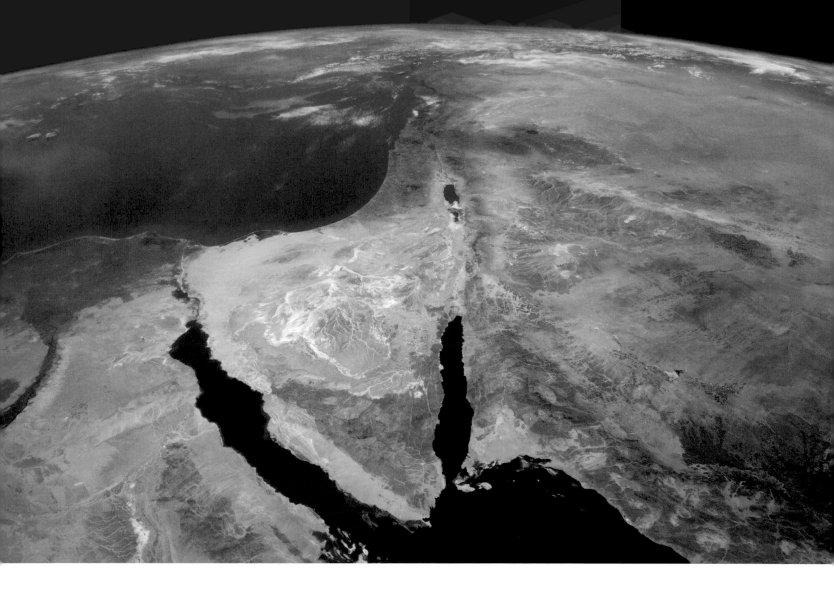

12 MAY 2016

Sharm El Sheikh, Egypt

Visible here are the eastern Mediterranean, the Nile Delta, the Sinai Peninsula, the Gulfs of Suez and Aqaba, and the Dead Sea. Turkey and Cyprus are at the top.

'The rugged landscape of Sinai and the Syrian desert.'

225

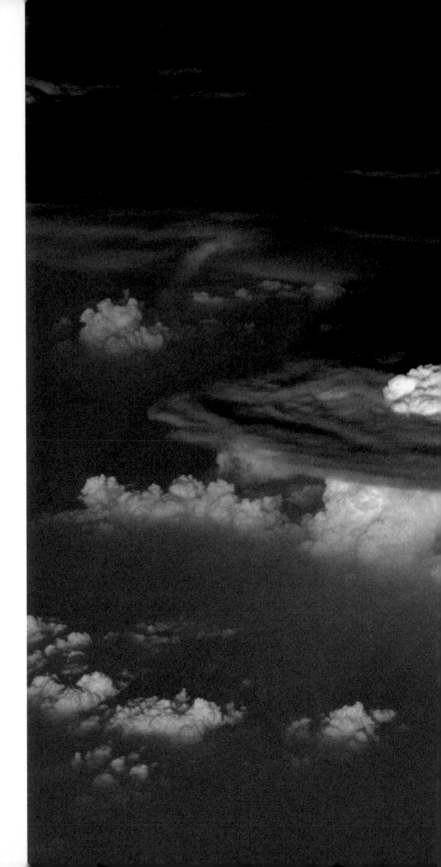

'I'm guessing there was
an impressive storm
going on under that
cumulonimbus cloud!'

3 APRIL 2016

Rajasthan, India

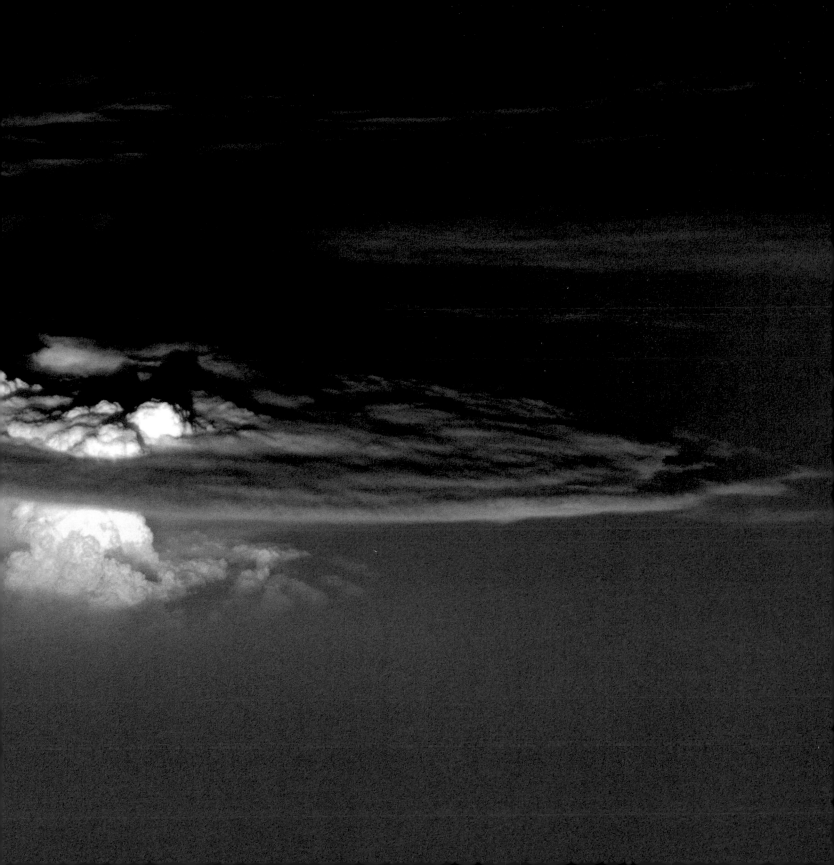

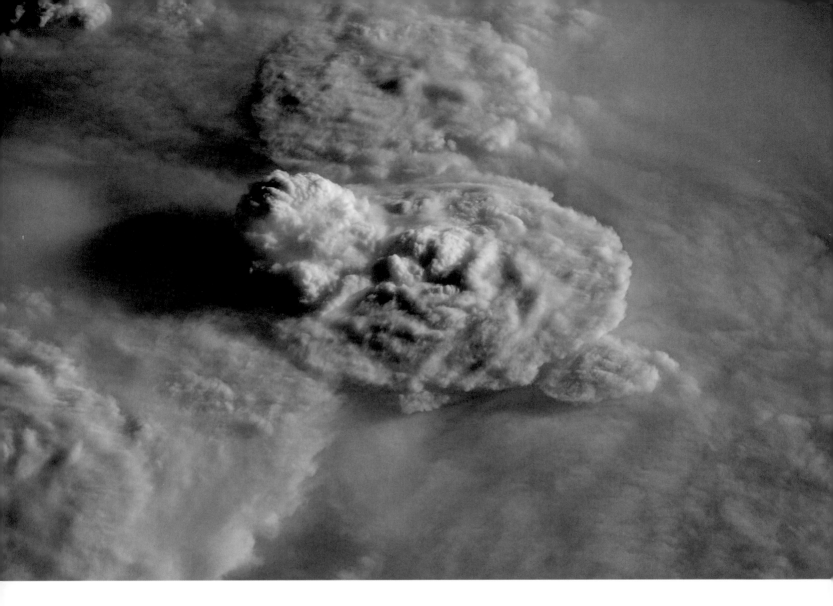

'Moody looking clouds building over Madagascar.'

23 APRIL 2016

Madagascar

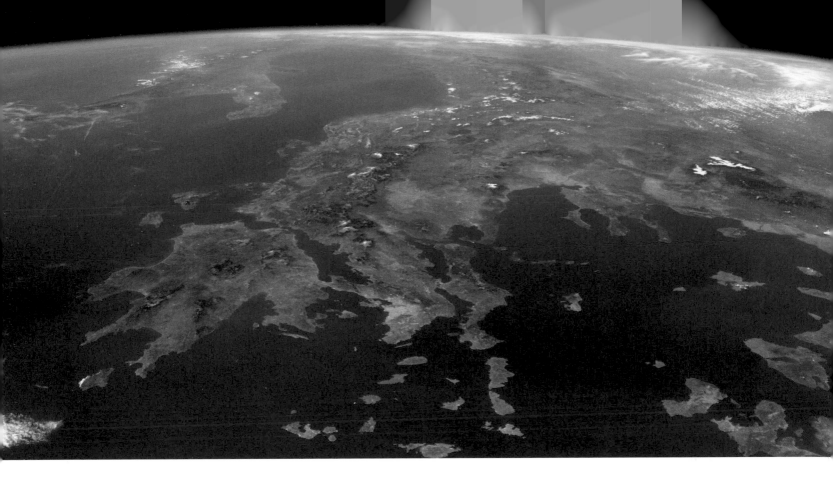

View looking north-west across the Mediterranean, with the Peloponnese and Athens in foreground, the Adriatic Sea and Italy and Albania at the top.

'Lovely view of the Greek islands.'

15 APRIL 2016

Crete, Greece

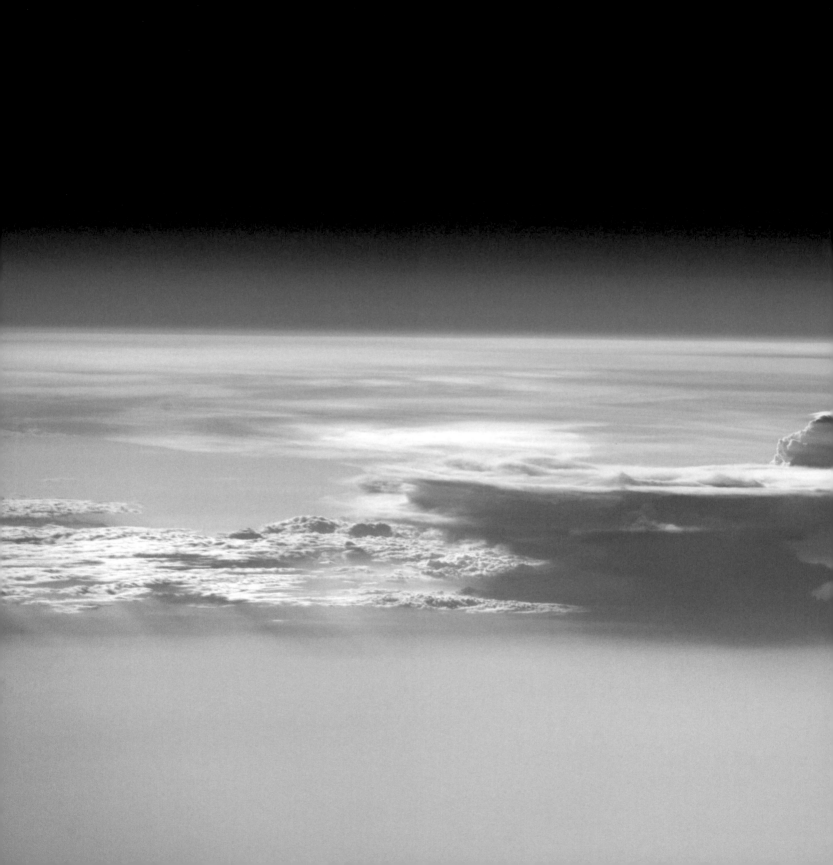

'Our orbit is giving us a very low sun angle right now – great for admiring cloud formations!'

28 MAY 2016

Indian Ocean

'Great to see DIWATA-1, the first Filipino microsatellite, launched today from the Space Station.'

This 50 kg microsatellite was developed by scientists in the Philippines and Japan to provide satellite images for environmental monitoring and meteorological applications.

27 APRIL 2016

North Atlantic Ocean

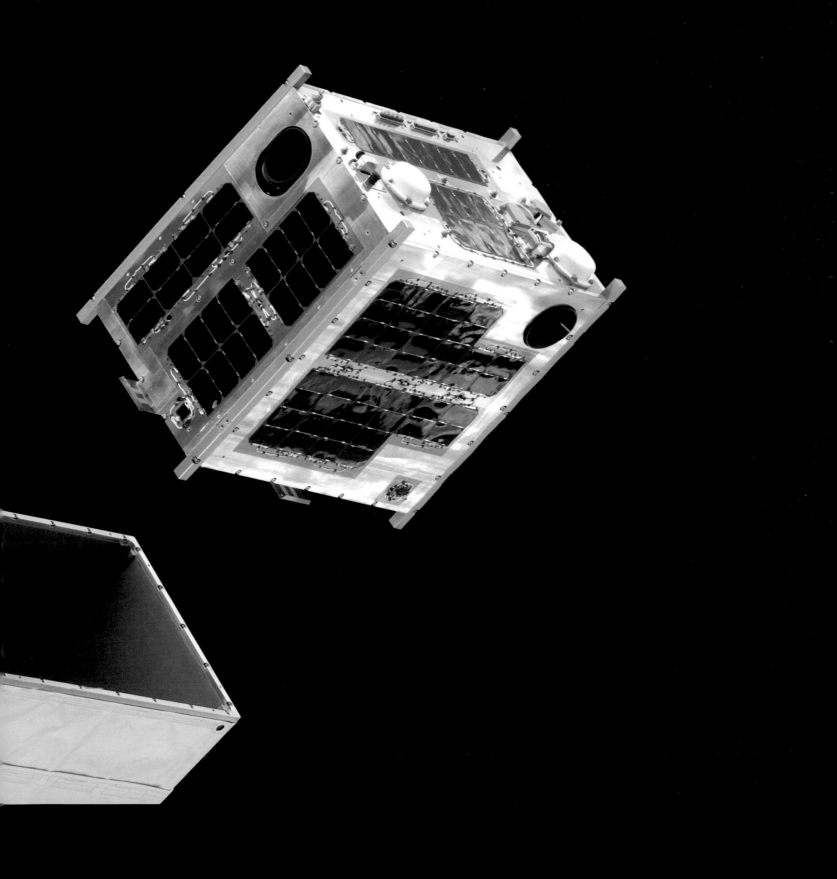

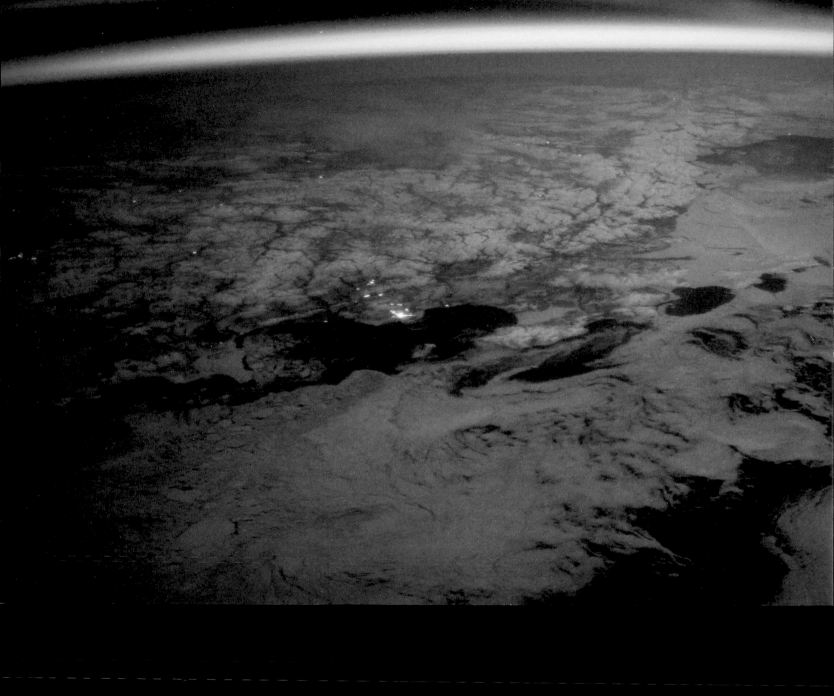

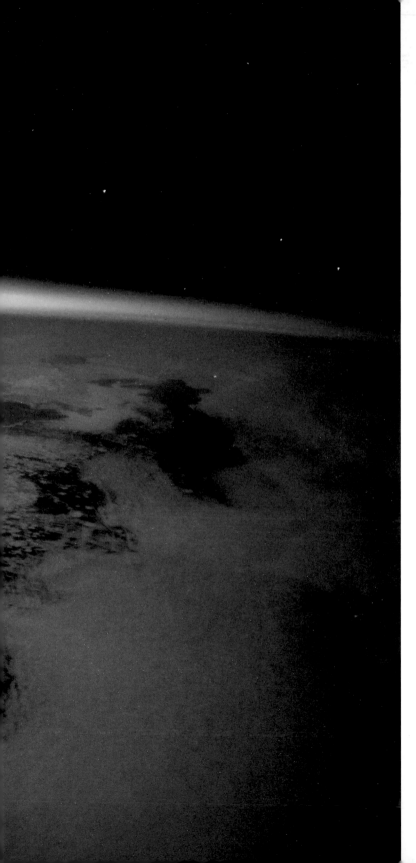

The city lights of Magadan, Russia, on the coast of the Sea of Okhotsk, with the Kolymar mountains behind.

25 MARCH 2016

Sea of Okhotsk, Russia

'Time to put on some weight! What an incredible journey it has been.'

Principia Expedition 46/47: 15 December 2015 – 18 June 2016

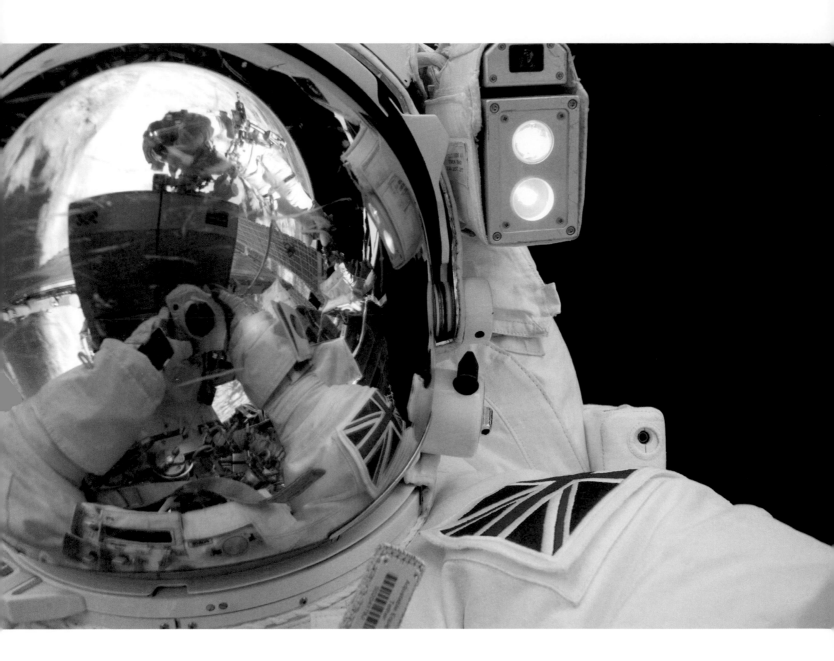

TIM PEAKE is a European Space Agency (ESA) astronaut. He finished his 186-day Principia mission working on the International Space Station for Expedition 46/47 when he landed back on Earth on 18 June 2016.

Tim attended Chichester High School for Boys. During this time he was also a member of the combined cadet force before joining the Army as an Army Air Corps Officer. He has over 3000 flying hours and has flown more than 30 different types of helicopter and fixed-wing aircraft.

Tim is married with two sons. Among his leisure activities he enjoys skiing, scuba diving, cross-country running, climbing, mountaineering and he completed the London Marathon (on Earth) in 1999. His interests include quantum physics and aviation. Tim is an ambassador for UK science and space-based careers and is working with the UK Space Agency in developing the UK's microgravity research programme. He is a Fellow of the Royal Aeronautical Society and a member of the Society of Experimental Test Pilots. Tim is also an ambassador for the Prince's Trust. In the Queen's Birthday Honours, Tim was made a Companion of the Order of St Michael and St George, an award given to those who have given distinguished service overseas, or, in Tim's case, in space.

This is his first book.

Acknowledgements

This book would not have been possible without the help and support of many people. In particular, I'd like to thank Katrina Willoughby and Steven Berenzweig at NASA for their patient instruction, crewmates Scott Kelly, Tim Kopra and Jeff Williams for sharing their on-board advice, and Max Alexander for helping me find a good eye for a picture. A huge part of this journey was about sharing my images with the public and receiving such encouraging feedback. For that I'd like to thank the communications team at the European Space Agency, notably Julien Harrod – my social media guru. Rosita Suenson, Carl Walker, Ben Brusey, Neil Bradford, David Eldridge and the team at Penguin Random House did an amazing job producing this book in record time. Finally, thanks go to my wife, Rebecca, for giving me strength, encouragement and enduring support at every step of the way.

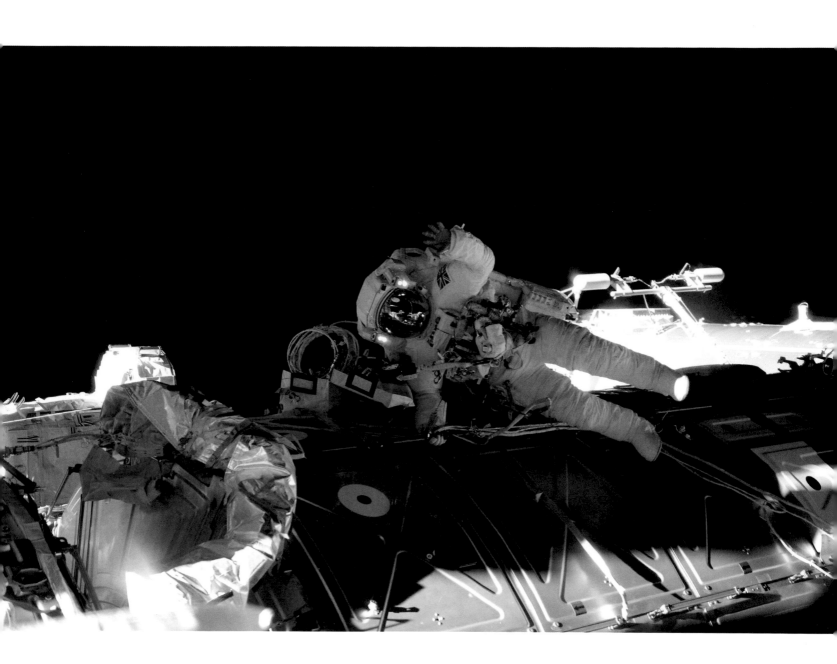

Picture List

Page 2. Selfie, Spacewalk; Page 6. Sunrise; Page 8. Cupola, International Space Station; Page 11. Cupola, International Space Station; Page 12. Detail, International Space Station; Page 17. Italy; Page 18/19. Dawn; Page 20/21. Sunrise 2; Page 22. Sunrise 3; Page 23. Egypt; Page 24/25. Sunrise 4; Page 26/27. English Channel; Page 28. United Kingdom; Page 30/31. London, England; Page 32/33. Australia; Page 34/35. Kiribati; Page 36/37. Algeria; Page 38/39. Italy; Page 40. Moonset; Page 42. Waxing Gibbous Moonset; Page 44 & 45. Gulf of Thailand; Page 46/47. Moscow, Russia; Page 48/49. Rio de Janeiro, Brazil; Page 50/51. India; Page 52/53. Dubai, United Arab Emirates; Page 54/55. Kyrgyzstan; Page 56/57. Mozambique Channel; Page 58/59. Northern Europe; Page 60. Brazil; Page 62/63. South Dakota, USA; Page 64/65. South Atlantic Ocean; Page 66/67. Brazil; Page 68/69. Patagonia; Page 70/71. The Bahamas; Page 72/73. The Bahamas 2 & 3; Page 74/75. Sudan; Page 76/77. Kazakhstan; Page 78/79. Cuba; Page 80. Utah, USA; Page 81. Arizona, USA; Page 82/83. Panama; Page 84. Turkmenistan; Page 85. Argentina; Page 86. Egypt; Page 87. South Africa; Page 88/89. Tibet, China; Page 90. Afar, Ethiopia; Page 91. UK; Page 92/93. Russia; Page 94. Kazakhstan; Page 95. Alaska, USA; Page 96/97. Egypt; Page 98/99. The Bahamas 4; Page 100/101. North Pacific Ocean; Page 102. Volgograd, Russia; Page 103. James Bay, Canada; Page 104/105. Illizi, Algeria; Page 106. Geneva, Switzerland; Page107. Goumeur, Chad; Page 108/109. Manicouagan, Quebec; Page 110/111. South Island, New Zealand; Page 112/113. Ennedi, Chad; Page114/115. The Himalayas; Page 116/117. The Andes; Page 118/119. Washington State, USA; Page 120/121. Kamchatka, Russia; Page 122/123. Nok Kundi, Pakistan; Page124. Chamonix, France; Page 125. Yinchuan, China; Page 126/127. Mount Everest, Nepal; Page 128/129. Chile/Argentina; Page 130. Southern Atlantic Ocean; Page 131. The Himalayas 2; Page 132/133. Tenerife, Canary Islands; Page 134/135. Xinjiang, China; Page 136. Illizi, Algeria; Page 137. Ubar, Oman ; Page 138/139. Chegga, Tiris Zemmour Region, Mauritania; Page 140/14. British Columbia, Canada; Page 142. Jammu and Kashmir, India; Page 143. Lake Argentino, Argentina; Page 144/145. Catania, Italy; Page 146/147. Gemeri Lake, Ethiopia;

Page148/149. Vancouver, Canada; Page 150/151. Calgary, Canada; Page 152. San Francisco, San Jose and the Bay Area, USA; Page 153. Salt Lake City, USA; Page 154/155. New Orleans, USA; Page 156/157. New York City, USA; Page 158. Charleston, USA; Page 159. Los Angeles, USA; Page 160/161. Constanta, Romania; Page 162/163. El Giza, Egypt; Page 164/165. El Giza, Egypt; Page 166/167. Medina, Saudi Arabia; Page 168/169. Munich, Germany; Page 170/171. Antwerp, Belgium; Page 172/173. Sydney, Australia; Page 174/175. Christchurch, New Zealand; Page 176/177. Istanbul, Turkey; Page 178/179. South Coast, UK; Page 180/181. Lisbon, Portugal; Page 182/183. Athens, Greece; Page 184. Cologne, Germany; Page 185. Edinburgh, Scotland; Page 186. London, England; Page 187. Dublin, Ireland; Page 188/189. Isle of Wight, England; Page 190. Newcastle upon Tyne, England; Page 191. Liverpool, England; Page 192/193. Vancouver Island, Canada ; Page 194/195. Astrakhan, Russia; Page 196/197. Milky Way; Page 198/199. Cadiz, Spain; Page 200/201. Aurora 1; Page 202/203. Aurora 2; Page 204/205. Aurora 3; Page 206/207. Aurora 4; Page 208/209. Soyuz TMA-19M spacecraft; Page 210/211. Aurora 5; Page 212/213. Tunisia/Libya; Page 214/215. Stars; Page 216/217. Progress MS-02 spacecraft; Page 218. Cygnus OA-6 spacecraft; Page 219. Soyuz TMA-20M spacecraft; Page 220/221. Clouds; Page 222/223. Dragon spacecraft; Page 224. Ontario, Canada; Page 225. Sharm El Sheikh, Egypt; Page 226/227. Clouds 2; Page 228. Cloud 3; Page 229. Rhodes, Greece; Page 230/231. Clouds 4; Page 232/233. DIWATA-1 microsatellite; Page 234/235. Sea of Okhotsk, Russia; Page 236. Selfie 2; Page 237. Author portrait; Page 239. Spacewalk.

Note: All photographs included in this book are © ESA/NASA, except the back endpaper image, which is ©SHAMIL ZHUMATOV/AFP/Getty Images.

The front cover is a composite image, based on a photograph of Tim's spacewalk and a photograph of Earth that he took from the International Space Station.